FISH STORY ALLAN SEKULA

Witte de With, center for contemporary art, Rotterdam
21.01.1995–12.03.1995

Fotografiska Museet in Moderna Museet, Stockholm
06.05.1995–27.08.1995

Tramway, Glasgow
06.10.1995–12.11.1995

Le Channel, Scène nationale and Musée des Beaux Arts et de la Dentelle, Calais
16.12.1995–25.02.1996

RICHTER VERLAG

Project and Exhibition Coordination Witte de With, center for contemporary art,
Rotterdam: Chris Dercon, Paul van Gennip

Local Exhibition Curators: Fotografiska Museet in Moderna Museet, Stockholm:
Jan Erik Lundström; Tramway, Glasgow: Charles Esche; Le Channel, Scène nationale
de Calais, Calais: Marie-Thérèse Champesme; Musée des Beaux-Arts et de la
Dentelle, Calais: Annette Haudiquet

Catalogue Design: Allan Sekula, Catherine Lorenz
Editor: Barbera van Kooij
Editorial Assistant: Robin Resch
Printer: Druckerei Winterscheidt GmbH, Düsseldorf
Publishers: Witte de With, center for contemporary art, Rotterdam, and
Richter Verlag, Düsseldorf
Edition: 3.000 softcover copies, 1.000 hardcover copies

Witte de With, center for contemporary art, Witte de Withstraat 50, 3012 BR Rotterdam,
Nederland, Tel. 31 (0)10 411 01 44, Fax. 31 (0)10 411 79 24, Witte de With is an initiative
of the Rotterdam Arts Council and is supported by the Dutch Ministry of Culture.
Staff: Gé Beckman, Chris Dercon, Paul van Gennip, Roland Groenenboom, Chris de
Jong, Barbera van Kooij, Maaike Ritsema, Miranda Spek, Rutger Wolfson and Bob
Goedewaagen

Fotografiska Museet in Moderna Museet, Box 16382, 10327 Stockholm, Sweden
Tel. 46 (0)8 666 43 86, Fax. 46 (0)8 611 62 75. Curatorial staff: Peter Åström, Eva Bagge-
Milanesio, Jan-Erik Lundström, Håkan Petersson

Tramway, 25 Albert Drive, Glasgow G41 2PE, Scotland, Tel. 44 (0)41 422 20 23,
Fax. 44 (0)41 422 20 21. Tramway is owned by the Glasgow City Council and managed
by the Department of Performing Arts and Venues (Director: Robert Palmer). It is
subsidised by the Scottish Arts Council. Curatorial staff: Katrina Brown, Nathan
Coley, Charles Esche

Le Channel, Scène nationale de Calais Galerie de l'ancienne poste, 13 Boulevard
Gambetta, B.P. 77, 62102 Calais Cedex, France, Tel. 33 21 46 77 10, Fax. 33 21 46 77 20.
Le Channel is subsidised by la Ville de Calais, le Ministère de la Culture et de la
Francophonie, la Région Nord/Pas-de-Calais, le Département du Pas-de-Calais.
Curatorial staff: Marie-Thérèse Champesme

Musée des Beaux-Arts et de la Dentelle, 25 rue Richelieu, 62100 Calais, France,
Tel. 33 21 46 62 00, poste 6317, Fax. 33 21 46 62 09. Curatorial staf: Annette Haudiquet

The organizers would like to thank: Gerlach Art Packers and Shippers, Amsterdam;
Ron de Hoog, Een visie in lijsten, Maassluis; Rotterdam Arts Council, Rotterdam;
Stichting Bevordering van Volkskracht, Rotterdam; Het Ministerie van O.C.W.,
Rijswijk; Nedlloyd Groep, Rotterdam; Stichting Bevordering van Volkskracht,
Rotterdam

ISBN 90-73362-30-X

Printed and bound in Germany

TABLE OF CONTENTS

To five people, for all of whom, in different ways, the sea holds meaning:
Evelyn Sekula, Stefan Sekula, Sally Stein, Stan Weir and Robert Wilkie.

FISH STORY

A sea-fight must either take place tomorrow or not, but it is not necessary that it should take place tomorrow, nor is it necessary that it should not take place.

Aristotle, *De Interpretatione*

1

2

1

Growing up in a harbor predisposes one to retain quaint ideas about matter and thought. I'm speaking only for myself here, although I suspect that a certain stubborn and pessimistic insistence on the primacy of material forces is part of a common culture of harbor residents. This crude materialism is underwritten by disaster. Ships explode, leak, sink, collide. Accidents happen everyday. Gravity is recognized as a force. By contrast, airline companies encourage the omnipotence of thought. This is the reason why the commissioner of airports for the city of Los Angeles is paid much more than the commissioner of harbors. The airport commissioner has to think very hard, day and night, to keep all the planes in the air.

2

In the past, harbor residents were deluded by their senses into thinking that a global economy could be seen and heard and smelled. The wealth of nations would slide by in the channel. One learned a biased national physiognomy of vessels: Norwegian ships are neat and Greek ships are grimy. Things are more confused now. A scratchy recording of the Norwegian national anthem blares out from a loudspeaker at the Sailors' Church on the bluff above the channel. The container ship being greeted flies a Bahamian flag of convenience. It was built by Koreans laboring long hours in the giant shipyards of Ulsan. The crew, underpaid and overworked, could be Honduran or Filipino. Only the captain hears a familiar melody.

3

What one sees in a harbor is the concrete movement of goods. This movement can be explained in its totality only through recourse to abstraction. Marx tells us this, even if no one is listening anymore. If the stock market is the site in which the abstract character of money rules, the harbor is the site in which material goods appear in bulk, in the very flux of exchange. Use values slide by in the channel; the Ark is no longer a bestiary but an encyclopedia of trade and industry. This is the reason for the antique mercantilist charm of harbors. But the more regularized, literally container-ized, the movement of goods in harbors, that is, the more rationalized and automated, the more the harbor comes to resemble the stock market. A crucial phenomenological point here is the suppression of smell. Goods that once reeked—guano, gypsum, steamed tuna, hemp, molasses—now flow or are boxed. The boxes, viewed in vertical elevation, have the proportions of slightly elongated banknotes. The contents anonymous: electronic components, the worldly belongings of military dependents, cocaine, scrap paper (who could know?) hidden behind the corrugated sheet steel walls emblazoned with the logos of the global shipping corporations: Evergreen, Matson, American President, Mitsui, Hanjin, Hyundai.

4

Space is transformed. The ocean floor is wired for sound. Fishing boats disappear in the Irish Sea, dragged to the bottom by submarines. Businessmen on airplanes read exciting novels about sonar. Waterfront brothels are demolished or remodeled as condominiums. Shipyards are converted into movie sets. Harbors are now less *havens* (as they were for the Dutch) than accelerated turning-basins for supertankers and container ships. The old harbor front, its links to a common culture shattered by unemployment, is now reclaimed for a bourgeois reverie on the mercantilist past. Heavy metals accumulate in the silt. Busboys fight over scarce spoons in front of a plate-glass window overlooking the harbor. The backwater becomes a frontwater. Everyone wants a glimpse of the sea.

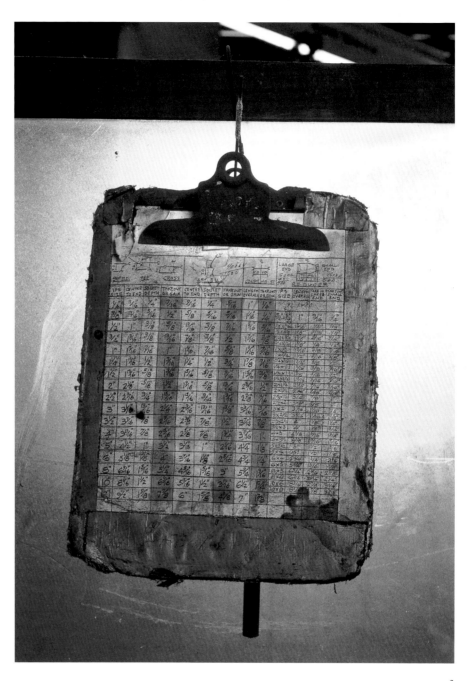

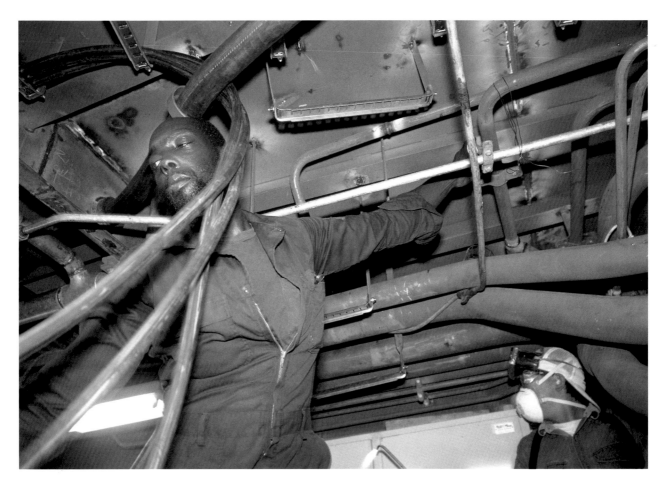

4

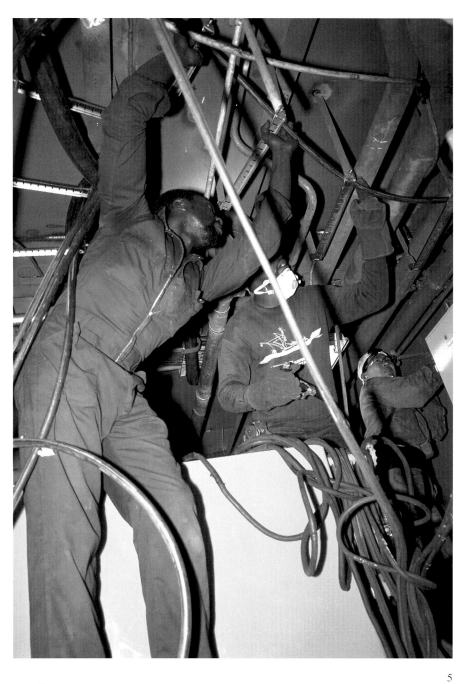

5

6

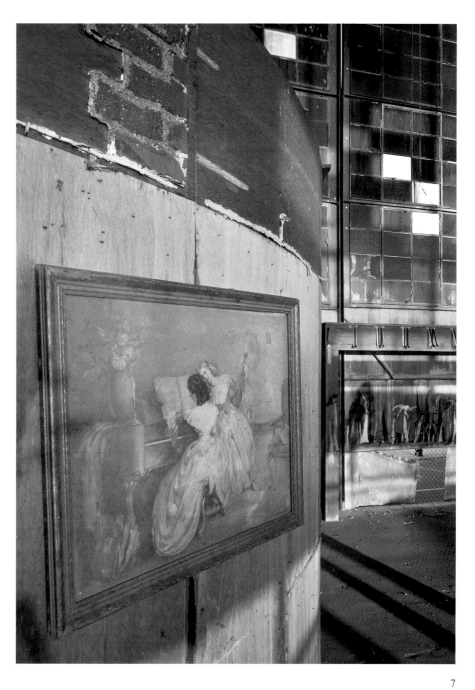

7

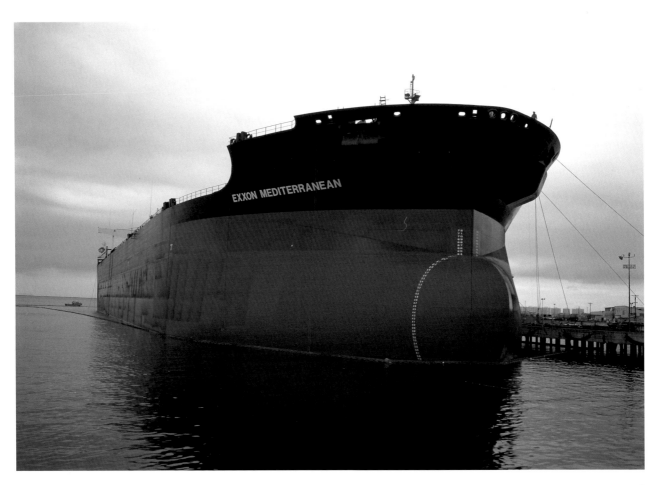

8

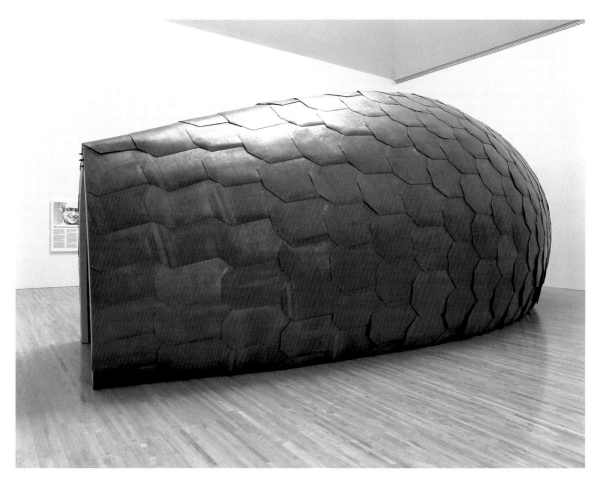

9

10

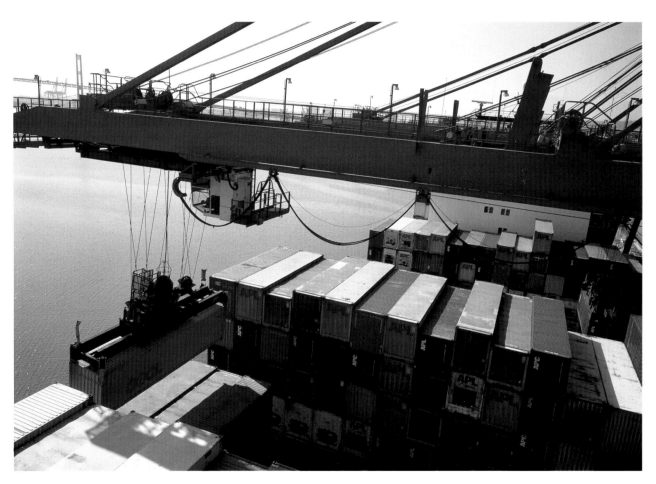

11

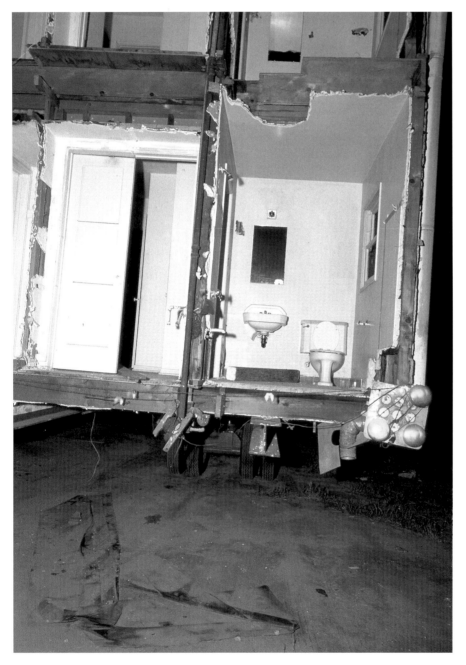

12

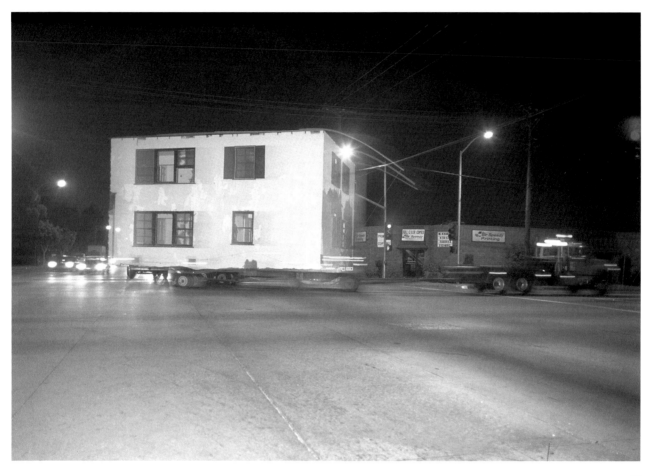

13

14

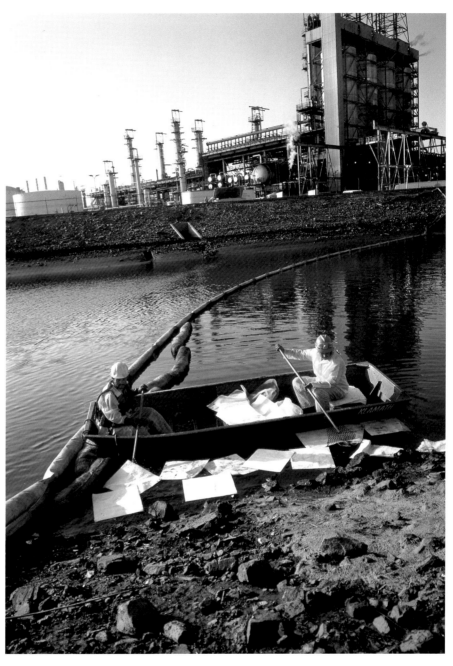

15

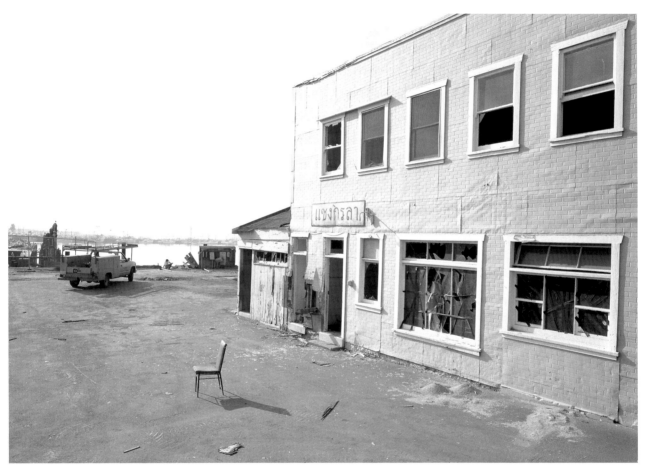

16

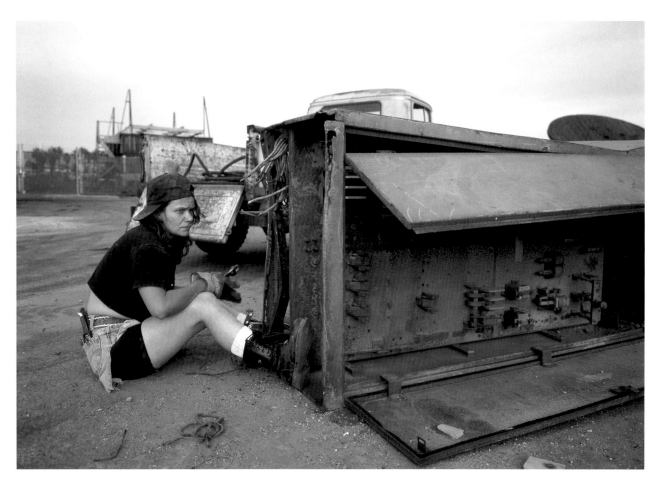

17

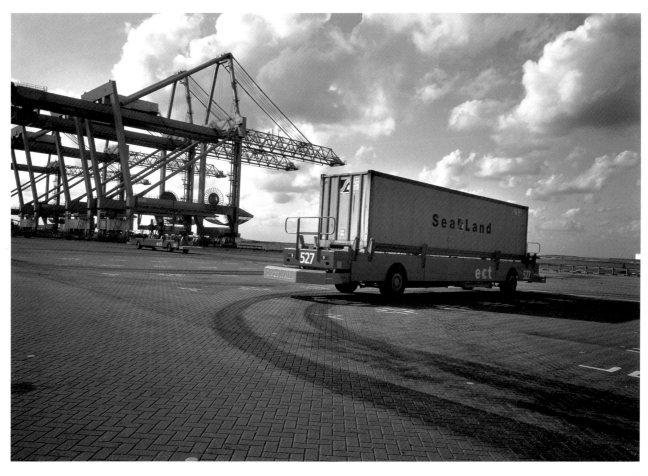

18

LOAVES AND FISHES

A German friend wrote me early in January 1991, just before the war in the Persian Gulf: "You should try to photograph over-determined ports, like Haifa and Basra." Her insight, that some ports are fulcrums of history, the levers many, and the results unpredictable, was written in the abstract shorthand of an intellectual. But she shares the materialist curiosity of people who work in and between ports, such as the Danish sailors who discovered that Israel was secretly shipping American weapons to Iran in the 1980s. *A crate breaks, spilling its contents.* But that's too easy an image of sudden disclosure, at once archaic and cinematic, given that sailors rarely see the thrice-packaged cargo they carry nowadays. *A ship is mysteriously renamed.* Someone crosschecks cargo manifests, notices a pattern in erratic offshore movements, and begins to construct a story, a suspicious sequence of events, where before there were only lists and voyages, a repetitive and routine industrial series.

Sailors and dockers are in a position to see the global patterns of intrigue hidden in the mundane details of commerce. Sometimes the evidence is in fact bizarrely close at hand: *Weapons for the Iraqis in the forward hold. Weapons for the Iranians in the aft hold.* Spanish dockers in Barcelona laugh at the irony of loading cargo with antagonistic destinations. For a moment the global supply network is comically localized, as pictorially condensed as a good political cartoon. Better to scuttle the ship at the dock. But limpet mines are tools of governments, not of workers.

At the very least, governments find it necessary to dispute the testimony of maritime workers. Ronald Reagan, the symbolic Archimedes of a new world of uninhibited capital flows, worried about the stories being told in 1986. The Great Anecdotalist presumably had a good ear for yarns: these "quite exciting" reports "attributed to Danish sailors" about shipload after shipload of weapons moving from the Israeli Red Sea port of Eilat to the Iranian Persian Gulf port of Bandar Abbas were best countered with an almost royalist affirmation of presidential authority: "Well now you're going to hear the facts from a White House source, and you know my name."[1]

This was not the first time that Reagan had worried about the maritime trades. As he launched his political career in the 1960s, Reagan recalled his experience as a conservative trade unionist in Hollywood in the late 1940s, and claimed that the secret Communist labor stategy at the time had been to bring the Hollywood unions under the control of the West Coast longshoremen. The longshoremen were led by Australian-born Harry Bridges, who, in Reagan's words, had been "often accused but never convicted of Communist membership." The future president concluded with a sly aside: "The only item which was unclear to me—then and now—was how longshoremen could make movies."[2]

We know now that actors can make politics. The next question to be asked is this: How do governments—and the actors who speak for governments—move cargo? How do they do it without stories being told by those who do the work? Could the desire for the fully automated movement of goods also be a desire for silence, for the tyranny of a single anecdote?

[1] "Transcript of Remarks by Reagan about Iran," *New York Times*, 14 November 1986, p. A8. Speech written by Patrick Buchanan in consultation with the National Security Council staff. Attribution from the archives of the Ronald Reagan Presidential Library. Simi Valley, California.

[2] Ronald Reagan with Richard G. Hubler, *Where's the Rest of Me? The Ronald Reagan Story* (New York: Duell, Sloan and Pearce, 1965), pp. 161, 164.

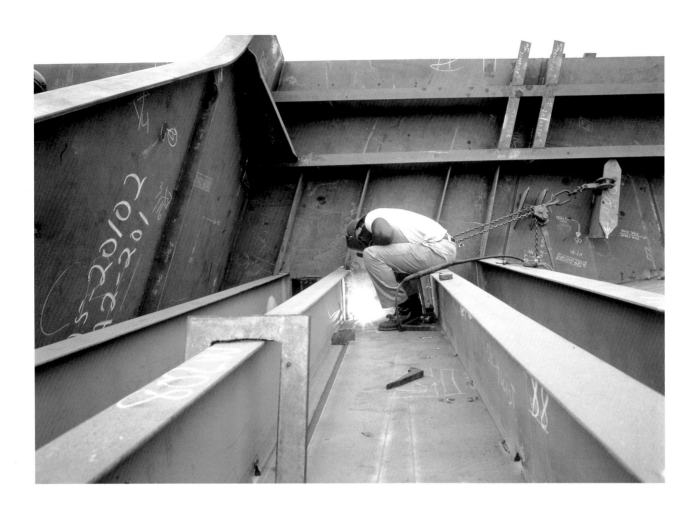

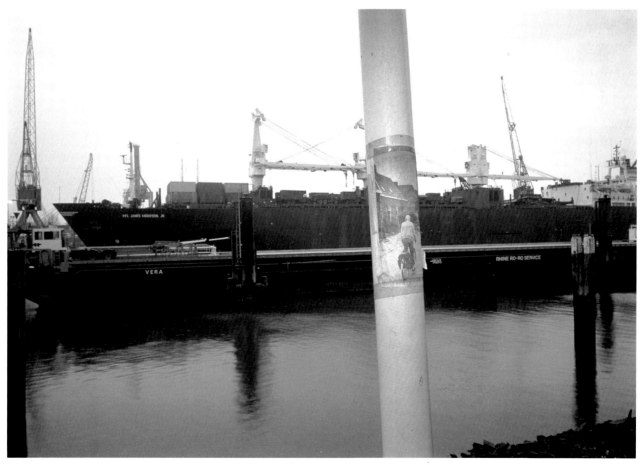

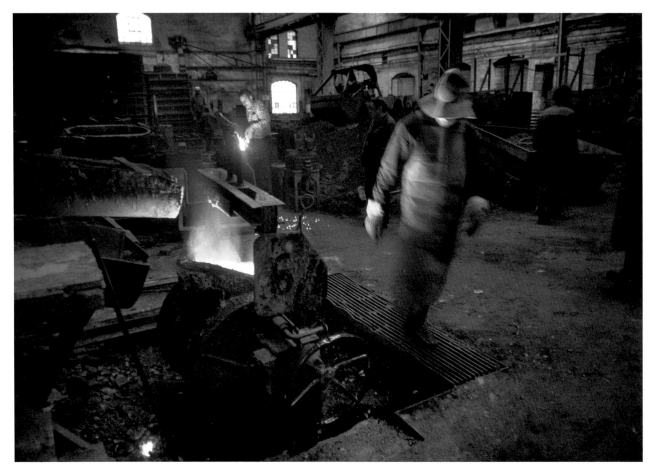

21

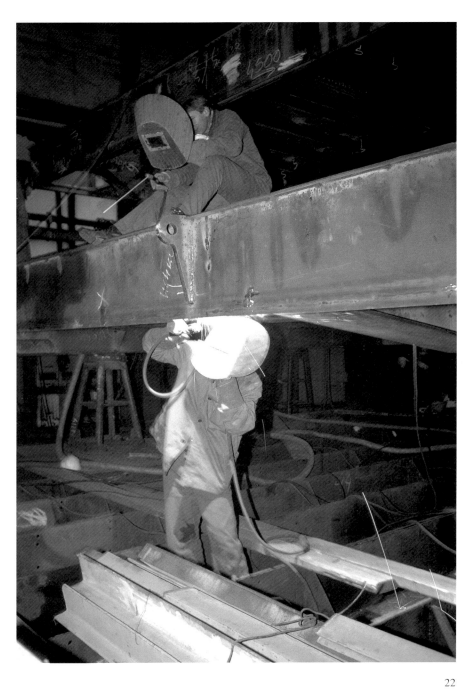

22

23

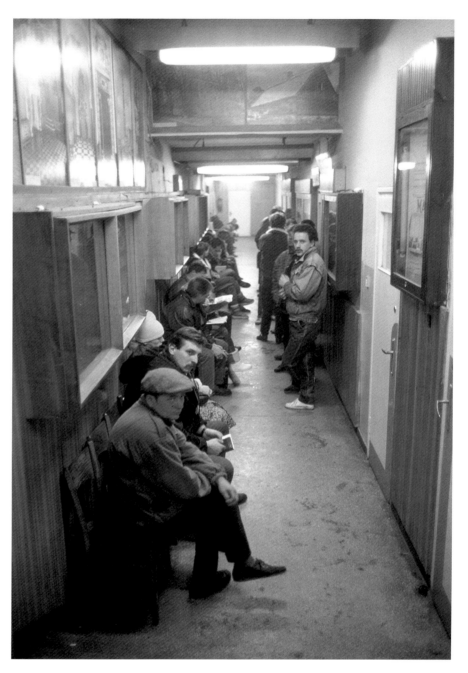

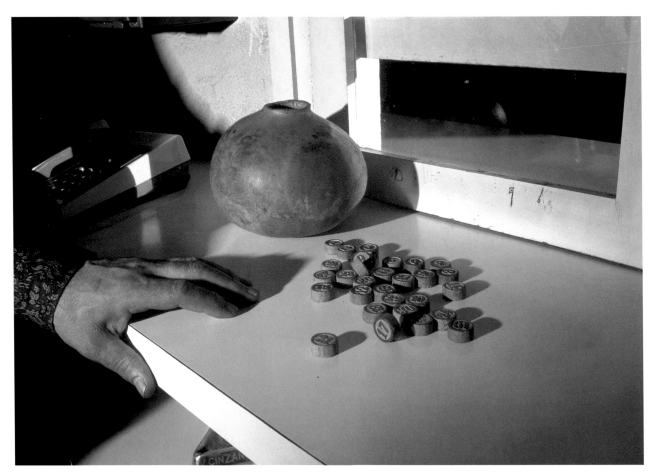

25

26

DISMAL SCIENCE: PART 1

When Friedrich Engels set out in 1844 to describe in detail the living and working conditions of the English working class, he began oddly enough by standing on the deck of a ship:

> I know of nothing more imposing than the view one obtains of the river when sailing from the sea up to London Bridge. Especially above Woolwich the houses and docks are packed tightly together on both banks of the river. The further one goes up the river the thicker becomes the concentration of ships lying at anchor, so that eventually only a narrow shipping lane is left free in mid-stream. Here hundreds of steamships dart rapidly to and fro. All this is so magnificent and impressive that one is lost in admiration. The traveler has good reason to marvel at England's greatness even before he steps on English soil. It is only later that the traveler appreciates the human suffering that has made all this possible.[1]

For Engels, the increasing congestion of the Thames anticipated a narrative movement into the narrow alleys of the London slums. Very quickly, the maritime view—panoramic, expansive, and optimistic—led to an urban scene reduced to a claustrophobic Hobbesian war of all against all:

> The more that Londoners are packed into a tiny space, the more repulsive and disgraceful becomes the brutal indifference with which they ignore their neighbors and selfishly concentrate upon their private affairs. . . . Here indeed human society has been split into its component atoms.[2]

Engels' descriptive movement from the open space of the river to the closed spaces of the city's main streets and slums also anticipated an incipient theoretical insight of historical materialism: the discovery of the unequal development of the technical means and the social relations of production. The river port, like Thomas Hobbes' Leviathan, is a huge figure of contained and purposeful energy, contrasting with the aggressive and brutish frictions of the city itself. The city, at this juncture, is more primitive than the river.

If the river and the city did not entirely exist in the same present, it is also the case that the river belonged to an earlier epoch. Thus the geographical passage from river to city was on a more subtle level a historical shift from one motive force to another: the river was still ruled by the wind while the city ran on coal. Looking back, in a footnote added to the 1892 German reissue of his book, Engels felt the need to qualify that moment on deck:

> This was so nearly fifty years ago, in the days of picturesque sailing vessels. In so far as such ships still ply to and from London, they are now to be found only in the docks, while the river itself is covered with ugly, sooty steamers.[3]

By the end of the century, Engels knew that his earlier rhetorical strategy had rested on an aesthetic and spatial contrast that had lost its validity, a contrast between the "picturesque" (*malerische*) port and the "ugly" city. Like Joseph Conrad, who described a steam tug as "an enormous and aquatic black beetle" leaving an "unclean mark" on the waves, Engels now found nothing to celebrate in the maritime use of steam. The city, and the factory system behind the city, had devoured any difference—or beauty—the river had to offer. But this obliteration of the river's "difference" is already prefigured in the

1 Friedrich Engels, *The Condition of the Working Class in England* [1845], trans. and ed. W.O. Henderson and W.H. Chaloner (Stanford, California: Stanford University Press, 1968), p. 30.

2 Ibid., p. 31.

3 Ibid., p. 30, n. 1.

[4] Joseph Conrad, *The Nigger of the "Narcissus"* [1898],
ed. Robert Kimbrough (New York: Norton, 1979),
p. 16.

[5] *Condition of the Working Class*, p. 334.

earlier text: as the river narrows it becomes less like a port and more like a city street.[4]

The "magnificent" (*grossartig*) scene on the Thames leads on to the dismal alleys of Manchester. At the outset, industrial capitalism is prefigured through its older mercantile counterpart, culminating in the image of the small steamships, that "dart rapidly to and fro," sharing their motive force with the modern factory. From this point on the text is permeated with the metaphor of steam: society is a contained and superheated gas under increasing pressure. The working-class slum is the ultimate locus of this looming explosion, of atomized forces that threaten to build and rupture the cast-iron walls of the urban factory-boiler. Engels was to push his Hobbesian prophecy to its grim limit in the concluding chapter of his book: "The war of the poor against the rich will be the most bloodthirsty the world has ever seen."[5]

Engels' narrative begins at sea, in *maritime space*, a space defined in many of its distinctive features by an earlier preindustrial capitalism, a capitalism based on primitive accumulation and trade. When it was initially seized by the imaginary and made pictorial as a coherent and integrated space rather than as a loose emblematic array of boats and fish and waves, maritime space became panoramic. Its visual depiction even today conforms to models established by Dutch marine painting of the seventeenth century. It is in these works that the relationship of ships to cities is first systematically depicted. Obviously, the various historical modes of picturing maritime space should be distinguished from any provisional list of actual maritime spaces: the ship itself, the hinterland, the waterfront, the seaport, breakwaters and seawalls, coastal fishing villages, islands, reefs, the beach, the undeveloped shoreline, the pelagic space of the open sea, the deeps, and so on. (I include the hinterland here because it is terrestrial space defined in its spatial relationship to the seaport.) One can produce other, more strictly functionalist or legalistic typologies: strategic naval space, fisheries, trade routes, national and international waters, exclusive economic zones, free ports. And yet, on a fundamental level, there is a strong connection between the qualities of boundedness or openness of these worldly spaces and the possibilities imagined in pictorial representation. Over time, this relationship became partially reciprocal, and some maritime spaces, those devoted to touristic pleasures, were developed to conform to pictorial exemplars.

The panorama is paradoxical: topographically "complete" while still signalling an acknowledgement of and desire for a greater extension beyond the frame. The panoramic tableau, however bounded by the limits of a city profile or the enclosure of a harbor, is always potentially unstable: "If this much, why not more?" The psychology of the panorama is overtly sated and covertly greedy, and thus caught up in the fragile complacency of disavowal. The tension is especially apparent in maritime panoramas, for the sea always exceeds the limits of the frame.

It is in early seventeenth-century Dutch legal theory that the sea is emphatically understood to exceed and even resist terrestrial boundaries and national proprietary claims. Writing in defense of the interests of the Dutch East India Company against Portuguese claims to exclusive trading rights in the southwest Pacific, Hugo Grotius spoke, perhaps somewhat cynically, of

> ... the OCEAN, that expanse of water which antiquity describes as the immense, the infinite, bounded only by the heavens, parent of all things. ... the ocean

which ... can neither be seized nor enclosed; nay, which rather possesses the earth than is possessed.[6]

6 Hugo Grotius, *The Freedom of the Seas, or the Right Which Belongs to the Dutch to Take Part in the East India Trade* [1608], ed. James Brown Scott, trans. Ralph van Deman Magoffin (New York: Oxford University Press, 1916), p. 37.

Thus the sea's infinitude gives rise to a doctrine of free trade well before it provides a basis for eighteenth-century aesthetic notions of the sublime. Panoramic maritime space in Dutch painting is implicitly "open" in this pre-romantic sense: open to trade, a net cast outward upon a world that yields property but that in its idealized totality is irreducible to property. When proto-romanticism is later confronted with this uncommodifiable excess, it trans-forms it into the sublime, taking it initially as proof of divinity; only later is the category naturalized and psychologized:

> A troubled Ocean, to a Man who sails upon it, is, I think, the biggest Object that he can see in motion, and consequently gives his Imagination one of the highest kinds of Pleasure that can arise from Greatness. I must confess, it is impossible for me to survey this World of fluid Matter, without thinking on the Hand that first poured it out....[7]

7 Joseph Addison, *The Spectator*, 20 September 1712.

In its blunt and clever materialism, seventeenth-century Dutch painting had not yet reached this point: the hands that mattered most in contemplating the sea were those of the shipwright and the seafarer. Svetlana Alpers has characterized the "descriptive" and "topographic" mode of Dutch painting in these terms:

> Like the mappers, [Dutch painters] made additive works that could not be taken in from a single viewing point. Theirs was not a window on the Italian model of art but rather, like a map, a surface on which is laid out an assemblage of the world.[8]

8 Svetlana Alpers, *The Art of Describing: Dutch Art in the Seventeenth Century* (Chicago: University of Chicago Press, 1983), p. 122.

Alpers' account of Dutch topographic methods invites us to consider a mobile spectator, more inquisitive than acquisitive, a crypto-cartographer, and not the fixed humanist subject of Renaissance Italian perspective. Nonetheless, the seventeenth-century Dutch still lived in a world in which commodification, while everywhere expanding, was not yet universal.

There is a profound historical shift in the passage from a seventeenth-century world view that recognizes a formal legal limit to the additive "assem-blage of the world" and one that submits the totality to the same pecuniary accounting procedures with which it had grasped the fragments. That latter world had arrived with the factory system by the middle of the nineteenth cen-tury, thrusting the confidence and measure of older panoramic methods into crisis, while simultaneously routinizing the mechanical panoramic possibili-ties of the camera. The prototypically "Dutch" mobile spectator had been transformed into a figure of passive consumption. Dolf Sternberger argued that steam-powered travel by rail had submitted the world to a new panoramic spectacularity:

> The railroad elaborated a new world of experience, the countries and oceans, into a panorama.... it turned the eyes of travellers outward, offering them a rich diet of changing tableaux, the only possible experience during a trip. [9]

9 Dolf Sternberger, *Panorama of the Nineteenth Century* [1938], trans. Joachim Neugroschel (New York: Urizen), 1977, p. 39.

Sternberger assumed that the rapid linearity of railroad travel extended even to the view from coastal tracks onto the sea, but implicitly this passage suggested that even sea travel had succumbed to the railroad model, for other-wise how could the oceans truly have become panoramic?

It is true that steam travel by sea developed from steam travel by land, and thus was a step forward in the increasing dominion of the land over the sea. The gigantic transatlantic steamer *Great Western* of 1838 was the logical outward extension of its designer Isambard Brunel's earlier project, the Great Western Railway. But the monotony and malaise and occasional terror of pelagic space, the space of the "middle passage," resisted conversion into "a rich diet of changing tableaux," whether or not one's ship was powered by wind or steam. The opulent interior spaces of first-class travel on the steamships of the late Victorian and Edwardian periods may well have been designed to compensate for that lack of external "tableaux" on the high seas. The sea's resistance to an all-consuming opticality lingered well into the modern period, most emphatically for those passengers unable to afford the outward view from the promenade deck or its inner surrogate in the grand saloon. Thus the sea's "excess" is not easily superseded by modernization.

Standing on the deck of his ship as it sailed upriver to London, Engels was straddling two very different ideas of panoramic space: the older panoramic tableaux of the Dutch and the new mobile panorama of an accelerated age of steam. He described a liminal maritime space that was just beginning to be enveloped by the polluted miasma of urban industry. This "enveloping" eventually rendered the older notion of the panorama obsolete, or at least anachronistic, in its reassuring depiction of a clear division between ships and the land, and ships and the sea.

This collapse, or blurring, of panoramic maritime space in painting was first grasped by J.M.W. Turner, in works produced coincidentally with the first appearances of oceangoing steam-driven ships in the decade preceding Engels' voyage up the Thames. This is not to reduce the Turneresque sublime to a simple technological determinist explanation, but rather to suggest that a painted sky that presumed the wind to be a motive force had a different referential status from one in which steam and smoke were introduced as evidence of new powers. Steam cut an imaginary straight line through a space previously governed by the unpredictability of the wind. Paradoxically, however, steam made the possible directions of movement less evident in the aggregate view of ship and sea and sky. A line of smoke from a funnel is not always an indication of the vector available to or taken by a ship. Only if the speed of the ship greatly exceeds that of the wind, or if the ship steams directly into the wind, will this line indicate the ship's path. Weather became paramount in painting as its actual power over human movement diminished, and transit times became more predictable. Turner's exorbitation of weather occurred at the very historical moment when it was widely imagined to be vanquished.

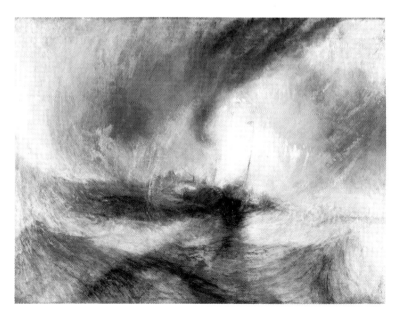

Fig. 1
Joseph Mallord William Turner, *Snow Storm—Steamboat off a Harbour's Mouth,* oil on canvas, 1842.

Engels' implicitly romantic attitude toward the sea and seafaring—his sense of a heroic and even redemptive potential of the sea—required that his literary description of the

approach to London on the Thames, while couched in the language of the romantic sublime, conform not to a Turner-esque blurring, but to the older model of sharp encyclopedic delineation of ships, shoreline, and buildings, albeit with a sense of an increasing congestion that anticipated disorder even as it testified to prosperity. By turning back to an older panoramic realism, the realism of Joseph Vernet or before that of Hendrick Vroom and the Willem van de Veldes, Engels initiated a newer social realism, an art of crowded spaces, previously hidden details and the statistics of misery. In doing so, he assaulted the optimism and confidence of those earlier aristocratic and bourgeois visions of economies seen from the waterfront. The slum was for Engels what the storm was for Turner in his later paintings: a catastrophic limit set against industrial hubris. Their great difference lies in the fact that industry and the slum produce one another, while the storm remains an external force.

There was a deliberate and ironic anachronism in Engels' choice of the sailing packet as a platform from which to launch an economic investigation of the city, underscoring capitalism's descent from its "earlier heroic phase" to the depraved exploitation of the fully developed industrial system.[10] This device contained an element of theater, a staging of a "backward" German traveller's touristic awe at the sights, which echoes even today in insurrectionary literature.[11]

But ultimately Engels recognized that the port of London was in no respect anachronistically "outside" the contemporary system of production: "This great population has made London the commercial capital of the world and has created the gigantic docks in which are assembled the thousands of ships which always cover the River Thames."[12] The order of causality here is significant: the port is the product of industrial capitalism. What is absent is a developed theory of primitive accumulation, which would comprehend the prior role of the merchant ship in producing that next stage of capitalist development. If the initial iconography of Engels' journey to London and Manchester can be traced to Amsterdam, the Dutch precedent for his opening description of the bustling scene on the Thames can be found most clearly in paintings such as Ludolph Backhuysen's *Shipping before Amsterdam* (1666), or earlier in Hendrick Vroom's *Return of the Second Dutch Expedition to the West Indies* (1599). These are paintings with a deck or lower-mast level viewpoint from which the profile of the city of Amsterdam is partly obscured by the density of triumphant vessels in the river IJ. The standard art-historical interpretation of pictures such as these assigns a larger symbolic and anthropomorphic significance to the image of the ship:

> ... a ship is not an inanimate object but a complex manned entity that is rarely depicted in isolation; by its very nature it is related to a larger visible or implied whole. Not only are these ships some of the most complex products of seventeenth-century engineering, but their inherently human presence arouses our interest. Once we realize that they are pitted against the elements or against each other we become absorbed in their destiny. By implication the subject is dramatic because there must be an outcome: survival or destruction—victory or defeat.[13]

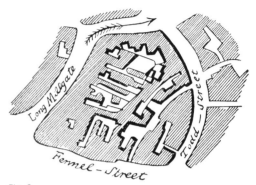

Fig. 2
Map of Manchester slum. From Friedrich Engels, *Der Lage der Arbeitenden Klasse in England*, 1845.

10 Steven Marcus, *Engels, Manchester, and the Working Class* (New York: Random House, 1974), p. 74. Marcus notes that in 1837 Engels, aged 17, wrote a "romance in prose" entitled "Seeräubergeschichte" (A Pirate Story).

11 See, for example, Marcos and the Zapatistas, *Mexico: A Storm and a Prophecy*, trans. and ed. Barbara Pillsbury, Open Magazine Pamphlet Series, no. 31 (Westfield, New Jersey: Open Magazine, 1994).

12 *Condition of the Working Class*, p. 30.

13 George Keyes, *Cornelis Vroom: Marine and Landscape Artist* (Alphen aan den Rijn: Canaletto, 1975), p. 17. See also his *Mirror of Empire: Dutch Marine Art of the Seventeenth Century* (Minneapolis and The Hague: Minneapolis Institute of Arts and Gary Schwartz/SDU Publishers, 1990).

It is precisely this insistence on hidden allegory that Svetlana Alpers opposes in her argument that what distinguishes Dutch paintings is the intellectually complex character of their non-narrative, "descriptive" engagement with the world and conditions of visual knowing. Alpers defends a mode of pictorial absorption that is not dependent on symbolization or narrativity. But the dramaturgy of eternal struggle and "destiny," intended to elevate marine paintings above the level of mere documents of "seventeenth-century engineering" manages to arrive unwittingly at the threshold of an interesting and sometimes embarrassing historical truth: these ships are *war machines*, and their purpose is bloody plunder.

It might do well for us to rethink these Dutch pictures in allegorical terms, to regard them as allegories of empire in which national identity and external threat and dominion are persistently figured by descriptive, topographic means. This requires a move from Alpers' interest in the epistemological basis of Dutch paintings to a regard for their combative and even paranoid features. Expansive panoramic space is always haunted by the threat of collapse or counter-expansion. Thus the panorama is always implicitly or explicitly militarized: the net can close in from the other side of the horizon. For example, nowhere is the panoramic spatialization of an external threat more topographically evident than in Willem van de Velde the Elder's *The English Fleet at Anchor off Den Helder*. This elongated drawing from 1653, with a vertical to horizontal ratio of 2:9, traces a densely massed line of British warships blockading the strategic gap between the island of Texel and the mainland of Holland. Here the imperium implicit in the Dutch panorama meets its mirror image. The blockade matches and implicitly "contains" the otherwise expansive view from the Dutch coast. The British antagonist is like-minded but stronger, and it is worth noting that this defeat of the Dutch "viewpoint" is reenacted in the van de Veldes' subsequent decision to cross the horizon line and practice their craft in England.

Fig. 3
Willem van de Velde the Elder, *The English Fleet at Anchor off Den Helder*, drawing, 1653.

Many Dutch maritime paintings were commissioned by city magistrates, or by shareholders in the great trading companies. One obvious condition of their success lay in the ability of the painter to articulate the economic link between the ship and the city in appropriately illusionistic and nonsymbolic spatial terms. Consider an earlier Dutch maritime painting, Hendrick Vroom's *View of Hoorn* of 1622. Hoorn does not sink modestly into the sea as Dutch cities tend to do when viewed from deck level. The elevated masthead view, and the slight curvature of the coastline combine to place the city of Hoorn at the center of a global circle, with favorable offshore winds propelling ships immediately outward in their quest for wealth. In effect, this picture gives us two panoramas: one visible and contained, showing the clear profile of the city and the parallel expanse of the IJsselmeer, and the other "providential," implied and open. This second, implied panorama extends outward at an oblique angle from the frame, along the speedy radius offered by the wind, leading to the larger expanse of the North Sea and on to the Baltic or the Indies. The viewer, a vicarious (or actual) seafarer, is invited to look back toward the city with the peculiar longings characteristic of approaches and departures.

Once the ship loses sight of land, this panoramic and umbilical linkage back to the port of origin is broken. At the end of the age of sail, Joseph Conrad would come to understand well the phenomenology of this separation of the ship from the land:

> The passage had begun, and the ship, a fragment detached from the earth, went on lonely and swift like a small planet. Round her the abysses of sky and sea met in an unattainable frontier. A great circular solitude moved with her, ever changing and ever the same, always monotonous and always imposing.[14]

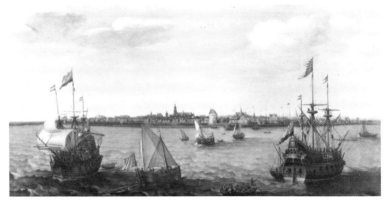

Fig. 4
Hendrik Cornelisz. Vroom, *View of Hoorn*, oil on canvas, c. 1622.

[14] *Nigger of the "Narcissus,"* p. 18.

The painter of this latter space was of course Turner. And with Conrad and Turner, the economic function of the ship loses the positive value it held for the Dutch. The mood shifts from the supposedly sanguine temperament of the lowlands to the melancholy of the late romantics, and the frontier, even bloodier and more colonized now than before, is imagined to be "unattainable." As it moves at the center of its own panorama, the ship becomes the lost and wandering daughter of the land. One measure of Engels' radicality was his ability to break with the fatalism of this emerging romance of the sea's isolation, and to step from the deck of the ship onto the streets of the city at the center of the global circle of power.

FORGETTING THE SEA

It may well appear at this juncture that I am performing a grotesque juggling act at a triple funeral: a memorial service for painting, socialism, and the sea. Leaving aside for the moment the second and presumably most recently deceased of the three, what possible claims can be made for the totalizing ambition of the classical maritime view a century and a half after Engels turned his back on the waterfront? Why would anyone be foolish enough to argue today that the world economy might be intelligently viewed from the deck of a ship? Furthermore, isn't an interest in marine painting liable to charges of antiquarianism and anti-modernism? And finally, by posing these three questions together, don't I risk the additional charge of "naive realism" or reflectionism? The economic questions are relatively easy to answer, while the aesthetic questions are more difficult.

To the extent that transnational capital is no longer centered in a single metropole, as industrial capital in the 1840s was centered in London, there is no longer "a city" at the center of the system, but rather a fluctuating web of connections between metropolitan regions and exploitable peripheries. Thus the lines of exploitation today may run, for example, from London to Hong Kong, from Hong Kong to Shenzhen, from Taipei to Shenzhen, from Taipei to Hong Kong and Taipei to Beijing, from Beijing to Hong Kong and from Beijing to Shenzhen, and perhaps ultimately from a dispersed and fluid transnational block of capitalist power, located simultaneously in London, New York, Vancouver, Hong Kong, Singapore, Taipei, and Beijing, drawing ravenously on the rock-bottom labor costs of the new factories in the border city of Shenzhen and in the surrounding cities and countryside of Guangdong province in southern

[15] See Xianming Chen, "China's Growing Integration with the Asia-Pacific Economy," in Arif Dirlik, ed., *What Is in a Rim? Critical Perspectives on the Pacific Region Idea* (Boulder, Colorado: Westview Press, 1993), pp. 89-119.

[16] I owe this insight to Stan Weir.

China. The ability of Taiwanese manufacturers to move rapidly from production in Taiwan to production in Guangdong or Fujian province is largely a function of the unprecedented physical mobility of manufactured goods and machinery. Shoes made one month in Taiwan are suddenly made a month later in Guangdong at greatly reduced cost. The shoes are identical, only the label registers the change. And even labels can be falsified when import restrictions are to be circumvented. The flow of cargo to Japanese or North American or European markets is never interrupted. A ship leaves Hong Kong with its forty-foot steel boxes full of sneakers, rather than Keelung or Kaohsiung.[15]

The key technical innovation here is the containerization of cargo movement: an innovation pioneered initially by United States shipping companies in the latter half of the 1950s, evolving into the world standard for general cargo by the end of the 1960s. By reducing loading and unloading time and greatly increasing the volume of cargo in global movement, containerization links peripheries to centers in a novel fashion, making it possible for industries formerly rooted to the center to become restless and nomadic in their search for cheaper labor.[16] Factories become mobile, ship-like, as ships become increasingly indistinguishable from trucks and trains, and seaways lose their difference with highways. Thus the new fluidity of terrestrial production is based on the routinization and even entrenchment of maritime movement. Nothing is predictable beyond the ceaseless regularity of the shuttle between variable end-points. This historical change reverses the "classical" relationship between the fixity of the land and the fluidity of the sea.

The transition to regularized and predictable maritime flows initiated by steam propulsion was completed a century later by containerization. If steam was the victory of the straight line over the zigzags demanded by the wind, containerization was the victory of the rectangular solid over the messy contingency of the Ark. As we will see, containerization obscures more than the physical heterogeneity of cargoes, but also serves to make ports less visible and more remote from metropolitan consciousness, thus radically altering the relationship between ports and cities.

The story is of course more complicated than this. It would be difficult to argue that the pioneers of containerized shipping had a vision of the global factory. Their innovations were responses to the internal competitive demands of the shipping industry, but these demands were by their very nature of an international character. Historically-militant seagoing and dockside labor had to be tamed and disciplined: the former had to be submitted to the international search for lower wages, the latter subjected to automation. Ships themselves had to be built bigger and differently and by workers earning relatively less than their historical predecessors. International capital markets had to be deregulated and tariff boundaries circumvented or dissolved by fiat or international agreement, but these legal changes follow rather than precede containerization. NAFTA and GATT are the fulfillment in international trade agreements between transnational elites of an infrastructural transformation that has been building for more than thirty years.

Indeed, it can be argued further that the maritime world underwent the first legally mandated internationalization or "deregulation" of labor markets with the invention by American shipowners and diplomats of the contemporary system of "flag of convenience" registry in the late 1940s. At the time, American trade unionists concerned about the decline of the U.S. merchant fleet

complained about "runaway ships," drawing an analogy with the "runaway shops" of the textile industry then relocating from New England to the non-union South.[17] Little did they imagine that within three decades factories would follow ships to a more complete severing of the link between ownership and location. The flag of convenience system, which assigned nominal sovereignty to new maritime "powers" such as Panama, Honduras, and Liberia, allowed owners in the developed world to circumvent national labor legislation and safety regulations. Crews today are drawn primarily from the old and new third worlds: from the Philippines, Indonesia, India, China, Honduras, and Poland, with Asians in the majority. Seagoing conditions are not infrequently as bad as those experienced a century ago.[18] The flag on the stern becomes a legal ruse, a lawyerly piratical dodge. To the victories of steam and the container, we can add the flag of convenience: a new ensign of camouflage and confusion, draped over the superficial clarity of straight lines and boxes.

My argument here runs against the commonly held view that the computer and telecommunications are the sole engines of the third industrial revolution. In effect, I am arguing for the continued importance of maritime space in order to counter the exaggerated importance attached to that largely metaphysical construct, "cyberspace," and the corollary myth of "instantaneous" contact between distant spaces. I am often struck by the ignorance of intellectuals in this respect: the self-congratulating conceptual aggrandizement of "information" frequently is accompanied by peculiar erroneous beliefs: among these is the widely held quasi-anthropomorphic notion that most of the world's cargo travels as people do, by air. This is an instance of the blinkered narcissism of the information specialist: a "materialism" that goes no farther than "the body." In the imagination, e-mail and airmail come to bracket the totality of global movement, with the airplane taking care of everything that is heavy. Thus the proliferation of air-courier companies and mail-order catalogues serving the professional, domestic, and leisure needs of the managerial and intellectual classes does nothing to bring consciousness down to earth, or to turn it in the direction of the sea, the forgotten space.

Large-scale material flows remain intractable. Acceleration is not absolute: the hydrodynamics of large-capacity hulls and the power output of diesel engines set a limit to the speed of cargo ships not far beyond that of the first quarter of this century. It still takes about eight days to cross the Atlantic and about twelve to cross the Pacific. A society of accelerated flows is also in certain key aspects a society of deliberately slow movement.

Consider, as a revealing limit case, the glacial caution with which contraband human cargo moves. Chinese immigrant-smuggling ships can take longer than seventeenth-century sailing vessels to reach their destinations, spending over a year in miserable and meandering transit. At their lowest depths, capitalist labor markets exhibit a miserly patience.

For those who face the sea under such conditions, the imagination both seeks, and is coaxed, to leap over the middle passage. This brings us back to the aesthetic questions posed earlier. In a short story by Bharati Mukherjee, a Tamil schoolteacher hoping desperately to emigrate from Sri Lanka seeks the services of a smuggler's go-between:

17 Rodney Carlisle, *Sovereignty for Sale: The Origins and Evolution of the Panamanian and Liberian Flags of Convenience* (Annapolis, Maryland: Naval Institute Press, 1981), p. 112.

18 See Paul K. Chapman, *Trouble on Board: The Plight of International Seafarers* (Ithaca, New York: ILR Press, 1992).

[19] Bharati Mukherjee, "Buried Lives," in *The Middleman and Other Stories* (New York: Fawcett Crest, 1988), p. 158.

[20] Ibid., pp. 168, 156.

"Options!" the man sneered. Then he took out a foreign-looking newspaper from a shopping bag. On the back page of the paper was a picture of three dour sahibs fishing for lobster. "You get my meaning, sir? They have beautiful coves in Nova Scotia. They have beautiful people in the Canadian maritimes."[19]

Having "heard stories of drowned Tamils," her protagonist dreams of safe passage to the north, "crisscross[ing] national boundaries on skates that felt as soft and comfortable as cushions."[20] Mukherjee's schoolteacher is a striking figure: a postcolonial "throwback" to the fearful Irish and Scottish emigrant passengers of the age of sail. And yet the image of danger is presented in the form of a grotesquely improvised tourist brochure; the counter-image of safe passage from tropical south to frozen north is conjured up as if from textbook reproductions of Pieter Bruegel the Elder. It is in diasporic texts such as Mukherjee's, full of desires sparked by images from elsewhere, that the threats and lures of actual maritime space continue to live.

The "forgetting" of the sea by late-modernist elites parallels its renewed intransigence for desperate third world populations: for Sri Lankans, Chinese, Haitians, Cubans, for the Filipinos and Indonesians who work the sealanes. Air travel assures that bourgeois cosmopolitanism no longer requires any contact with the sea. Social classes no longer rub shoulders in the departure terminals of the great steamship lines. And cruise ships, the floating apartheid machines of postmodern leisure, have a way of obscuring from passengers the miserable conditions endured by the third world crews who cater to their mobility and their desires.

Culturally, the sea becomes a vast reservoir of anachronisms, its representation redundant and overcoded. The last aesthetic movement to claim the sea with any seriousness was surrealism. It is both perverse and fitting that the founder of structural anthropology should later in life sustain this surviving surrealist spirit, asserting his preference for the eighteenth-century maritime painting of Joseph Vernet while dismissing cubism and lamenting the modernist "shipwreck of painting." Of Vernet he says:

> By means peculiar to the art, one is transported into a vanished world. And even more marvelous, perhaps this world never existed, for the painter didn't slavishly reproduce what he saw; he rearranged the elements and combined them into a lyrical synthesis. One of Vernet's great harbors is not far from the evening at the Opera that Proust described![21]

[21] Claude Lévi-Strauss and Didier Eribon, *Conversations with Claude Lévi-Strauss*, trans. Paula Wissing (Chicago: University of Chicago Press, 1988), p. 174.

In keeping with the surrealist love of obsolete didacticisms, Claude Lévi-Strauss is producing here a radical recoding of the classical edification demanded from the port scene. This earlier project of waterfront enlightenment, toward which we can orient the ironical figure of Engels as well, has been described in a recent book by Alain Corbin:

> The practice of walking along wharfs and stone piers ... expressed the fascination exerted by a stage on which spectators could observe particularly manifest displays of energy, activity, heroism, and misfortune. It fitted logically into the classical journey. Here nature had retreated before the labors of man, who had cut stones and reshaped the boundaries that God had set to the ocean.[22]

[22] Alain Corbin, *The Lure of the Sea: The Discovery of the Seaside in the Western World 1750-1840*, trans. Jocelyn Phelps (Berkeley: University of California Press, 1994), p. 187.

Corbin remarks further that "Vernet made the harbor view into a privileged panorama. In his work, the port is first and foremost a picture that walk-

ers in the hills examined with their spyglasses."[23] We can better understand Lévi-Strauss's point when we realize that Vernet's viewpoint, described thus, corresponds to Proust's initial "naive" attitude toward the theater: "... real people, just living their lives at home, on whom I was thus able to spy without their seeing me...."[24] But Lévi-Strauss's discovery of Marcel Proust in Vernet is all the more perverse and comical when we turn to some of what Proust had to say about seascapes:

> A few weeks later, when I went upstairs, the sun had already set. Like the one I used to see at Combray, behind the Calvary, when I was coming home from a walk and looking forward to going down to the kitchen before dinner, a band of red sky over the sea, compact and clear-cut as a layer of aspic over meat, then a little later, over a sea already cold and blue like a grey mullet, a sky of the same pink as the salmon that we would presently be ordering at Rivebelle reawakened the pleasure which I was to derive from the act of dressing to go out to dinner.[25]

This paragraph, in which the mundane synesthesia of culinary anticipation slides into a reverie of shipborne escape from "the necessity of sleep and ... confinement in a bedroom," ends with the line, "I was on all sides surrounded by pictures of the sea." But it is precisely the unity of the "picture" that Proust is dissolving, by stripping the perceptual qualities of iconic signs away from the larger visual field. As Walter Benjamin observed:

> It is the world in a state of resemblances, the domain of *correspondances*; the Romanticists were the first to comprehend them and Baudelaire embraced them most fervently, but Proust was the only one to reveal them in our lived life.[26]

Throughout this chapter, "Seascape, with Frieze of Girls," Proust repeatedly forces the tropes of romantic longing up against a de-psychologized post-impressionist treatment of seashore space. On the one hand, his narrator speaks of "the shipwreck of my nervous storms." At the other extreme, the optical superimposition of a garden in the foreground and a steamship in the far distance is described in this way: "... the tiniest slice of blue still separates the questing prow from the first petal of the flower towards which it is steaming."[27]

Proust's deconstruction *avant la lettre* of seascape is all the more striking for being staged within the realistic idiom of the novel. For Proust, it is photography that initiates the collapse of seascape into an increasingly undifferentiated spatiality. His character Elstir, a painter of seascapes and port scenes, produces confusions of terrestrial and maritime space for which a precedent was already found in certain photographs. Elstir "reproduce[s] things not as he knew them to be but according to the optical illusions of which our first sight of them is composed....." Having "prepared the mind of the spectator by employing, for the little town, only marine terms, and urban terms for the sea," Elstir gives the "impression of harbours in which the sea entered into the land, in which the land was already subaqueous and the population amphibian...."[28]

Over the course of this chapter, Proust engages in a double and contradictory movement: participating both in a romantic revival of the deluge and in the counter-tendency to domesticate the maritime sublime by converting its perceptual properties into the raw material of still life. This ambivalent strategy is entirely consistent with surrealism.

23 Ibid., p. 90.

24 Marcel Proust, *Within a Budding Grove* [1919], in *Remembrance of Things Past*, vol. 1, trans. C. K. Scott Moncrieff (New York: Random House, 1934), p. 343.

25 Ibid., p. 606.

26 Walter Benjamin, "The Image of Proust" [1929], in *Illuminations*, ed. Hannah Arendt, trans. Harry Zohn (New York: Schocken, 1969), p. 211.

27 *Within a Budding Grove*, pp. 619, 602.

28 Ibid., pp. 629-31.

But this ambivalence, which allows the features of classical and romantic seascape to atrophy and hypertrophy at the same time, has also become a routine and unconscious staple of journalistic prose. A reporter for the New York Times produced a series of accounts of the oil tanker Braer breaking apart on the rocky coast of the Shetland Islands:

> The Braer's final hours came in the overnight darkness, in a setting of almost primeval fury, as 30-foot surf and winds gusting up to 95 miles an hour smashed the writhing superstructure. Every so often, flashes of lightning illuminated the dark cliff and the wild seascape.[29]

But two days before this, the scene is described with an almost Proustian taste for the banality of culinary metaphors: "At its worst, patches of cappuccino-colored foam swirl along the shore, barely staining the beaches and rocks."[30]

If this account seems to veer between Lord Byron and Proust with a shift in the weather, the reporter's confusion may have more to do with an epistemological difficulty than with any migration of modernist indifference or postmodern semiotic play into journalistic discourse. Confronted with an oil spill and a tempest, the reporter is hard-pressed to differentiate between the destructive workings of first nature (the storm) and manufactured second nature (the leaking oil). The result is the forced simile by which leaking crude oil is repeatedly and reassuringly likened to upscale coffee. Wittingly or not, this metaphoric loop takes us back to the very origins of maritime risk insurance at Lloyd's coffeehouse in eighteenth-century London.

But it is unlikely that most readers of the New York Times would make this connection. If Proust can be said to have rigorously enacted the exhaustion and death of seascape within the modernist literary canon, then the elite newspaper of a coastal cosmopolis, the New York Times, can be said to have taken the lead in turning its back to the sea. When maritime news appears it is restricted to stories of disaster, war, and exodus: thus the subject is compressed into a weirdly blasé and episodic faux-sublimity. The sea is the site of intermittent horrors and extraordinary but brief expenditures of energy, quite distinct from the dramas of everyday life.

The disappearance of the sea took place slowly, over two decades. In the 1960s, the New York Times typically ran a page of shipping and transport industry news, alongside the weather, which was charted far into the Atlantic. Cargo and passenger ship departures and arrivals were reported daily. By 1970, the "Shipping/Mails" section was restricted to passenger and mail ships only, excluding cargo vessels. By 1980, the "Shipping/Mails" listing had migrated to a small corner of the "Stock Options" pages of the newspaper's business section. The weather maps, placed elsewhere, were more likely to hug the Eastern seaboard. By the end of 1985, in the middle of the Reagan-era decade of speculative accumulation, the everyday shipping news sank entirely from sight. By contrast, a paper such as Hong Kong's South China Morning Post continues to make shipping news a major feature of daily coverage, rivaling the more specialized press, such as the New York-based Journal of Commerce, in the depth of its reporting.

One can argue correctly that this disappearance is coincident with New York City's decline as a seaport. But this argument misses the point that the

29 William E. Schmidt, "Tanker in Shetlands Breaks Apart, Losing All Oil," New York Times, 13 January 1993, p. C17.

30 William E. Schmidt, "The Afflicted Shetland Islands Pray, for Themselves and for the Beasts," New York Times, 11 January 1993, p. A7.

combined Port of New York and New Jersey remains second only to Los Angeles and Long Beach on the west coast as the preeminent port in the Americas. But the working port is invisible from Manhattan and increasingly so from Brooklyn, with the main cargo terminals relocated with the advent of containerization to Port Elizabeth and Port Newark.

The metropolitan gaze no longer falls upon the waterfront, and a cognitive blankness follows. Thus despite increasing international mercantile dependence on ocean transport, and despite advances in oceanography and marine biology, the sea is in many respects less comprehensible to today's elites than it was before 1945, in the nineteenth-century, or even during the Enlightenment.

This incomprehension is the product of forgetting and disavowal. In this sense elites become incapable of recognizing their own, outside of narrow specialist circles. Consider, by contrast, the obscurity of Malcom McLean, the trucking executive who initiated containerized cargo movement in 1956, alongside the historical and cultural importance accorded to Donald McKay, the nineteenth-century Boston clipper-ship builder. In his *American Renaissance* of 1941, F.O. Matthiessen reproduced as a frontispiece a striking daguerreotype portrait of McKay by Southworth and Hawes:

> McKay's portrait makes the most fitting frontispiece, since it reveals the type of character with which the writers of the age were most concerned, the common man in his heroic stature, or as Whitman called the new type, "Man in the Open Air."[31]

31 F.O. Matthiessen, *American Renaissance: Art and Expression in the Age of Emerson and Whitman* (New York: Oxford University Press, 1941), p. xxvi.

Matthiessen's choice reflects both the legacy of American romanticism and the pragmatism of a nation entering a convoy war in the North Atlantic. But the line leading from American romanticism to American pragmatism has since been broken. The new model hero, in an age that celebrates cunning survivors of corporate bankruptcies and victorious commanding generals in wars against abysmally inferior opponents, is less Walt Whitman's "common man" than Herman Melville's archetypal American swindler, the Confidence-Man.

MIDDLE PASSAGE

27

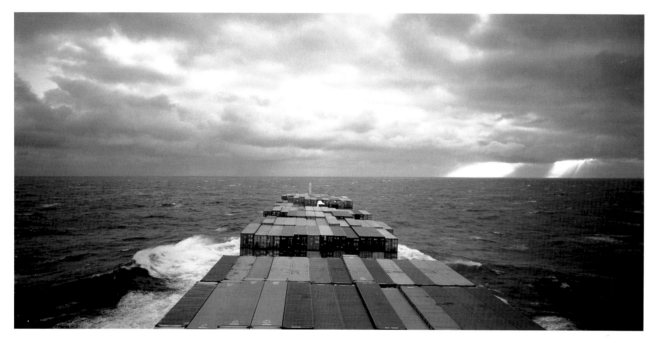

28

29

30

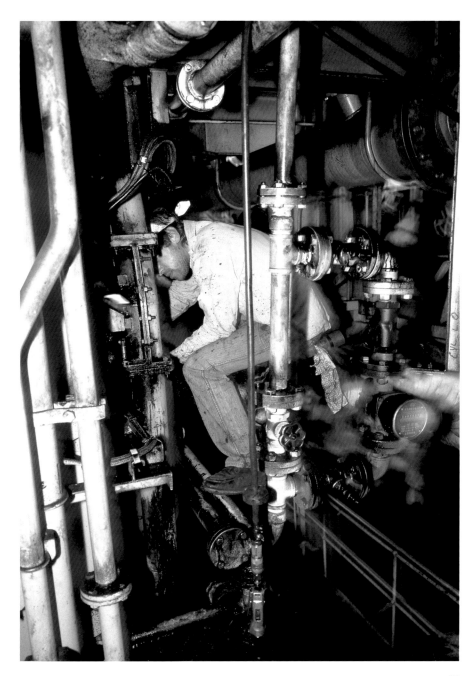

31

Le Corps d'un Américain découvert à bord d'un voilier à la dérive

FALMOUTH.—Le corps d'un Américain de 63 ans mort dans des circonstances mystérieuses a été retrouvé samedi à bord d'un voilier dérivant à plus de 1.000 kilomètres au sud-ouest des côtes britanniques, tandis que sa femme ne se trouvait plus à bord. Les gardes-côtes ont précisé que le "Happy End" était enregistré dans l'Alabama et qu'il avait quitté les côtes américaines le 1er novembre à destination de l'Irlande avec à son bord le propriétaire du bateau, Gerald Hardesty et son épouse Carol, âgée de 60 ans. Un membre d'équipage d'un porte-container américain, le "Sealand Quality", a pu monter sur le voilier repéré à la dérive vendredi par un cargo norvégien et voir le corps du propriétaire du bateau, Gerald Hardesty, mort selon lui depuis deux ou trois jours.

Enlarged photocopy of clipping from unidentified Cherbourg newspaper brought aboard by the North Sea pilot and posted by the captain without translation in the officers' and crew's mess rooms, *Sea-Land Quality*.

As the crew filed back into the house from the main deck after the memorial service for the two Americans, the usually taciturn captain announced to no one in particular and everyone in general: "Well, that should put an end to all the ghost stories that have been going around."

FIRE AND EMERGENCY
Muster at boat station

ABANDON SHIP
Muster at station

NUCLEAR, BIOLOGICAL, CHEMICAL WARFARE
Remain in stateroom

Notice engraved on steel plate bolted to stateroom bulkhead, *Sea-Land Quality*.

THE BO'SUN'S STORY

"Black-and-white photos tell the truth. That's why insurance companies use them."

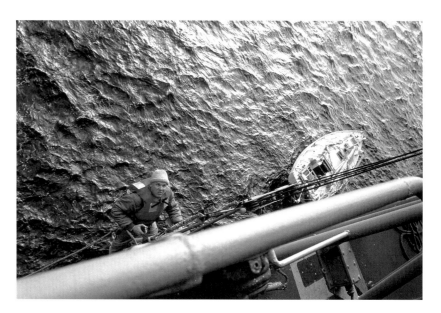

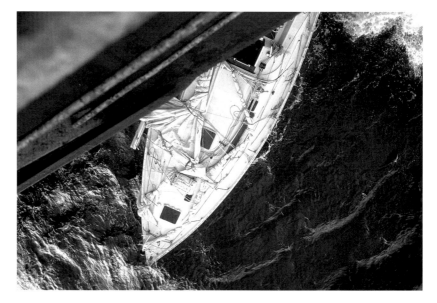

32–34

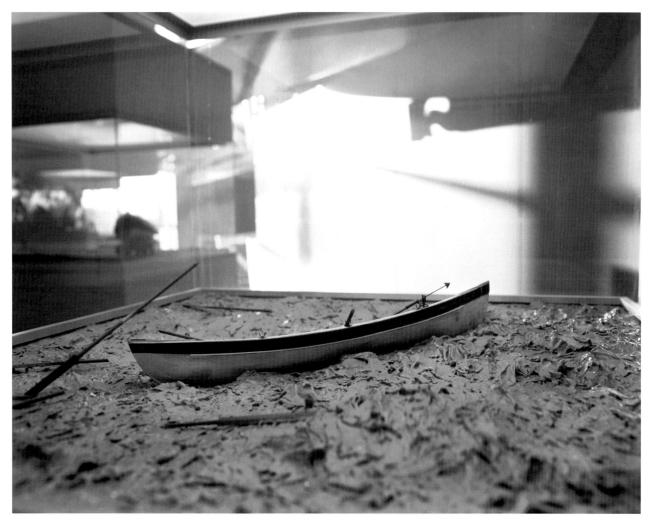

35

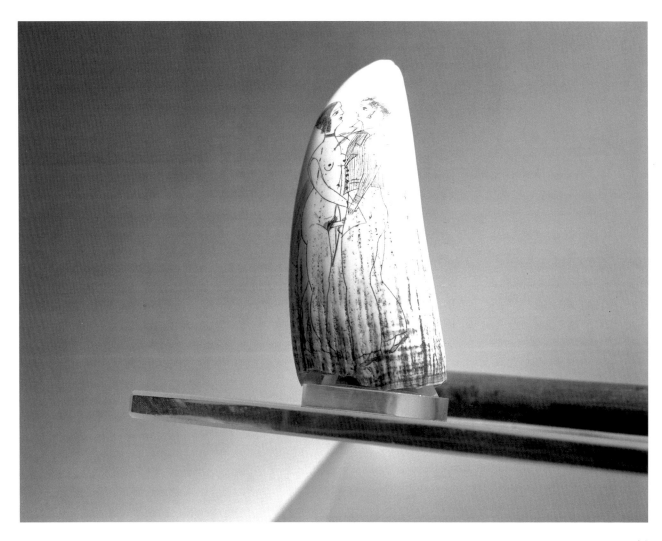

36

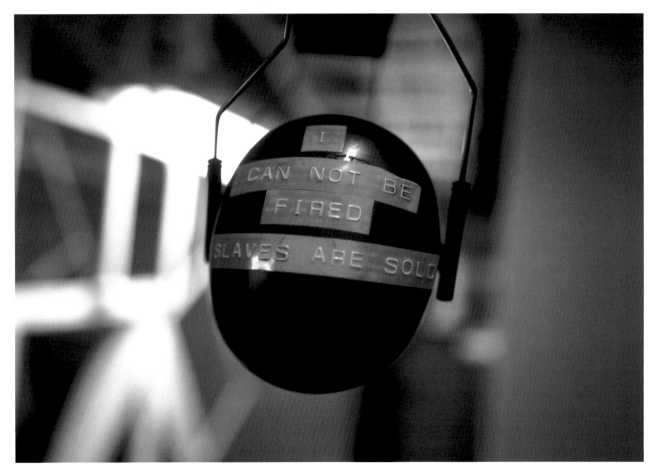

38

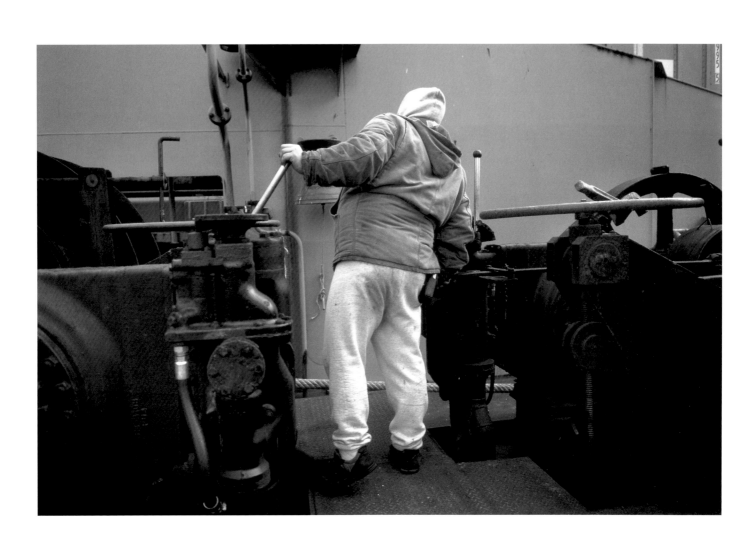

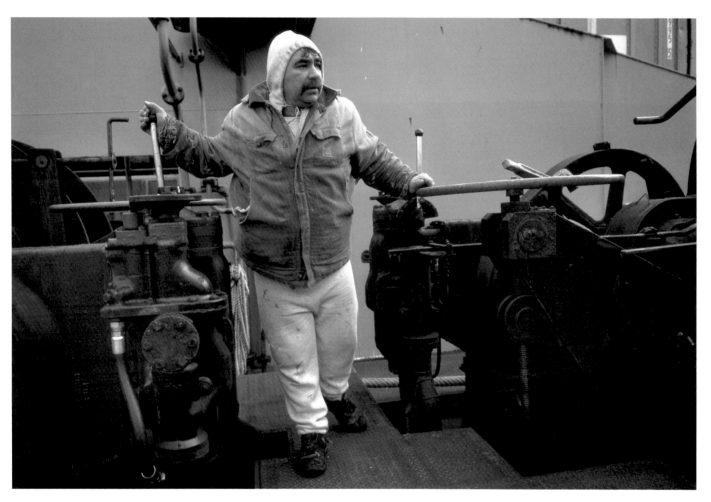

39–40

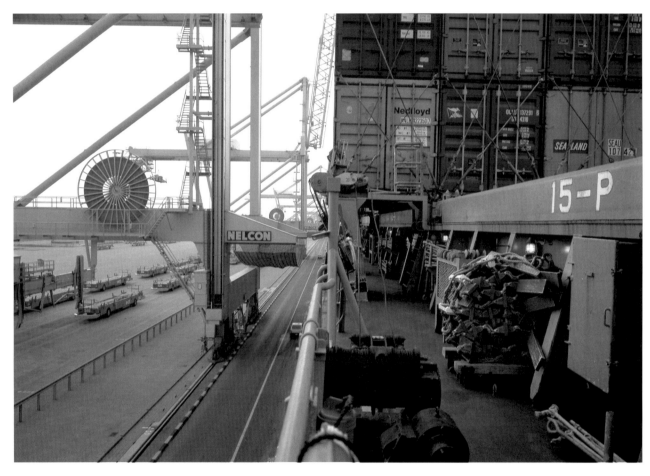

41

42

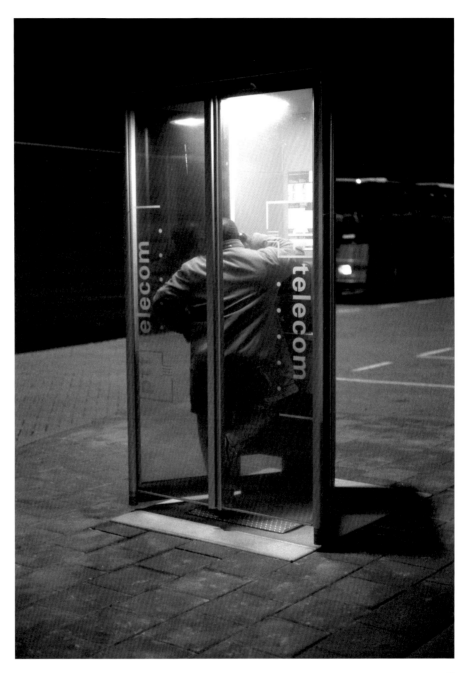

43

Question?
De-flagging.
Is it true
Sea-Land will
use Russian officers
with Vietnamese crew?

They are digging
up Jack Kennedy
to see if he's rolled
in his grave.

They couldn't beat us
so they'll unemploy us!

God bless corporate America.

> Handwritten message on yellow legal pad, engine-room
> bulletin board, *Sea-Land Quality.*

Launched in 1984, the *Sea-Land Quality* was one of the first ships built at the Daewoo shipyard on the island of Keoje off the southeast coast of South Korea, and one of a series of "econships" commissioned by the now-defunct United States Lines of Malcom McLean, the trucking executive who initiated containerized cargo movement in 1956. These were the biggest container ships built to date, deliberately slow: exercises in economies of scale, cheap construction, and conservative fuel use.

When an American crew picked up the first of these ships from the Daewoo dockyard, completed the sea trials, and began the voyage back across the Pacific, they discovered in the nooks and crannies of the new ship a curious inventory of discarded tools used in the building of the vessel: crude hammers made by welding a heavy bolt onto the end of a length of pipe, wrenches cut roughly by torch from scraps of deck plate. Awed by this evidence of an improvisatory iron-age approach to ship building, which corresponded to their earlier impressions of the often-lethal brutality of Korean industrial methods, they gathered the tools into a small display in the crew's lounge, christening it "The Korean Workers' Museum."

American elites have cultivated a fantastic fear of superior Asian intelligence; in doing so they obscure their own continued cleverness. For their part, American workers fear the mythic Asian brain and something else: an imagined capacity for limitless overwork under miserable conditions. The first assistant engineer, once a Navy commando in Vietnam, fears being replaced by former enemies. Veering abruptly from the right-wing paranoia of the politician Ross Perot to the left-wing paranoia of filmmaker Oliver Stone, his diatribe is less farfetched than it seems. Shipping companies increasingly turn to flag-of-convenience registry, a legal loophole that allows for the hiring of cheaper, usually Asian, crews. American shipowners have long favored Liberia and Panama, two notoriously independent nations, for these registry services, services which require an infrastructure roughly equivalent to that needed for commemorative stamp issues. Now Sea-Land threatens to turn to the newest bastion of paper sovereignty, the Marshall Islands, otherwise renowned as a cluster of irradiated coral atolls devastated by American thermonuclear testing in the 1950s.

And thus the general spirit of the ship was one of mournful and weary anticipation of unemployment, heightened by a pervasive insomnia caused by the vibration of the low-speed Hyundai-Sulzer diesel running at 100 RPM, the speed of an amphetamine-driven human heart.

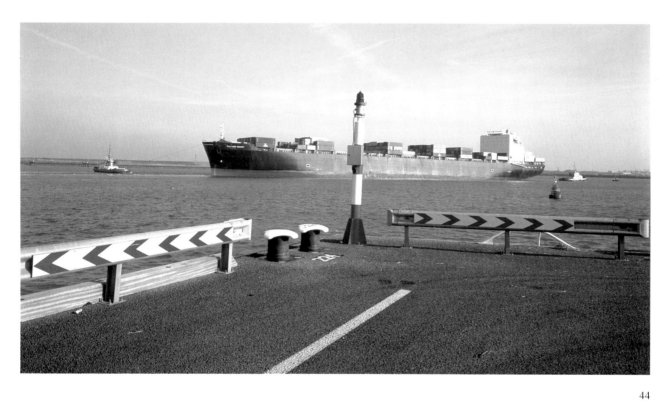

44

Voyage 167 of the container ship M/V *Sea-Land Quality* from Elizabeth, New Jersey, to Rotterdam. November 1993.

Port Elizabeth–Norfolk–Rotterdam–Bremerhaven–Felixstowe–Le Havre–Boston–Port Elizabeth. While crisscrossing the North Atlantic, David Brown works twelve hours a day for a month at a time, putting in an extra watch of work on deck from 0800 to noon, chipping and painting, standing watch at the wheel from noon to 1600, then back at the wheel from midnight to 0400. The extra watch at overtime pay allows him to earn "just enough to make the trip worthwhile," considering his family in Jacksonville and the fact that despite his years as a merchant sailor, the scarcity of American-flag ships means that he usually works for only six to nine months out of twelve.

A day before landfall, nearing the end of his watch and restless from standing in one place for four hours, Brown leaves the wheel on autopilot and begins to describe Ethiopian dockworkers unloading a cargo of grain, gaunt and wiry men walking in circles carrying huge sacks on their backs. Brown stoops and begins to pantomime a precise memory of their movement, pacing a repetitive circle in front of the navigation computer, bent over in the ancient stance of the stevedore, assuming the burdened posture found in the monochromatic floor mosaics still visible amid the ruins of the Roman port of Ostia Antica, called into life wherever there were or are no machines to lift the weight of cargo.

Haunted by this image of sheer Sisyphian toil, Brown turns abruptly to the case of a hypothetical worker who loses his job to automation: "First he lose his sanity, then his car, then his house." The circle narrows and one world falls into the vortex of the other.

"SIBERIA"

For the crew, this crossing is the first to make port at the new robot terminal built on the ever-expanding landfill at the outer reaches of the River Maas. The Dutch engineer responsible for designing the system of automated cranes and trucks that gives the ECT/Sea-Land Terminal an eerie depopulated aspect even in pleasant weather remarked that the new method is "much more comfortable than when you have a lot of individuals under the crane. They say hello to each other, they talk to each other." He warned me away from the path of the robot trucks: "Watch out, they don't see you!"

In winter, the outer dike wall does little to shield the ship and the dock from the North Sea wind. A freezing forty-five-minute hike through the container stacks and across the sandy soil leads to the solitary truckers' bar nestled up against the dike at the foot of a row of roaring windmills. Beyond that, it's a half-hour van drive to the nearest store, a duty-free shop surrounded by oil tanks in the Botlek, where Russian and Filipino sailors remind Americans what it means to comb the shelves for bargains. But the nickname for this new port of call—barren, cold, and far from everything regarded as interesting and human—had stuck earlier, in the middle of the Atlantic, as someone recalled a farewell visit a month earlier to a familiar neighborhood bar just outside the old terminal twenty-five kilometers upriver toward Rotterdam. It is no longer possible, as it was three centuries ago on the River Maas, to infer the warmth of a still life from a picture of a wooden ship full of whale blubber.

SEVENTY IN SEVEN

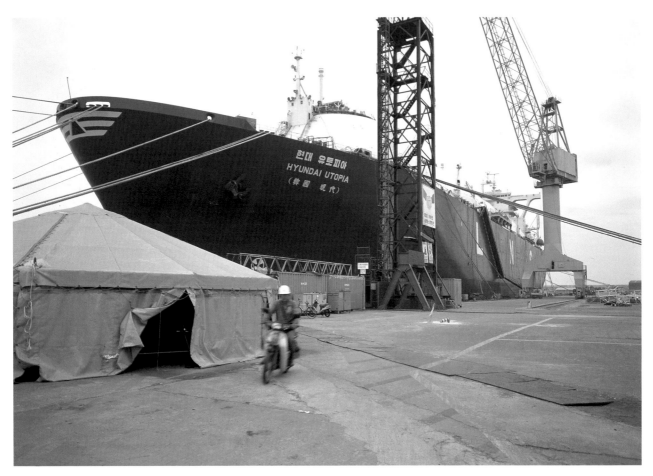

45

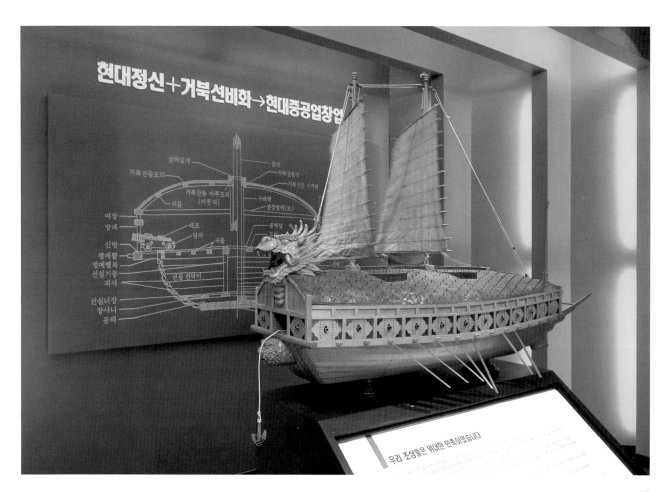

46

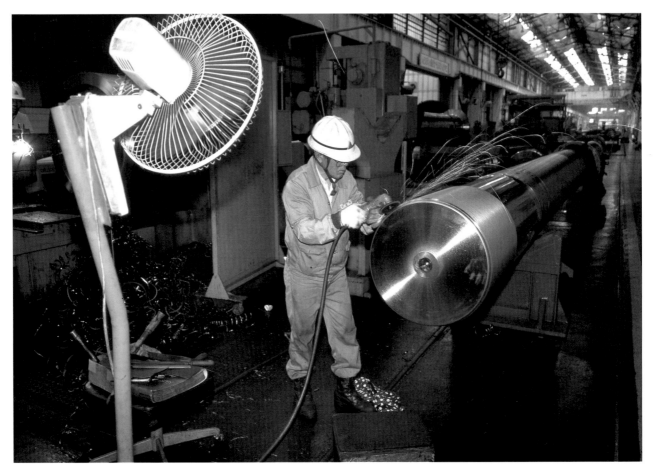

47

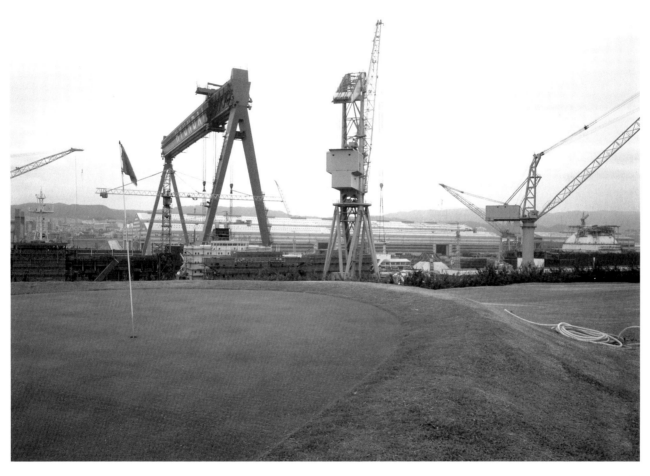

48

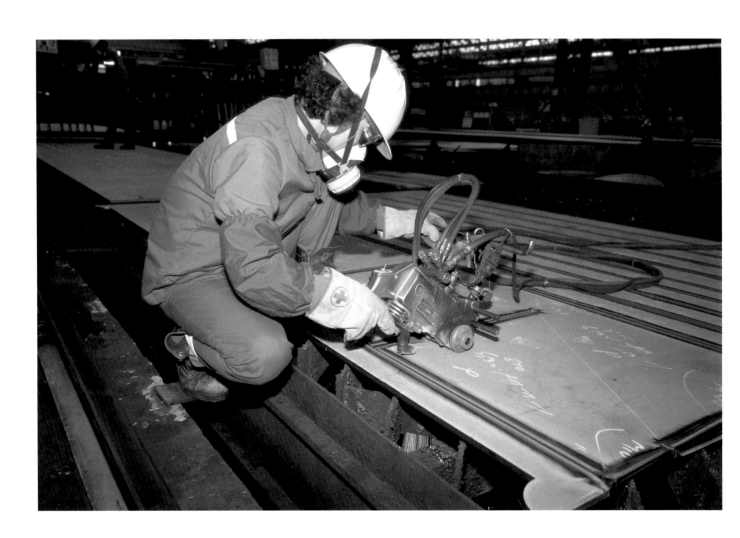

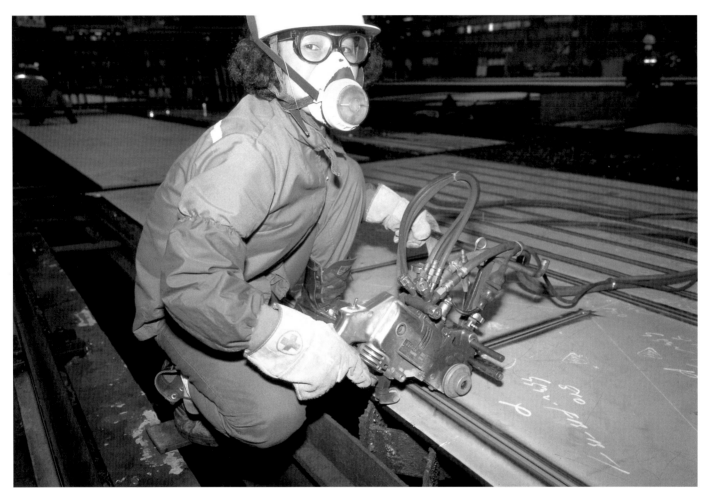

49–50

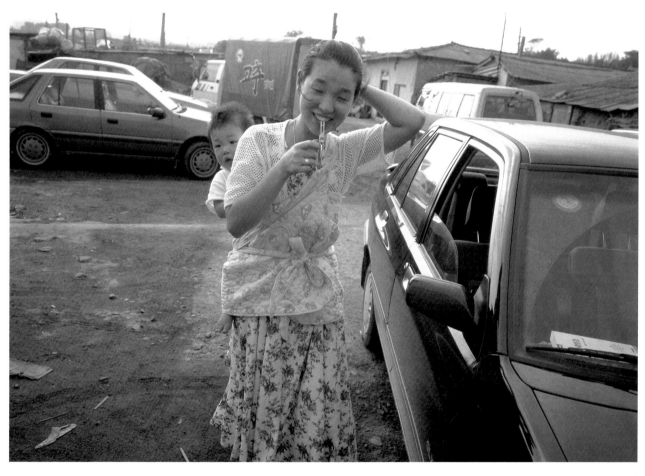

51

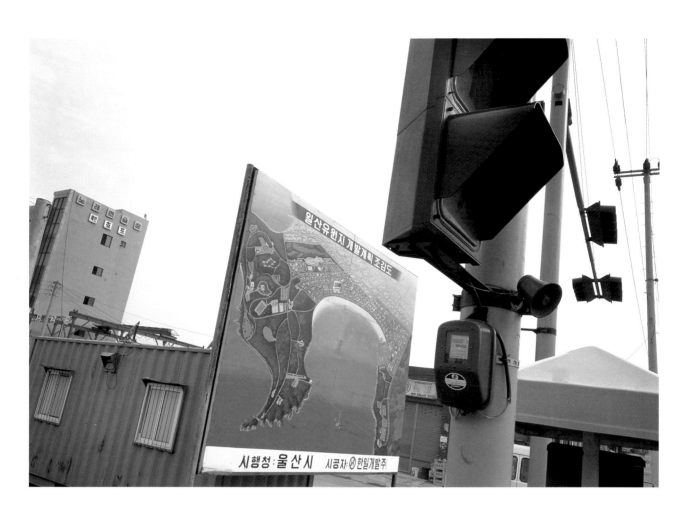

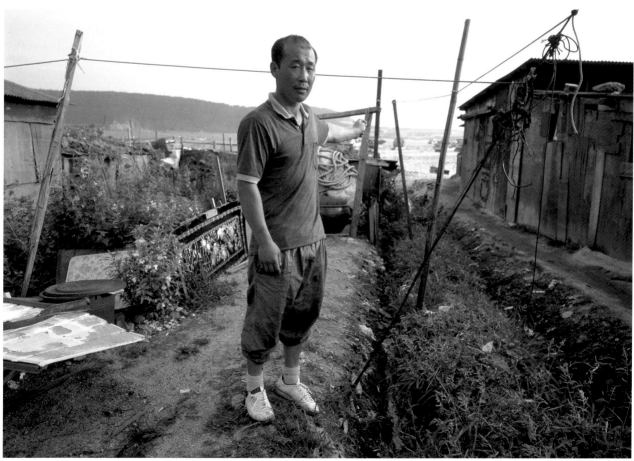

52-53

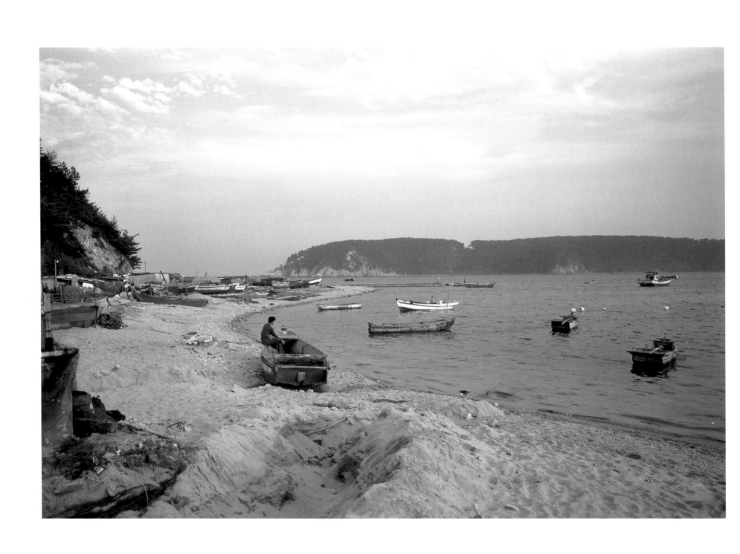

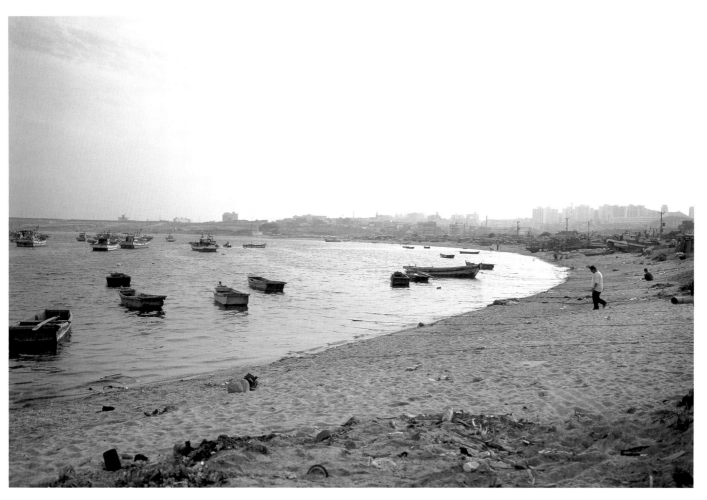

54–55

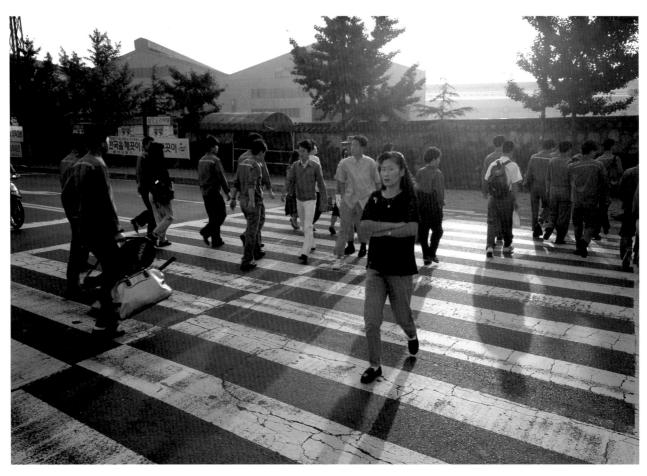

56

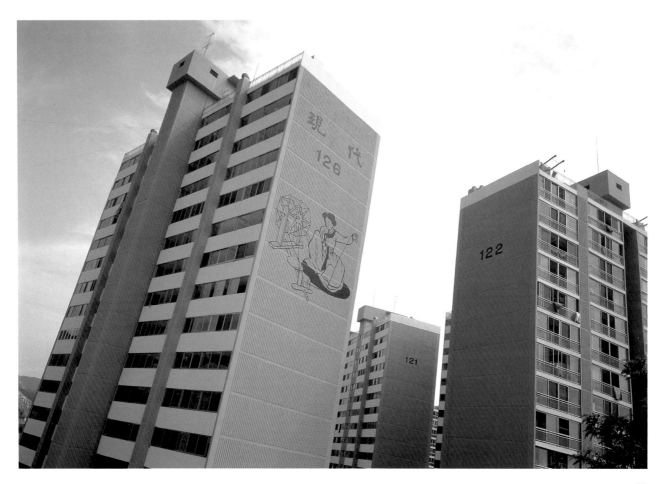

57

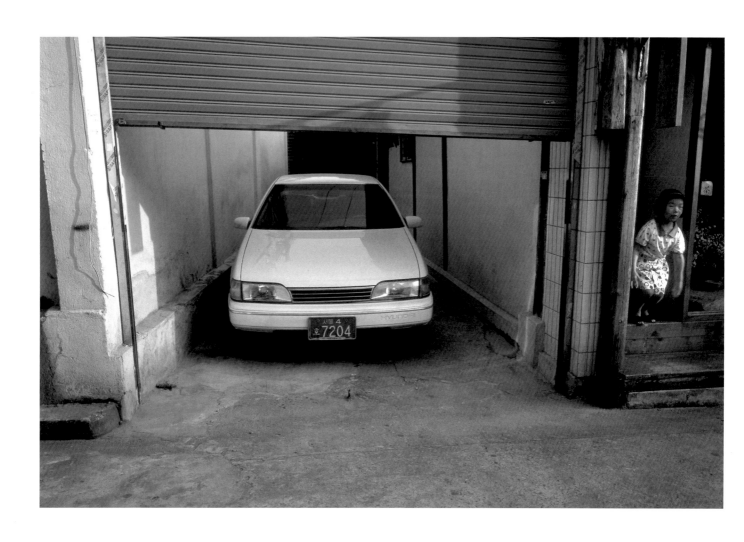

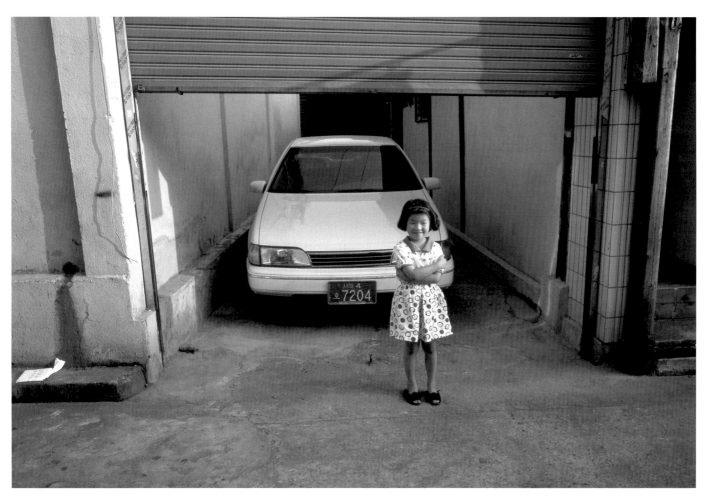

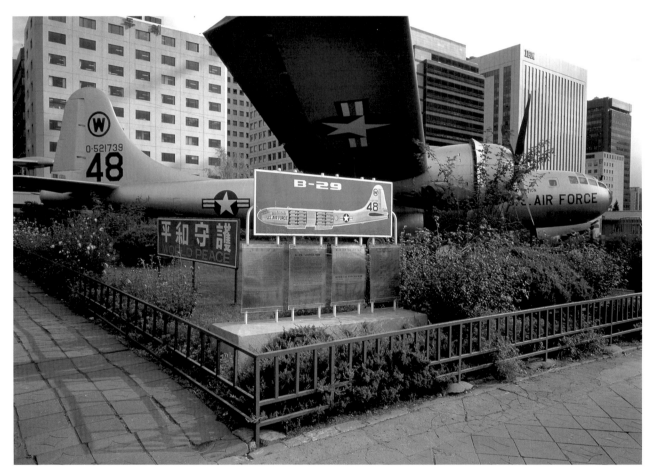

60

61

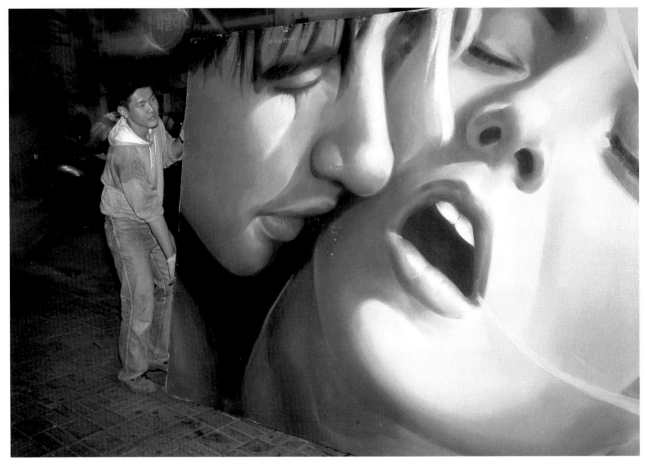

62

63

Seventy years in Europe is equal to seven years in Korea.

Saying among left-wing South Korean intellectuals.

COMPANY TOWN

In Ulsan, once a mere fishing village on Mipo Bay, it is possible to stay in a Hyundai-owned hotel, schedule appointments by Hyundai cellular telephone, shop for a bottle of Scotch whiskey or *soju* or a packaged snack of dried squid at the Hyundai department store, and travel in a Hyundai automobile—manufactured just down the street—to meetings with the officials of the world's largest shipyard, a division of Hyundai Heavy Industries. This situation provokes paranoid speculation. A visiting shipowner soliciting competing bids from the shipbuilding divisions of two transnational conglomerates, the Mitsubishi *zaibatsu* in Japan and the Hyundai *chaebol* in Korea, might have reason to be nervous when telephoning headquarters in Piraeus or New York from the company hotel.

The overt appearance of a purely "national" industry obscures more complicated lineages and patterns of investment. Hyundai propaganda strives to keep the story simple: the historical origins of Korean shipbuilding are traced to the ironclad "turtle ship" used by Admiral Yi Sun-Sin to defeat Japanese invaders in sea battles of 1592, battles won in a war that was lost. This legend of national metallurgical precocity conveniently forgets the prehistory of Koreans as a paleolithic fishing people, and ignores the subsequent and more systematic transition from wooden to iron ships in the deforested Britain of the nineteenth century. By looking backward only to look forward, this legend of a ferocious Korean ur-battleship strips iron plate away from its once inescapable resemblance to the scales of a fish or the shell of a turtle. If the turtle ship has lost contact with the sea's archive of primal organic structures, these equivalences are revived in less "heavy" industrial contexts: in the ponderous and cynical "fish-buildings" of the Canadian-American architect Frank Gehry or in the mournful and delicate clothing of the Japanese fashion designer Issey Miyake.

In a similarly nationalist vein, the Hyundai housing blocks are decorated with large reproductions of female figures from eighteenth-century genre paintings by Sin Yun-Bok. Nonetheless, the name Hyundai is given in Chinese characters, a mark of traditional authority and status affixed to buildings previously reserved only for managers until workers, hard-pressed by the boomtown housing shortage of the late 1980s, demanded apartments of their own. The reassuring domestic diligence of the pictured women suggests a comforting barrier between the factory and the home, while masking the fact that it is women who also perform the most menial jobs in the shipyard.

But for the 450-ton Goliath cranes that tower over the dry docks, the shipyard is visible only as a vast and indistinct industrial space from the housing blocks. Cranes like these lowered the huge seven-cylinder Hyundai-Sulzer engines into the containerized "econships" of Malcom McLean and Sea-Land. Seeking a panoramic view of their own, hunger-striking shipyard workers occupied these cranes for twenty days in 1990, as if to signal desperately from the heights, like James Cagney in the film *White Heat*, to the rest of Korean society.

The world-record speed of a snail, established on glass in 1970, was 2 feet in three minutes, 0.00758 miles per hour. We used to drive our jeeps at 110 kilometers per hour on Highway 1 in Vietnam to avoid VC snipers. Now I crawled my life away like a mollusc. Like a slug.

Ahn Junghyo, *White Badge: A Novel of Korea*, author's trans., (New York: Soho Press, 1989), p. 4.

The weird origins of Korean shipbuilding in the 1970s can be traced in part to the purchase of plans from bankrupt Scottish yards on the River Clyde. With the second Industrial Revolution repeating itself on the shores of Mipo Bay, a number of unemployed Glasgow shipwrights migrated to Ulsan. This new planetoid within the solar system of late capitalism sustains a solitary moonlet of its own: a "Scotch Pub" in the foreigners' bar district of Ulsan, across the street from the shipyard, and next door to "Bar Romance."

The greater Hyundai empire began as a fledgling construction firm building bases for the Americans, first during the Korean War, then later in Vietnam. Perhaps this is the company described in Ahn Junghyo's novel, patriotically donating tins of pickled *kimchi* to supplement the "insipid" Vietnamese rice fed to the South Korean "national mercenary" troops fighting in Vietnam. In the film version of *White Badge*, Vietnamese peasants are massacred by Koreans within sight of a busy superhighway that could not have existed in Vietnam during the war, but that did come to be built in Korea by the same construction company that got its start building roads and barracks for the Americans. This scenographic "mistake," just barely discernible in the far background of the shot, is a clever way of looping forward in time, drawing a link between Korea and Vietnam that looks forward and not simply back to the similarities between the Korean and Vietnamese wars.

For Koreans of a certain generation, Vietnam represents an image of the Korean past. But does South Korea represent an image of the Vietnamese future, or for that matter, of the Mexican future as well, as writers in the business pages of American newspapers are fond of suggesting?

Think of the Korean shipping executive who started out as a crane driver unloading American military cargo at Cam Ranh Bay, later pissing in a bottle in the cab above a Hong Kong dock, setting a twelve-hour record moving containers in the early 1970s. Now that Hyundai has a container factory in Mexico, how is his biography related to that of express bus drivers running five hours nonstop from Mexico City to Veracruz, the new Stahanovites of bladder control?

This accelerated mode of life leaves behind certain eddies, whole Sargasso seas of enforced idleness or drudgery, great hidden doldrums and sweatshops: think of the press-ganged fisherman in another recent Korean film, *The Sorrow, Like a Withdrawn Dagger, Left My Heart*, masturbating off the stern of a shrimp barge in the West Sea, moored out of reach of a tantalizingly visible coastline for a year at a time.

The Korean fishing industry slips into decrepitude just outside the octopus-like grasp of the *chaebol* conglomerates. The fishing village of Ilsan is left to rot in the shadow of the Hyundai shipyard, inshore waters polluted and fished out, ground water stagnating, increasingly miasmic, the village fated to become the site of a new coastal amusement park offering Fordist leisure to the factory workers of Hyundai and its myriad subsidiaries. The former fisherman Kim Kyung-Seok, no longer able to survive at his chosen trade, now reluctantly works for one of these factories: "We could feed people in Somalia with the money spent to go five miles faster on the highway."

Maybe the wisest policy for the United States and South Korea would be to flood North Korea with food, clothing and consumer goods. Send in surplus grain, fashionable clothes and a few thousand Kia cars from South Korea. . . . That would give North Koreans an introduction to the joys of motoring and help Kim Jong Il succeed his father without factional fighting.

James Flanigan, "North Korea Today: A Need to Join Asian Development," *Los Angeles Times*, 13 July 1994, p. D1.

A further question for the business press: Does South Korea represent an image of the North Korean future, or will North Korea be a Mexico to South Korea's dynamic hyper-USA?

The English-language *Korea Herald* reports on a defector's account of a vast underground model of Seoul built to train North Korean spies, complete with "imitations of facilities popular in the South such as cafes, restaurants and hotels." Maybe the story is untrue but nonetheless I imagine full-scale coffeehouses, billiard parlors and *karaoke* bars, perhaps slightly shabby and closer to what one might find, say, in my neighborhood in L.A.'s Koreatown than to the chic spots in Myong-dong. The defector claimed that the simulation, spanning two kilometers, was "how he came to know the South is economically more prosperous than the North."[1]

And in Seoul, a didactic counter-display exhibits captured North Korean "spy boats," wooden fishing skiffs more decrepit than anything moored in the bay at Ilsan. In this fashion the fast society and the slow society, the projectile society and the bunker society, lie side by side, armed to the teeth. The richer of the two provides butter with its guns, the poorer does without, and presumably takes seventy years to achieve seven years of "European" progress.

Can *chaebol* hyper-capitalism and family-dynastic Stalinism potentially reunite with the exchange of the most deadly token of "peaceful" developmental potlatch: the nuclear reactor, yet another of the many products of the Hyundai conglomerate? What will the abyss of North Korean wages do to the momentary Fordist prosperity of South Korea's *chaebol* employees? The whole affair is coached and prodded by anxious American diplomats and military commanders afraid of losing their grip on Asia, who understand the condition of permanent war to be the primary engine of economic development. At least some of them are still committed to the endless scenario outlined with comic-book brutalism in Samuel Fuller's 1951 Korean War film *The Steel Helmet*. This anti-communist parable "concludes" with a final title, which could just as well have been growled by "Sergeant Zack," the war-weary American GI hero, over the stub of his cigar: "There is no end to this story." The pot still boils.

[1] "Former N.K. Intelligence Official Defects to South," *Korea Herald* [Seoul], 11 September 1993, p. 3.

FROM THE PANORAMA TO THE DETAIL

Horizon is a pictorial, but also a strategic notion.

Michel Foucault[1]

Obviously, the sea does not simply disappear over the course of the twentieth century. The broader culture of modernity, modernist or not, sustains a repetitive fascination with maritime themes. If many of the features of pre-modern and romantic attitudes toward the sea are no longer credible, they surface nonetheless, as if the sea were indeed a bottomless reservoir of well-preserved anachronisms.

This is especially true of commercial mass culture. A good example is Peter Benchley's novel *Jaws* (1974), which revived in a timely fashion the ancient Biblical figure of the leviathan as voracious agent of the divine. Structurally, this novel constituted a kitsch reversal of the proto-modernist radicality of Herman Melville's *Moby-Dick*, to which it was glibly compared in reviews. Thematically, *Jaws* countered Melville's implicit democracy of toil with an oblique defense of an aristocracy of leisure. (One can also detect the tamed shadows of Ernest Hemingway and the comte de Lautréamont in this story.) Benchley's novel is haunted by the fear that upper-class decadence will proliferate downward to the social classes whose servitude is required to keep the machinery of leisure moving. *Jaws* can be read as a reaction against well-established notions, derived from romanticism, of the restorative and health-giving properties and erotic potential of the seashore and of ocean bathing. It is only a half-joke to say that by terrifying large numbers of people, no single text (and film) has done more to discourage democratic access to the sea, and perhaps thus to further the interests of a patrician class of boaters and beach-club members. *Jaws*, the gothic ultimate in "summer reading," draws an imaginary line in the sand, well above the reach of high tide. The horizontal sweep of the panorama is revived in the form of a police ribbon at a crime scene, beyond which hidden dangers lurk.

But these are merely the mirror image of the fantasized dangers of domestic life. The novel draws an explicit parallel between two threats to order: the preternatural appetite of a marauding white shark and an extramarital affair pursued by the wife of the police chief of the beleaguered beach resort. Deliberate or not, Benchley's prurient but stern anti-eroticism was an early salvo in the cultural war waged by American conservatives against the libertarian and women's-liberationist ethos of the 1960s and early 1970s. Thus even the unruliness of the sea can be revived in the interests of a narrative return to order.

I have argued already that modernity dissolves the edifying unity of the classical maritime panorama. Steam performs the initial work in this process. With Turner, the role played by steam is explicit. Later, in Proust, the seashore panorama shatters into a thousand metaphoric fragments. After Proust, it is the phenomenal world of the underwater swimmer that breaks through the panoramic surface of the sea. For those who can afford to live an industrialized version of Byronic romanticism and scuba dive in crystalline shark-free waters, or for these who merely watch the commercials for Club Med on television, Proust's "red sky over the sea" and his "pink of the salmon" are now

1 Michel Foucault, "Questions on Geography," in *Power/ Knowledge: Selected Interviews and Other Writings 1972-1977*, ed. Colin Gordon, trans. Gordon et al. (New York: Pantheon, 1980), p. 68.

Fig. 5
Jacques Cousteau, photograph from J.Y. Cousteau and
Frederic Dumas, *The Silent World*, 1953.

2 Alfred Thayer Mahan, *Naval Strategy: Compared and
Contrasted with the Principles and Practice of Military
Operations on Land* (Boston: Little, Brown, 1911),
p. 115.

combined in a routinized montage of touristic images. The close-up view of the
scuba-diver's underwater camera replaces the sweeping gaze of the stroller on
the boardwalk. Now thoroughly seized by tourism and sport, these close-ups
have lost the surrealist charge they possessed when first made in the 1940s by
Jacques Cousteau, the *flaneur* of reefs and shipwrecks, the underwater coun-
terpart of Henri Cartier-Bresson.

Modernity entails a maritime victory of the detail over the panorama:
these details circulate within the generalized stream of consumption, can be
activated in any context. The sea is everywhere and nowhere at the same time,
but only in decantable quantities. But under conditions of social crisis—war,
mass exodus, environmental disaster—the bottle of representation can burst,
and the sea again exceeds the limits imposed upon it by a de-radicalized and
stereotypical romanticism. In these circumstances, as the earlier example of
the *Braer* oil spill suggests, details clash sharply with other details ("cappuc-
cino," "flashes of lightning") or with the residual and anachronistic evocation
of the maritime panorama. The result is a kind of modernism by default,
prompted by distress.

The recoding of the sea by modernity begins with the rupture between
the age of sail and that of steam. As on so many other fronts, it is the modernity
of the military that provokes broader cultural change. The passage from the
prestige of the panorama to that of the detail is perhaps most strongly mani-
fested in the intertwined discourses of naval strategy and naval intelligence.
In classical paintings of naval battles, the position of ships before or against
the wind could serve as a key indication of tactical advantage or disadvantage,
of offensive or defensive posture. The critical space of naval maneuver and
engagement was eminently picturable, and legible to a knowledgeable viewer.
Coal-fired boilers, torpedoes and long-range naval guns introduced a new
abstractness to the maritime space of combat. Abstract measured distance—
from coaling stations, from one gun to another—came to matter more than the
immediate and local vagaries of the wind. The wind gave precedence to time:
under sail, the crucial question was how long favorable or unfavorable condi-
tions would hold. Steam gave precedence to space: the key question, the
question of the gunner and the chief engineer, was "How far?" A contradiction,
however, arose from the fact that steam-powered ships, while free to travel
thousands of miles in any direction without regard for the wind, were restricted
by the capacity of their coal bunkers. Thus establishment and control of coal-
ing stations became a factor of utmost strategic importance. Steam tethered
ships more firmly to the land, by a line that stretched back to the bowels
of the earth.

The ultimate and likewise contradictory result of the "distancing" of
determining factors was that the detail, rather than the panorama, became
crucial. At the level of naval "intelligence" details became the analytic frag-
ments that had to be entered into a vast statistico-taxonomic grid, a grid that
compared and weighed the fleets of the world.

The new analytic spirit was best expressed by Captain Alfred Thayer
Mahan, who served as both lecturer and president at the newly founded United
States Naval War College in Newport, Rhode Island, in the 1880s and 1890s:

> The turns of the screw can be counted on even better than the legs of the soldier.
> An Art of Naval War becomes possible....[2]

Mahan was a resolute historicist, intent on learning practical contemporary lessons from bygone battles. His historicism made him especially sensitive to the novel characteristics of modern war. Maritime time, previously unpredictable, submits to a new metronomic industrial regularity. Steam made the sea the first site of thoroughly mechanized warfare, well before the advent of mechanized infantry in the German *Blitzkrieg* against Poland in 1939. Mahan's recurrent metaphor for the sea was that of a "great highway." Furthermore, the end of reliance upon the wind transformed the surface of the sea into a smooth and abstract horizontal field of action: "The sea, until it approaches the land, realizes the ideal of a vast plain unbroken by obstacles."[3] Modernization proceeds as a substitution of efficient, smooth surfaces for broken, interrupted surfaces. Containerization was understood to have a similar salutary effect on waterfront space almost a century later.

There was a profoundly expansionist logic to this new strategic vision of maritime space. Mahan was the chief proponent of American imperial expansion into the Pacific, arguing for the geo-strategic importance of a canal through the Isthmus of Panama, for the colonial annexation of the "invaluable half-way house" of Hawaii, all the while gauging the importance of Pacific rivalries with the old naval power, Britain, and warning of the rising new powers, Germany and Japan. Beyond that immediate horizon of inter-imperialist competition, Mahan counseled fear of "barbaric invasion" from China.[4]

Mahan's conception of the new geostrategic field of action put the final nail in the coffin of Hugo Grotius' older idea of the "sea which can neither be seized nor enclosed," the idea used to rationalize Dutch colonial expansion under the banner of the "freedom of the seas" in the early sixteenth century. For Mahan, the sea no longer stood for that which exceeded property and wealth by its very infinitude, but rather came to symbolize and to permit the very flux of the global clash of national political economies:

> Sea power primarily depends upon commerce, which follows the most advantageous roads; military control follows upon trade for its furtherance and protection. Except as a system of highways joining country to country, the sea is an unfruitful possession. The sea, or water, is the great medium of circulation established by nature, just as money has been created by man for the exchange of products. Change the flow of either in direction or amount, and you modify the political and industrial relations of mankind.[5]

The sea is money. The imperial bluntness of Mahan's economism is worth recalling in an age in which Cold War ideological justifications for

3 Alfred Thayer Mahan, *The Interest of America in Sea Power, Present and Future* [1897] (Freeport, New York: Books for Libraries Press, 1970), p. 41.

4 *Naval Strategy*, p. 138. Letter to the *New York Times*, 30 January 1893, reprinted in *The Interest of America in Sea Power*, p. 32.

5 *Naval Strategy*, p. 139.

Fig. 6
Visual index to ship portraits, from *All the World's Fighting Ships*, 1898.

Fig. 7
The battle cruiser *Queen Mary*, photograph from *Fleets of the World*, 1915.

gigantic naval fleets no longer hold, and maritime conflicts are more likely to be nakedly—that is, overtly rather than covertly—economic in character. As a consequence, Mahan, always revered in American naval circles, enjoys a broader contemporary revival in the United States, in an attempt at ideological compensation for public ignorance of the sea in the world's only maritime superpower.[6]

Thus naval strength came to be measured by a new relentlessly analytic archivalism, sharing methods developed in criminalistics, bibliographic cataloguing, and art history at the end of the nineteenth century. A forensic technique was developed for identifying types of vessels at a distance: instead of authentication provided by tell-tale ears in Renaissance paintings and police mug shots, ships were classified by their funnels. The ship portrait no longer led to the unity of the panoramic tableau, but rather to the taxonomic index of vessel types, epitomized by *Jane's Fighting Ships*, an annual first published in 1898. As the publisher, Fred Jane, put it, "the aim of this work is, primarily, to supply...details of warships."[7] Armed with the new hand-held Kodak, the passenger and the civilian waterfront stroller were enlisted into an informal cadre of spies:

> I have to thank an unprecedented number of correspondents, many in far corners of the world, for their kindness in making a practice of photographing every warship they encountered and sending the photos to me.[8]

These photos were converted into identifying silhouettes, classified according to the number, type, and grouping of funnels protruding from the ship's superstructure. As such they corresponded to the empirical limits of vision at sea. More detailed photographic reproductions and diagrams were accompanied by data on speed, guns and armor plate. This basic informational ensemble survives virtually unmodified in Jane's publications to this day.

If Mahan saw naval power "following upon" commerce, Fred Jane understood the reverse: that imperialist rivalries required the militarization of all maritime functions. Thus his annuals are designed to enlist merchant ships in the service of naval intelligence:

> The essential idea of Signal Code has always been to provide a means whereby any merchant steamer may act as an intelligent scout in the time of war without preparation or any special knowledge of warships.[9]

With this enthusiastic cataloguing of the hypertrophic contest between rival naval powers, the climactic narrative of combat was displaced in two directions, both unpictured. Battles of the recent past, such as those of the Russo-Japanese war, were scrutinized with a forensic pathologist's precision, in preparation for the bigger war to come. The portrait of the naval vessel recorded a precise incremental increase in the global investment in war. The image was seized by the dismal science. This shift can be understood in structuralist terms. It was no longer important to picture war syntagmatically, but only paradigmatically. This

6 See the recent PBS television series *Sea Power: A Global Journey* (1993).

7 Fred Jane, *All the World's Fighting Ships* (London: Sampson Low, Marston, 1898), p. 5. On the institutionalization of the model of the photographic archive in this period, see Allan Sekula, "The Body and the Archive," *October*, no. 3 (Winter 1986), pp. 3-64.

8 Fred Jane, *Fighting Ships* (London: Sampson Low, Marston, 1905-6), p. 11.

9 Ibid.

Fig. 8
The submarine *E-9*, photograph from *Fleets of the World*, 1915.

subordination of concrete syntagma—this narrative rather than any other—to the predictive openness of overtly paradigmatic systems of description and comparison is precisely the logic we find fulfilled in modern cybernated war games. Strategic and tactical power flows from the rehearsal and mastery and probabilistic ranking of all possible narratives. The war machine must be pictured in a potential rather than actual state of use. Despite Mahan's insistence on the lessons of military history, stories were replaced ultimately by scenarios. The narrative picture became increasingly anachronistic, suited for the nostalgic reveries of retired officers and industrialists, useful only insofar as it could be factored into a future scenario.

And so, by the beginning of the twentieth century, the panorama, once the most geographically encompassing form of pictorial representation, became inadequate to a world of explosive long-range shells, smoke screens, torpedoes, and above all else, the submarine. The naval blockade, which was visible and could be pictured in panoramic terms, as it was by Willem van der Velde the Elder, no longer constituted the most threatening manifestation of force.

With the First World War, the submarine introduced a qualitatively new order of invisibility and stealth into naval warfare, a new form of modernist terror. Fred Jane's ship silhouettes—the key to naval intelligence—ultimately corresponded most closely to the vignetted view through a periscope. This explains the inordinate symbolic importance attached to the periscope in fiction films about submarine warfare. The periscope reaffirms in a perversely one-sided way the old idea of visual contact between combatants. For example, the melancholic low-point of Stanley Kramer's 1959 post-apocalyptic film *On the Beach*—made before the ballistic missile submarine became the lurking instrument of Armageddon—is reached at those moments when the surviving submarine's crew members take turns gazing through the periscope at small circular fragments of a poisoned and dead world.

And yet submarine space was initially imagined to be amenable to panoramic representation. If the sea's surface had previously constituted a plane through which it was impossible to gaze, the submarine and the diving suit offered a new realm of imaginary visibility. Jules Verne's *Twenty Thousand Leagues under the Sea* (1870) is replete with panoramic accounts of the ocean floor, as in this passage describing the sunken city of Atlantis as an immense classical pastiche:

> There, indeed, under my eyes, ruined, destroyed, lay a town—its roofs open to the sky, its temples fallen, its arches dislocated, its columns lying on the ground, from which one could still recognize the massive character of Tuscan architecture. Further on, some remains of a gigantic aqueduct; here the high base of an Acropolis, with the floating outline of a Parthenon; there traces of a quay, as if an ancient port had formerly abutted on the borders of the ocean, and disappeared with its merchant vessels and its war-galleys. Further on again, long lines of sunken walls and broad deserted streets—a perfect Pompeii escaped beneath the waters. Such was the sight that Captain Nemo brought before my eyes![10]

The transparency of the underwater scene described here it not only spatial, but temporal as well, as the spectator takes in a veritable sunken museum of architecture ranging from the Attic to the Romanesque, evidence of what Roland Barthes termed "the egg-like fullness" of Verne's encyclopedic world.[11]

Figs. 9–10
Gregory Peck and Ava Gardner in production stills from *On the Beach*, 1959.

Fig. 11
Edouard Riou, frontispiece to Jules Verne, *Twenty Thousand Leagues under the Sea*, 1870, steel engraving.

10 Jules Verne, *Twenty Thousand Leagues under the Sea*, trans. H. Frith (London: Everyman's Library, 1908, reprint 1992), p. 197.

11 Roland Barthes, "The *Nautilus* and the Drunken Boat," in *Mythologies* [1957], trans. Annette Lavers (New York: Hill and Wang, 1972), p. 65.

Edouard Riou's frontispiece to the first French edition of Verne's novel is a panorama, split between the sea's surface and the depths, intersected by the sounding mammalian body of a whale. In the pictorial imagination, the undersea world offers a verticalization of panoramic space, a submerged neo-gothic ninety-degree reorientation of the floating eye. This viewpoint attempts to integrate the view from the deck, or from the periscope, with the underwater world inhabited by the submarine. But the view here is curiously contained, aquarium-like, serving almost as a model for the newer public aquaria that attempt to reproduce whole local ecosystems in tanks behind huge cathedral-scale plate-glass windows.

The most extraordinary of these nineteenth-century "Vernean" semi-submerged split representations is found in a late *ukiyoe*, or *nishike*, print by the Japanese artist Kobayashi Kiyochika, entitled *The Japanese Fleet Sinks Chinese Warships in the Battle of the Yellow Sea* (1894). A ferocious sea battle on the surface, cropped close to the horizon, occupies less than a third of the upper portion of the frame; the lower space depicts a battered warship plunging to the bottom, its drowning crew struggling to swim upward to the air. As in this case, Kiyochika's pictures are often structured along violent lines of force that cut across the long horizontal dimension of the frame. These prints exhibit an almost proto-futurist fascination with explosions, tracers, searchlights, and eerily illuminated action at night, in what Donald Keene has termed a "respon-siveness to the brave new world of Meiji Japan's modernizing influence."[12]

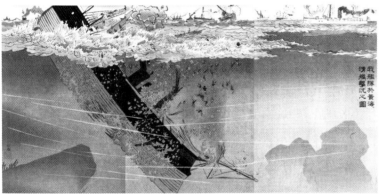

Fig. 12
Kobayashi Kiyochika, *The Japanese Fleet Sinks Chinese Warships in the Battle of the Yellow Sea*, color woodcut, 1894.

These propagandistic war prints by Kiyo-chika, and the descriptions and engravings of underwater tableaux by Verne and his illustrators, are all committed to sustaining the prestige of vis-ual empiricism in an age increasingly committed to the positivism of statistics and quantitative abstraction. The theatrical *faux* realism of these images has much to do with the phenomenologi-cal impossibility of the point of view they attempt to naturalize. (Verne's undersea world never existed and Kiyochika never visited the front in the Japanese war with China.) In both cases there is a strong appeal to a bourgeois confidence in con-quering new frontiers, vanquishing more primitive enemies. As Roland Barthes remarked of Verne, "The basic activity ... is unquestionably that of appropriation."[13] As they move the eye below the sur-face of the sea, these become, in effect, the last "Dutch" pictures.

In the wake of the horrors of the First World War, there was an attempt to construct a proletarian answer to the imperialist optimism of Verne, Kiyo-chika, Mahan, and Jane. One literary tactic was to run the process of abstrac-tion in reverse, as in this description of the Battle of Jutland from Theodore Plivier's novel *The Kaiser's Coolies*:

> Thirty thousand tons of hulls, sent into action in columns and pushed about like the quantities in an arithmetical problem. Armour-piercing shells—and when they crashed through the sides and exploded inside the ship, they shattered her vital organs. When they burst as they struck, the place of the impact turned white-hot. Fragments of armour-plate! Flowing lava! The bodies of men were turned into grey, boiling filth.[14]

12 Donald Keene, "Prints of the Sino-Japanese War," in Shumpei Okamoto, *Impressions of the Front: Woodcuts of the Sino-Japanese War, 1894-95* (Phila-delphia: Philadelphia Museum of Art, 1983), p. 8. I am grateful to John O'Brian for calling Kiyochika's work to my attention.

13 "The *Nautilus* and the Drunken Boat," p. 66.

14 Theodor Plivier, *The Kaiser's Coolies*, trans. Margaret Green (New York: Alfred A. Knopf, 1931), p. 207. The book was originally published by Malik-Verlag in 1930 with a dustjacket designed by John Heartfield.

Plivier repeatedly shifts from a panoptico-strategic point-of-view derived from post-hoc "official accounts" of the battle to the claustrophobic blind horror of the engine room and gun turret. Elaborating an industrialized bio-mechanics, he places bodily flows within the circuit of machine-functions; the ultimate reduction of the flesh is excremental, in life as well as death:

> Eighty men cooped up in a turret suffering pressure on the bladder. They sought relief till the fire-buckets were full to overflowing. The battle continued for an hour. The men's physical organs and functions—blood, nerves, intestines—worked at the furious pace of the engines. The stokers relieved nature upon their shovels and hurled it into the fires.[15]

It is not surprising, then, that Plivier describes the dockyard latrines at Wilhelmshaven as the initial site of mutinous plotting within the German High Seas Fleet:

> ... all the abuse and humiliations they were forced to swallow in their destroyer, cruiser, battle-ship, or fishing-vessel they here spat out again. The closets were the club-houses of the crews. In them you were even less liable to interruption and observation than in the public houses of the evening. Here the men criticized conditions in the Navy and the fleet's enterprises, slogans were coined and express messages dispatched. The wooden walls were adorned with scribbled epigrams.[16]

With this we have arrived at an insurrectionary aesthetic of the detail. The ship is no longer a "perfect cubby-hole," as Barthes described its metaphoric existence for Verne, but a deadly prison, fit only to be commandeered by the inmates.[17]

PHANTOM MUTINY

> To those who are unable to pursue a life of adventure on their own, the Navy (as all armed forces) offers them one on a platter: all they do is sign up, and it will take its methodical course, finally underlined with the thin red ribbon of the Legion of Honor.
>
> Jean Genet[18]

> I scarcely know of anything but those two harbors at dusk painted by Claude Lorrain—which are at the Louvre and which juxtapose two extremely dissimilar urban ambiances—that can rival the beauty of the Paris metro maps. It will be understood that in speaking here of beauty I don't have in mind plastic beauty—but simply the particularly moving presentation, in both cases, of a *sum of possibilities*.
>
> Guy Debord[19]

During the long twilight of romanticism, a twilight whose flickering dim luminosity sustains the very idea of a modernist art of photography, the ship retains its *heterotopic* attraction. In this light the ship is more than the dismal object of political economy, it becomes poetic, even mutinous.

15 Ibid., p. 109.

16 Ibid., p. 71.

17 "The *Nautilus* and the Drunken Boat," p. 66.

18 Jean Genet, *Querelle* [1953], trans. Anselm Hollo (New York: Grove Weidenfeld, 1974), p. 258.

19 Guy Debord, "Introduction to a Critique of Urban Geography," [1955] in Ken Knabb, ed. and trans., *Situationist International Anthology* (Berkeley: Bureau of Public Secrets, 1981), p. 5.

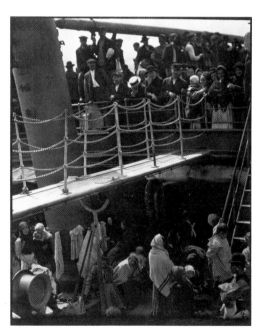

Fig. 13
Alfred Stieglitz, *The Steerage*, photogravure, 1907.

In a conversation transcribed and edited by Dorothy Norman sometime between 1927 and 1942, Alfred Stieglitz remembered an earlier conversation with his first wife, Emmeline, in 1907. He had just made his photograph of working class passengers crowded into the forward steerage decks of the "fashionable ship of the North German Lloyd" the *Kaiser Wilhelm II*, as it steamed toward England from New York:

> I took my camera to my stateroom and as I returned to my steamer chair my wife said, "I had sent a steward to look for you. I wondered where you were. I was nervous when he came back and said he couldn't find you." I told her where I had been. She said, "You speak as if you were far away in a distant world," and I said I was.[20]

Thus while the legend initiated by this memoir transformed *The Steerage* into the birth-moment of a peculiarly American mode of symbolist photography, into a *post hoc* allegory of the Proustian wrenching of abstraction from everyday life, the picture was also remembered by its maker in terms of almost boyish wonder and awe. *The Steerage* was quite simply this: *another space*.

And if Alfred Stieglitz was to recall *The Steerage* as a momentous personal move in the direction of symbolism and abstraction, "a picture of shapes and underlying that the feeling I had about life," he was appreciated by Lewis Mumford for having resisted another kind of abstraction: the abstraction of commodity exchange.[21] Mumford's 1934 essay on Stieglitz lamented the fading of the city's distinct character as a maritime metropolis. Mumford imagined a kind of reverse or negative synesthesia: the smell of the rivers, the odors of the Hudson and East River docks, had been obliterated by a blizzard of paper stocks, bonds, commercial paper, business documents. This was the New York City in which:

> the ledger and the prospectus, the world of paper, paper profits, paper achievements, paper hopes, and paper lusts, the world of sudden fortunes on paper and equally grimy paper tragedies, in short, the world of Jay Cook and Boss Tweed and James Gordon Bennett, had unfolded itself everywhere, obliterating under its flimsy tissues all the realities of life that were not exploitable, as either profits or news, on paper.

Mumford concluded, "No wonder the anarchists, with more generous modes of life in mind, have invented the ominous phrase: 'Incinerate the documents!'"[22]

Mumford's anaesthetic but befouled "pathopolis" had lost touch with the "salty lick and lap of the sea at the end of every crosstown street."[23] For Mumford, it was Stieglitz who maintained contact with the older Melvillian port city. For when *The Steerage* was first published, in a 1911 issue of *Camerawork*, it was embedded in a series of pictures of the maritime edges of Manhattan in which the smoke and steam from the funnels of ferryboats, tugs, and ocean liners mingled with the steam of the city's heating plants in an impressionist atmospherics of the maritime city, a flux of water, steam, smoke, clouds, massed bodies, and machines that would be recapitulated cinematically in Paul Strand's and Charles Sheeler's film *Manahatta* of 1921.

But what Stieglitz discovers in *The Steerage* is a maritime space that *becomes metropolitan*, vertical and hierarchical, jam-packed with anonymity.

20 Alfred Steiglitz, "Four Happenings," *Twice A Year*, no. 8-9 (1942), p. 129.

21 Ibid., p. 128.

22 Lewis Mumford, "The Metropolitan Milieu," in Waldo Frank et al., eds., *America and Alfred Stieglitz: A Collective Portrait* (New York: Literary Guild, 1934), pp. 36-37, 38.

23 Ibid., p. 36.

Fig. 14
Alfred Stieglitz, *The City of Ambition*, photogravure, 1910.

The steamship, the largest machine capable of being pictured in its totality, yields a partial image of that larger, unpicturable machine: the city. Moreover, Stieglitz found in *The Steerage* a space analogous to other spaces he could no longer bring himself to photograph after initial forays in the mid-1890s: the slum and the tenement, spaces depicted with more perseverance by Jacob Riis, by Lewis Hine, and by the Ash Can painters.

Just before he wrote his essay on Stieglitz and New York, Lewis Mumford argued that, in the social contrast of its passenger spaces, "the big ocean steamship remains a diagrammatic picture of the paleotechnic class struggle."[24] The rigid boundaries and disproportionate spatial allotments of first- and third-class trans-Atlantic passage provided Stieglitz with a compressed image of the social packing of the Lower East Side immigrant ghetto of Manhattan. Approximately seven hundred third-class passengers, equal in number to those traveling first class on the *Kaiser Wilhelm II*, were jammed into roughly one-quarter the space, berthed just behind the bow, next to the boilers and above the coal bunkers. When these passengers sought the relief of the ocean air, they could only press upward onto a tiny forward deck wedged amongst hatch covers and capstans. Thus Stieglitz produced an image of the tenement twice removed, from shore to ship and from the fetid interior of the lower decks to the open air of the upper deck. For Stieglitz too, this was an escape: "How I hated the atmosphere of the first class on that ship."[25]

The modernist self-consciousness of *The Steerage* is most clearly registered in its double embodiment as a liminal space and as a space of spectatorship. Thus the "untouched" gangplank leading forward from the first-class promenade deck to the upper third-class deck figures strongly both in the structure of the picture and in Stieglitz's recollections of its making. Likewise the figure of the "young man in with a straw hat...watching the men and women and children on the lower steerage deck" served as a spectator-double for Stieglitz, rather like Edgar Allan Poe's mysterious "man of the crowd." The spectator, distinguished from the surrounding crowd by the middle-class character of his clothing, was remembered by Stieglitz as the key to the picture: "If he had [moved], the picture I had seen would no longer be." But mere good fortune gave way to a curious display of mental omnipotence; Stieglitz claimed that the scene photographed, after he dashed to his cabin to retrieve his camera, was identical to the scene he first encountered on his promenade: "Seemingly no one had changed position." This magical fusion of the moment of inspiration with the moment of creation pivots on the appearance of a second, more prestigious, *Doppelgänger*: "Rembrandt came into my mind and I wondered would he have felt as I was feeling."[26]

Stieglitz moved quickly from memories of "the common people" to the gauging of his own emotions on a register of genius. His mutinous longings were fleeting, leading to little beyond occasional abstract declarations of solidarity with the exploited, exemplified by his accounts of meetings with the anarcho-syndicalist leader Bill Haywood and the anarchist Emma Goldman, both tales presented as parables of his own parallel authority as a leader of an aesthetic vanguard. The most revealing of these Socratic monologues, a story called "The Six Tailors," recounts a 1906 visit by aggrieved immigrant garment workers to the Photo-Secession Gallery, seeking "in a queer English" to enlist Stieglitz as an "arbiter." (There is a odd homophony between Stieglitz's choice

24 Lewis Mumford, *Technics and Civilization* [1934] (New York: Harcourt, Brace, 1963), caption to pl. 4, following p. 244. John Malcolm Brinnin describes an incident in January of 1909 in which "simple class privilege" nearly caused a mutiny of Italian emigrant passengers. Two liners, the *Republic* and the *Florida*, collided off Nantucket. As the lifeboats were being loaded, "first-class male passengers were given precedence over ... women emigrants. One of the unwritten laws of the sea, quite the established custom ashore, was that persons of means were exempt from the stricter applications of democracy. When this law clashed with the also unwritten rule of women and children first, something had to give." *The Sway of the Grand Saloon: A Social History of the North Atlantic* (New York: Delacorte Press, 1971), p. 350. Another writer notes that, with the *Kaiser Wilhelm II* and the other four ships in its North Atlantic liner fleet, Norddeutscher Lloyd "reaped enormous profits from the very lucrative immigrant trade as well as from the very rich, who could pay as much as $ 2,430 per crossing." Mark D. Warren, "Introduction," in *The Cunard Turbine-Driven Quadruple-Screw Atlantic Liner "Mauretania"* [1907] (Wellingborough, Nottinghamshire: Patrick Stevens, 1987, reprint), p. i.

25 "Four Happenings," p. 127.

26 Ibid., p. 128. See Edgar Allan Poe, "The Man of the Crowd" [1840/45], in *Great Short Works of Edgar Allan Poe*, ed. G.R. Thompson (New York: Harper and Row, 1970), p. 262-72. Poe's "double" is preternaturally animated, while Stieglitz's is frozen still. Both are figures of the uncanny for the narrators, looming out of the anonymous mass of the city and the ship.

of words and the German and Yiddish terms for "worker," *Arbeiter* and *Arbeter.*)
Stieglitz responds with a patronizing indifference to the craft-obliterating
pressures of industrialized production:

> You will find many men who will plead your case for higher pay and shorter hours.
> You do not need me, but if ever you should come to me and say, "we refuse to work
> for anybody who will not let us give our best"—I will be your leader. My life will
> belong to you.[27]

The direction of his movement, from the overwhelming misery of the city to the
encapsulated misery of the ship, was the opposite of that taken by Friedrich
Engels sixty-odd years earlier on the Thames. The stories later recounted to
Dorothy Norman suggest that Stieglitz was, perhaps more than most other
members of the avant-garde intelligentsia of early twentieth-century America,
haunted and cast adrift by the implications of his choice.

It would be a mistake, however, to reduce *The Steerage* to Stieglitz's
own retrospective interpretation, or to an illustration of his various parables of
self-justification. In its initial appearance within the *Camerawork* series, it
served as a radical complement to the other more traditional pictures of Man-
hattan. If Stieglitz preserved Melville's seascape image of the "insular city of
the Manhattoes, belted round by wharves as Indian isles by coral reefs," in his
photographs of the Battery, the Staten Island ferry, and the *Mauretania* steam-
ing seaward from the mouth of the Hudson River, he also found the claustro-
phobic image of the city in the ship far from land.[28] He banished the last
vestiges of the "natural" seascape, dictated by the persistence of the horizon
line, from the shipboard scene. Thus *The Steerage* dispenses with the conven-
tion of the horizon retained in an earlier radical depiction of shipboard ano-
nymity and packing of bodies, Édouard Manet's *Departure of the Folkestone
Boat* (1869), of which Georges Bataille remarked, "When Proust alludes to a
ship as 'some citified, earth-built thing,' to what other painting do these words
more aptly apply…?"[29] In this, *The Steerage* is a step in the direction of a
greater modernist blurring of the distinction between the ship and other
machines.

The loss of the horizon in *The Steerage* bespeaks claustrophobic
entrapment, at odds with Stieglitz's retroactive appeal to liberating seascape
memories of "the feeling of ship and ocean and sky." The escape from his
status-conscious wife and "the mob called the rich" becomes an uncanny cir-
cular movement back to the depths of the city, to a frozen slum-tableau.[30] It is
at this level that Mumford's appreciation of Stieglitz breaks down. Mumford is
continually opposing a redemptive, essential, and normative nature, of which
Stieglitz is the vigorous bohemian prophet, to the depraved and pathological
culture built on the foundation of modern technics. Underlying this is a faith in
democracy, and in a gendered, *masculine* truth of work, sexuality and nature.
As Mumford put it in another context, speaking of the building of ships and
bridges: "The masculine reek of the forge was a sweeter perfume than any the
ladies affected."[31] But Stieglitz's "neurotic" dilemma expressed in his memo-
ries of *The Steerage*—exemplified by his projection of doubles and predication
of his own ecstasy and transport on the absolute stasis and containment of the
scene—may be closer to the nightmares of Poe than to the optimistic and dem-
ocratic prospects of Walt Whitman, or the transcendent nature of Ralph Waldo
Emerson and Henry David Thoreau. Here we can contrast Mumford's character-
ization of Stieglitz's "manly sense of the realities of sex," with Freud's remark

[27] Alfred Stieglitz, "Ten Stories," *Twice A Year*, no. 5-6 (1940-41), p. 139.

[28] Herman Melville, *Moby-Dick* [1851] (New York: Penguin, 1972), p. 93.

[29] Georges Bataille, *Manet* [1955], trans. Austryn Wainhouse and James Emmons (New York: Rizzoli, 1983), p. 80.

[30] "Four Happenings," p. 128.

[31] *Technics and Civilization*, p. 209.

on the double: "From having been an assurance of immortality, he becomes the ghastly harbinger of death."[32]

* * *

Horizonless, closed in, vertically segmented: *The Steerage* is another space. In a lecture delivered in March 1967, Michel Foucault revises and extends the standard meanings of the term "heterotopia," lexically given as "displacement of position," and further specified as "an abnormal habitat," or "deviation of an organ from the normal position."[33] (This latter usage is found, for example, in nineteenth-century medical descriptions of the pathology of tumors.) Overall, Foucault is outlining a history of spatial epistemologies in three stages: moving from a medieval spatial logic governed by static hierarchies of "emplacement," to a classical "Galilean" logic of temporal "extension," and on to a modern logic of "relations between sites."

For Foucault, heterotopias are real spaces—distinct from nonexistent or "virtual" utopian spaces—that seize and activate the imagination, that "are absolutely different from all the sites they reflect and speak about." These are "counter-sites" within which "all the other real sites that can be found within the culture are simultaneously represented, contested, and inverted."[34] Cemeteries, retirement homes, psychiatric hospitals, prisons, fairgrounds, motels, brothels, libraries and museums are all heterotopic spaces. But the "heterotopia *par excellence*" is the ship:

> ... if we think, after all, that the boat is a floating piece of space, a place without a place, that exists by itself, that is closed in on itself and at the same time is given over to the infinity of the sea.[35]

The ship always exceeds the formidable materiality of its function. For European civilization since the sixteenth century, the ship,

> ... the great instrument of economic development ... has been simultaneously the greatest reserve of the imagination....In civilizations without boats, dreams dry up, espionage takes the place of adventure, and the police take the place of pirates.[36]

As with Stieglitz earlier, there is a certain boyish or "adolescent" romanticism in these remarks. Yet Foucault's historical sources for this understanding precede romanticism. Implicitly, Foucault was returning to the image of the late medieval *Narrenschiff*, or "ship of fools," analyzed in the first chapter of his 1961 *Histoire de la folie*. The shipborne banishment of the madman produced a voyage that "develops, across a half-real, half-imaginary geography, the madman's *liminal* position on the horizon of medieval concern."[37]

But Foucault is trying to claim a subversive potential for the ship within late modernity. The ship, a "real site," is the metaphoric engine of both *social* and *archival* disruption. In the latter sense, the heterotopic vessel, as a world unto itself, resists the rigid classifications sought by Mahan's naval espionage. For Foucault, the ship challenges spatial categories in the same way that the fantastic and heterotopic "Chinese encyclopedia" of Jorge Luis Borges challenges categories of language and grammar, by offering up both all-inclusive and partial categories as if they were part of a uniform series of equivalently weighted elements. The Borgesian encyclopedia is the Ark of

32 "The Metropolitan Milieu," p. 57. Sigmund Freud, "The Uncanny" [1919], trans. Alix Strachey, in *Studies in Parapsychology* (New York: Collier, 1963), p. 40.

33 *Webster's New International Dictionary*, 3rd ed., s.v. "heterotopia."

34 Michel Foucault, "Of Other Spaces," trans. Jay Miskowiec, *Diacritics* 16:1 (Spring 1986), pp. 24.

35 Ibid., p. 27.

36 Ibid.

37 Michel Foucault, *Madness and Civilization: A History of Insanity in the Age of Reason*, trans. Richard Howard (New York: Vintage, 1973), p. 11. Emphasis in original.

38 Michel Foucault, *The Order of Things: An Archaeology of the Human Sciences* [1966], unidentified collective trans., (New York: Random House, 1970), p. xvii. Emphasis in original.

39 Michel Foucault, "On Attica: An Interview," trans. and ed. John K. Simon, *Telos*, no. 19 (Spring 1974), pp. 155, 157. Compare a veteran prisoner's description of his first incarceration in the five-tier cellblocks of San Quentin: "When I stepped in I was astounded. I was dwarfed by the unit. It looked like a huge slave ship." Sankika Shakur (aka Kody Scott), *Monster: The Autobiography of an L.A. Gang Member* (New York: Penguin, 1993), p. 342.

40 Peter Linebaugh, *The London Hanged: Crime and Civil Society in the Eighteenth Century* (Cambridge: Cambridge University Press, 1992), p. 372. Linebaugh points out that Bentham and his brother Samuel "left Russia without knowing whether the singular architectural idea would transform a 'madhouse' into a 'utopia,' but determined with their experience to put the idea into practice in England." Under the supervision of Samuel Bentham, who became Inspector-General of Naval Works in 1795, British naval dockyards became the key site of early industrial rationalization and control. Linebaugh further stresses — in opposition to what he regards as Foucault's overemphasis on the absolute character of "the great confinement" — the radical insurgent role played by sailors, port workers, and ex-slaves in the late eighteenth-century movements of "excarceration," directed against the new institutions of prison and police, institutions designed in large measure to control the unruliness that found its home in maritime London. Ibid., pp. 373, 3.

language transformed into a *Narrenschiff*, defying attempts to define a "stable relation of contained to container," ultimately doing "away with the *site*, the mute ground upon which it is possible for entities to be juxtaposed."[38]

There is good reason to be stubbornly literal about this aspect of Foucault's work, if only to resist the widespread academic tendency to retain from his overall project only the epistemological critique of normative archival systems. When, beyond this, Foucault's work on prisons is remembered, it is often in the spirit of an increasingly generalized and metaphoric model of panoptic surveillance, forgetting his interest in actual prisons and prison revolts, and thus in the spatial conditions of one late modern variety of mutiny. Consider Foucault's description of a visit to the Attica state penitentiary, seven months after the September 1971 massacre of rebellious convicts and their hostages by New York state troopers:

> . . . at first sight you have the impression that you are visiting more than just a factory, that you are visiting a machine, the inside of a machine
>
> The only way for prisoners to escape from this system of training is by collective action, political organization, rebellion.[39]

In the late 1960s and early 1970s, the prison, as the most dismal of heterotopias, could still be linked to the ship, the "heterotopia *par excellence*." The justifications for this linkage were political, spatial and historical: authoritarian total institutions, cellular machine space, the legacy of slavers, floating prison hulks, and convict transport ships.

Despite their obvious differences, prison revolts invited comparison with naval mutinies of the past. It is instructive to discover that Jeremy Bentham's famous panopticon prison proposal — so central to Foucault's *Discipline and Punish* (1975) — had its origins (unknown or unacknowledged by Foucault) in his brother's plan for the control of unruly late eighteenth-century naval-dockyard labor in tsarist Russia, "in Kirchev, on an estate recently sequestered by Prince Potemkin."[40]

Foucault began his lecture on heterotopias by arguing that the persistent attempt to understand contemporary space in terms of unexamined oppositions — between public and private sites, sites of work and sites of leisure — revealed that "contemporary space is still not entirely desanctified." But he ended with an even more fanciful, archaic and "imaginary" set of oppositions, juxtaposing espionage and adventure, the police and pirates. But in March of 1967 Foucault may well have detected an emerging spirit of insurrection among French students and workers. Even if drained of literal meaning by the transformations of maritime life, the metaphor of the ship as the vessel of mutinous "contestation" and "inversion" retained a particular resonance in a society about to explode.

* * *

During the first four decades of this century, mutiny carried a more literal maritime charge. The crucial period extended from 1917 to 1921, marked at both ends by revolts of sailors based on the Russian island stronghold of Kronstadt, guardians of the Baltic approach to Petrograd. Here is a passage from the American journalist John Reed's account of the Bolshevik seizure of power in that city, in October 1917:

Five or six sailors with rifles came along, laughing excitedly, and fell into conversation with two of the soldiers. On the sailors' hat bands were *Avrora* [*sic*] and *Zaria Svobody*, the names of the leading Bolshevik cruisers of the Baltic Fleet. One of them said, "Cronstadt [*sic*] is coming!" ... It was as if, in 1792, on the streets of Paris, someone had said: "The Marseillais are coming!" For at Cronstadt were twenty-five thousand sailors, convinced Bolsheviki and not afraid to die....[41]

Four years later, at the end of the brutal civil war against restorationist White forces, the Kronstadt sailors—who had been termed by Leon Trotsky "the pride and glory" of the revolution—rallied to the old Bolshevik slogan "all power to the soviets," demanding a measure of democracy and relief from the hardships of war communism. The Kronstadt sailors rebelled against a weakened but increasingly unilateral and unyielding Bolshevik authority, only to be slaughtered by government troops under Trotsky's command. Prisoners were executed by the Cheka.[42] Thus with 1921, mutiny, never attractive to aristocratic and bourgeois imaginations, came to carry an uglier, tragic resonance for revolutionary workers' movements as well. After 1921, three distinct but often overlapping visions of mutiny circulated, encompassing fading anarchist dreams, Bolshevik legends, and enduring bourgeois nightmares.

The preceding four years had seen a virtual wave of maritime revolt. The October Revolution in Petrograd had been bracketed by the German naval mutinies of August 1917 and October-November 1918, the subject of Theodor Plivier's novel, *The Kaiser's Coolies*. The first of these mutinies was suppressed; the second prevented the officers of the German High Seas Fleet from pursuing the war with England, and initiated the November Revolution that brought an end to Imperial Germany.[43] To the revolts in Russia and Germany can be added a number of unsuccessful revolutionary uprisings and general strikes in maritime cities, often strongly anarcho-syndicalist in character: Barcelona in August of 1917 and February of 1919, Seattle in February 1919. Internationally, the postwar strike wave found its multiple nodal points in the reciprocity of ships and ports, its haven in the proletarian cosmopolitanism of the waterfront. To Red Petrograd, then, could be added a threatening (or inspiring) list of other insurgent waterfront cities: Wilhelmshaven, Kiel, Hamburg, Barcelona and Seattle, but also Glasgow, Genoa, Le Havre and Los Angeles.

On the eve of their decline as a political force, syndicalists came to imagine a vast stateless association of seafaring and waterfront proletarians of all nations, described as "an industrial republic of the ocean," or, alternately, as a workers' "dictatorship of the seven seas."[44] However stillborn it may have been, the syndicalist idea was incipiently one of Foucauldian "relations between sites," a revolutionary network that paralleled and challenged the global capitalist system of transport and trade by linking as subjects the toilers within that system. This notion of revolt broke with the older bourgeois-romantic fantasy of the single vessel as the vehicle of mutinous contestation, exemplified by Captain Nemo's submarine in Verne's *Twenty Thousand Leagues under the Sea*. The task of that novel's narrative quest was to decipher the mutinous demiurge in Nemo's vengeful brain: the submarine was merely the marvelous product—the self-portrait—of it's captain's tortured genius. Nemo's crew remained an unexamined cipher behind the cipher, communicating in an incomprehensible tongue. It was this tongue that seafaring syndicalism sought to universalize.

[41] John Reed, *Ten Days that Shook the World* [1919] (New York: Random House, 1960), p. 96.

[42] See Paul Avrich, *Kronstadt 1921* (Princeton: Princeton University Press, 1970).

[43] See Daniel Horn, *The German Naval Mutinies of World War I* (New Brunswick: Rutgers University Press, 1969).

[44] *The Story of the Sea: Marine Transport Workers' Handbook* (Chicago: Industrial Workers of the World, 1922), p. 39. The historical echo here was with the "Floating Republic" of the British naval mutineers at Spithead and the Nore in 1797, who had already articulated, in the context of mercantile capitalism, a subjective and "workers" premonition of the labor theory of value: "Shall we, who in the battle's sanguinary rage, confound, terrify and subdue your proudest foe, guard your coasts from invasion, your children from slaughter, and your lands from pillage— be the footballs and shuttlecocks of a set of tyrants who derive from us alone their honours, their titles and their fortunes? No, the Age of Reason has at length revolved. Long have we been endeavoring to find ourselves men. We now find ourselves so. We will be treated as such." Address of the Nore Delegates "to their fellow-Subjects" in Conrad Gill, *The Naval Mutinies of 1797* (Manchester: University of Manchester Press, 1913), p. 301. On seventeenth-century merchant sailors as "workers of the world," see Marcus Rediker, *Between the Devil and the Deep Blue Sea: Merchant Seamen, Pirates, and the Anglo-American Maritime World 1700-1750* (Cambridge: Cambridge University Press, 1987).

The anarchist vision of the port city as a "sum of possibilities" (Guy Debord) is perhaps best exemplified by the opening chapter of Victor Serge's novel, *The Birth of Our Power* (1931). "This City and Us" is an extraordinary evocation of the cityscape of Barcelona on the eve of the 1917 revolt, viewed from the heights of Montjuich. Serge begins by describing the mountain itself in almost Cézannesque terms:

> ... sharp angles dominating the mountain, set in relief or faceted by the play of sunlight ... We would have loved this rock—which seems at times to protect the city, rising up in the evening, a promontory over the sea (like an outpost of Europe stretching toward tropical lands bathed in oceans one imagines as implacably blue)—this rock from which one can see to infinity ... We would have loved it had it not been for those hidden ramparts, those old cannons with their carriages trained low on the city, that mast with its mocking flag, those silent sentries with their olive-drab masks posted at every corner. The mountain was a prison—subjugating, intimidating the city, blocking off its horizon with its dark mass under the most beautiful of suns.[45]

The city reveals its liberated possibilities only in the distance, and in the flux of the sea. In contrast, stasis and the close-up view are the domains of repressive force:

> One *sees*, in the sea of roofs compressed into motionless waves, how they shrivel up and crush numberless lives....
>
> Our eyes, scanning the faraway snowcap at leisure, or following a sail on the surface of the sea, would always light on the muzzle of a cannon, across the thicketed embankment.[46]

For the narrator and his comrades, "a fraternity of fighters without leaders, without rules, and without ties," the horizon was the image of freedom.[47] Much as he ended his life alone among revolutionists, penniless in Mexico City, Serge was alone in this effort to redeem distant or panoramic space as the ultimate purview of autonomous popular revolt. And yet this aesthetic predisposition was in certain respects consistent with the popular culture of anarcho-syndicalist maritime workers in the early 1920s. Here is a description of agitation organized by members of the Industrial Workers of the World during the 1923 Los Angeles maritime strike, centered in the San Pedro port district:

> A red airplane with the word SOLIDARITY painted on it circled overhead dropping leaflets, and a red automobile carrying an IWW placard drove around in the streets below. A fast launch distributed strike literature to ships in the harbor.[48]

Another account of the same period reveals that "on San Pedro's Liberty Hill a big sign that read 'Join the IWW' was clearly visible to seamen as their ships entered the port."[49]

If American radicals were inclined to use the most advanced advertising techniques to communicate over distances, the culture of Catalan anarchism was more grounded in pre-modern popular rituals, pageants and demonstrations that wound their way through *ramblas* of the city, symbolically taking possession of urban sites and territory. But Barcelona was the place where anarchism established its deepest urban roots.[50] Viewed in this light, Serge's

[45] Victor Serge, *The Birth of Our Power*, trans. Richard Greeman (London: Writers and Readers, 1977), pp. 17.

[46] Ibid., p. 19.

[47] Ibid., p. 22.

[48] Louis B. Perry and Richard S. Perry, *History of the Los Angeles Labor Movement 1911-1941* (Berkeley: University of California Press, 1963), p. 184.

[49] Bruce Nelson, *Workers on the Waterfront: Seamen, Longshoremen, and Unionism in the 1930s* (Urbana: University of Illinois Press, 1988) p. 61.

[50] See Temma Kaplan, *Red City, Blue Period: Social Movements in Picasso's Barcelona* (Berkeley: University of California Press, 1992). Kaplan points out the pivotal role of women, especially women from the working-class port district of Barceloneta, in 1918 marches denouncing profiteering in subsistence commodities. See pp. 119-120.

emphasis on the horizon may well be the mark of the professional revolutionary as perpetual refugee and outsider. The city was a ship, one of many, and the mountain was a quarterdeck to be seized by an intrepid band of mutineers.

If anarcho-syndicalism conjured up an image of fluid, multiple intercommunicating but autonomous points of insurrection, Bolshevism, especially for its enemies, offered up the counter-image of a fire with a single flashpoint. A quarter-century before the October Revolution, in the manuscript of *Billy Budd*, Herman Melville had characterized the threat of mutiny as a form of foreign contagion, describing the 1797 Nore Mutiny of the English Fleet as "irrational combustion as by live cinders blown across the channel from France in flames." *Billy Budd* was first published posthumously in 1924, at a time when the temperature of its image of mutiny had been pushed upward by immediate historical events.[51]

Maritime insurrection was a recurrent and almost obsessive theme within the modernist culture of the 1920s and 1930s. Ultimately this obsession focused on the physical body and *habitus* of the sailor. Even Trotsky, who presented the clearest and most dispassionate description of the *strategic* importance of naval mutiny as the spark of wider social revolution, saw the need to begin by describing the warship as a space of claustrophobic social frictions:

> The life conditions of the fleet even more than the army nourished the live seeds of civil war. The life of the sailors in their steel bunkers, locked up there by force for a period of years, was not that much different even in the matter of food from that of galley slaves. Right beside them the officers, mostly from privileged circles and having voluntarily chosen naval service as their calling, were identifying the Fatherland with the tsar, the tsar with themselves, and regarding the sailor as the least valuable part of the battleship. Two alien and tight-shut worlds thus live in close contact, and never out of each other's sight. The ships of the fleet have their base in the industrial seaport towns with their great population of workers needed for building and repairing. Moreover, on the ships themselves, in the engineering and machine corps, there is no small number of qualified workers. Those are the conditions which convert the fleet into a revolutionary mine. In the revolutions and military uprisings of all countries the sailors have been the most explosive material....[52]

The maritime space that for Engels could only be described as a panorama, Trotsky described as a dense compacted synecdoche for the larger society of tsarist Russia. That is, for Trotsky maritime space *in itself* contained the contradictions found by Engels in the movement from the waterfront to the slum. On the warship, peasant conscripts were individuated and thrust into technical conditions characteristic of proletarian modernity, but under the backward and oppressive conditions of

51 Herman Melville, *Billy Budd, Foretopman* [1891] in *The Shorter Novels of Herman Melville* (New York: Liveright, 1928), p. 242.

52 Leon Trotsky, *The History of the Russian Revolution* [1932], trans. Max Eastman, (New York: Pathfinder Press, 1980.) vol. 1, p. 254-55. Emphasis added.

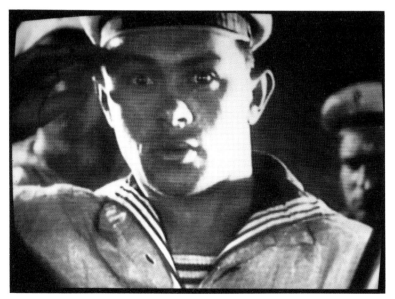

Figs. 15-16
Battleship Potemkin, 1925.

tsarist social command. Combining features of the modern factory with the conditions of serfdom, the warship was a prime instance of Trotsky's theory of "combined and uneven development," simultaneously backward and advanced, an imbalanced powder keg.

The great image of the warship as mutinous heterotopia is found of course, in Sergei Eisenstein's *Battleship Potemkin* of 1925. This film was based on the June 1905 mutiny aboard the most modern battleship of the Black Sea Fleet. *Potemkin* became, in a departure from the original plan for a more sweeping film commemorating the 1905 revolution, a grand synecdoche in itself. In effect, the triumphal story of the most "advanced" revolutionaries of 1905 came to substitute for a wider story that would have been hard-pressed to avoid evidence of backwardness, chaos, and eventual defeat. In this sense, the film extracts the grimly optimistic political lesson of Trotsky's *1905*, first published in Russian in 1922. For Trotsky, the sailor of 1905 had already become the figure of proletarian political maturity within the larger chaos:

> Who raised the red banner on the battleship? The technicians, the engine men. These industrial workers in sailor's uniforms who form a minority among the crew nevertheless dominate the crew because they control the engine, the heart of the battleship.

> Friction between the proletarian minority and the peasant majority in the armed forces is a characteristic of all our military risings, and it paralyzes them and robs them of power.[53]

Thus Trotsky was to blame mutinous failure on the "backwardness and distrustful passivity of the muzhik-soldier." Writing much later from his fortified and ship-like refuge in Coyoacan, Trotsky defended his role in the suppression of the 1921 Kronstadt revolt, and returned to the example of the *Potemkin* in 1905:

> ... the uprising on the battleship...was based on the struggle between proletarian and petty bourgeois reactionary extremes for influence over the more numerous middle peasant layer. Whoever does not understand this problem... had best be silent about the problems of the Russian Revolution in general.[54]

In Trotsky's view, Kronstadt of 1921 was the *Potemkin* running in reverse. The pure "heart of the battleship" still figured, then, as an imaginary precursor of 1917. But historian Paul Avrich has demonstrated that the leaders of the later revolt against the Bolsheviks were actually drawn from that very heart: machinists, electricians, clerks and navigators, many of them veterans of the October Revolution.[55]

Although *Potemkin* begins with a clandestine conference between two such "advanced sailors," Matyushenko and Vakulinchuk, the mutinous drive is quickly traced to deeper and more

53 Leon Trotsky, *1905*, trans. Anya Bostock (New York: Random House, 1971), p. 208. Trotsky's book may well have provided two of the key metaphors for the Potemkin segment of the shooting script of the original film, which was to have been called *The Year 1905*. Both metaphoric images are retained in the final version: the opening montage of storm surf breaking over the jetties of Odessa (Trotsky's "ocean tide whipped by storm") and the shots of a ladle skimming the surface of a boiling cauldron of rancid soup (Trotsky's "stirring the social cauldron, right to the very bottom, with a gigantic spoon"). For Trotsky, these are images of the unruly spontaneity and social heterogeneity of the revolt. (p. 198.) For an extract of the original script, by Nina Agadzhanova-Shutko and Eisenstein, see *Eisenstein: Three Films*, ed. Jay Leyda, trans. Diana Matias, (New York: Harper and Row, 1974), pp. 147-148.

54 Ibid, p. 209. Leon Trotsky, "Hue and Cry over Kronstadt," *New International* [New York], 4:4 (April 1938), p. 99.

55 *Kronstadt 1921*, pp. 91-92.

"primitive" levels. Eisenstein, a great champion of what might be termed the aqueous collectivity of the polymorphous perverse, could imagine an erotics of the ship as revolutionary war machine, just as he was later able to detect currents of revolutionary and utopian desire in Walt Disney's frolicking *Merbabies*:

> One of Disney's most amazing films is his *Merbabies*. What purity and clarity of soul is needed to make such a thing! To what depths of untouched nature is it necessary to dive with bubbles and bubblelike children in order to reach such absolute freedom from all categories, all conventions. In order to be like children.[56]

But Disney's "merbabies," for all their idiosyncracies, obey a choreographed discipline, much as the militant, ecstatic and then terrified—but always highly individuated—emotions of Eisenstein's crowds give way to channeled movement. On the battleship, this channeling takes the form of a Bolshevized erotics (or an eroticized Bolshevism). The budding rage of younger sailors is subjected to the tutelary observation and direction of veterans, with an affective surplus directed outward toward the spectator. This is evident in the intercutting of Matyushenko's glance—weighing the situation—within a "microphysiognomic" sequence of shots in which a fearful younger sailor (gazing directly into the camera) deferentially salutes an officer and then registers resentment and sullen anger as his superior turns away. The spectator is afforded the haughty point-of-view of the tsarist officer-class, only to have that view immediately canceled by clandestine insurrectionary knowledge. In this regard, the novelist Lion Feuchtwanger invented an exemplary spectator for the film, Dr. Klenk, a portly and conservative former Bavarian Minister of Justice, who was "far too full-blooded not to be carried away by the impetuousness of the mutiny."[57]

In *Potemkin* it is initially the image of sleep, of swaying hammocks heavy with bodies, that serves to define the edenic state of "untouched nature." These moments, which fall outside the violence that drives the film forward, reappear in the *caesurae* that punctuate the flow of the film. As the key example, Eisenstein later cited the sequence showing the idyllic port at sunrise, as the body of the martyred sailor Vakulinchuk—sacrificial envoy from the ship to the city—awaits discovery by the citizens of Odessa. It is at this point that the film resurrects the classical maritime tableau, especially the port scenes of Claude Lorrain, with their strong narratives of arrival and departure, and their ambiguous luminosity emanating from the rising or falling disc of the sun.

It is significant that the mutiny on the *Potemkin* first begins, not with a panorama, but with an extreme close-up, with a dispute over a mere detail, the pince-nez of the ship's physician tapping the carcass of meat, writhing with tiny creatures: "These are not maggots....They are only the dead larvae of flies." This conflict over living or dead organisms, over uncanny meat "so rotten it could walk overboard," plays comically with the evolutionary biological metaphor—derived from Engels—at the center of Eisenstein's conception of the "organic" structure of his film. The clinical microscopy of the close-up allows the spectator to judge the cynical incompetence of the physician's inspection. And yet the maggoty meat exceeds this fact, living on metaphorically in the boiling cauldron of soup. The mutiny begins in earnest with the refusal of this rotten soup, but the soup itself, as it boils, is the anticipatory

[56] Sergei Eisenstein, *Eisenstein on Disney*, ed. Jay Leyda, trans. Alan Upchurch (London: Methuen, 1988), p. 2. This passage was written in 1941.

[57] Lion Feuchtwanger, *Success*, trans. Willa Muir and Edwin Muir (New York: Viking, 1930), pp. 479-80.

image of that mutiny. Thus the movement of the film requires that organisms which are metonymically "dead"—that is, dead according to the conventions of narrative realism—be revived as symbols. This path, which opens up a poetics of revolutionary violence, is consistent with a small vitalist loophole (or equivocation) in Engels' physiological materialism:

> Already no physiology is held to be scientific if it does not consider death as an essential element of life. ... The dialectical conception of life is nothing more than this. But for anyone who has once understood this, all talk of the immortality of the soul is done away with. Death is either the dissolution of the organic body, leaving nothing behind but the chemical constituents that formed its substance, or it leaves behind a vital principle, more or less a soul, that then survives *all* living organisms, and not only human beings.[58]

Engels' comment sanctions two different ways of speaking about military violence. First, we hear echoes of his physiological materialism both in Plivier's anti-militarist description of the bodies of sailors reduced to "grey, boiling filth," and in Trotsky's strategic description of sailors as "explosive material." Eisenstein, on the other hand, follows the more "humanist" path offered by the lingering metaphysics of the "vital principle." Within the vitalist continuum (or dialectical opposition) established by the title of the first section of *Potemkin*, "Men and Maggots," the maggots have "less" soul, and the men "more." And it is at the level of this "more," that quantity is dialectically transformed into quality. Revolutionary fraternity is simultaneously reduced to an elemental vital force and raised to a higher spiritual power, through the portrayal of the militant assertion of natural rights, the portrayal of sacrifice and collective mourning.

Citing Engels' Hegelian dictum in *Dialectics of Nature* that "the organism is certainly a higher unity," Eisenstein outlined the evolutionary synthesis enacted by *Potemkin*:

> From a tiny cellular organism of the battleship to the organism of the entire battleship; from the tiny cellular organism of the fleet to the organism of the whole fleet—thus flies through the theme of the revolutionary feeling of brotherhood.[59]

Eisenstein's dialectic required that he establish a wider view, that mutiny become general, that ships connect not only to other ships but to cities. One "danger" in the narrative progression of the film is that the city—the polyglot space of civilians, militants, women, and children—functions merely as a relay between one ship and many ships. This is the problem of the homeless floating brotherhood imagined by Jules Verne and Victor Serge. (And in fact, the historical *Potemkin* did wander about the Black Sea, running low on fuel, until the mutineers sought refuge in the Rumanian port of Constanza.) Eisenstein was aware of this danger, tracing it's avoidance to the *caesura* provided by "the episode of the dead Vakulinchuk and the harbor mists":

> And with this moment the theme, breaking the ring forged by the sides of one rebellious battleship, bursts into the embrace of a whole city which is topographically *opposed to the ship*, but is in feeling fused into a unity with it; a unity that is, however, broken away from it by the soldiers' boots descending the steps at that moment when the theme once more returns to the drama at sea.[60]

This is a film of convergence, unification, rupture, and displaced reunification, a film of heterotopic "relations between sites." In its debt to the

58 Friedrich Engels, *Dialectics of Nature*, trans. Clemens Dutt (Moscow: Progress Publishers, 1954), p. 296. Engels is beginning here by paraphrasing Hegel. This fragment was written in 1874. The first publication of the book was in Russian, in 1925.

59 Sergei Eisenstein, "The Structure of the Film" [1939], in *Film Form: Essays in Film Theory*, trans. and ed. Jay Leyda (New York: Harcourt, 1949) pp. 160, 163-64. Eisenstein is citing *Dialectics of Nature*, p. 250. Engels' complete sentence reads: "For the organism is certainly *the higher unity which within itself unites mechanics, physics, and chemistry into a whole* where the trinity can no longer be separated." (Emphasis in original.) I am of course speculating that Eisenstein could have read *Dialectics of Nature* while making *Potemkin*, which was released at the very end of 1925. Engels' physiological materialism would have already been available in his *Anti-Duhring*, which had been in print for some time.

60 "The Structure of the Film," p. 165. Emphasis in original. Eisenstein could have been responding indirectly here to Ivan Anisimov's charge of "technical fetishism," according to which the battleship served as an "exterior form emphasizing the unity of [the] broken-up mass." Anisimov argued that Eisenstein's inability to individuate the sailors was symptomatic of his "petty-bourgeois" class outlook. The evidence of the film suggests however that the crew *is* individuated, but perhaps not in a way that Anisimov was willing or able to see. "The Films of Eisenstein," *International Literature* [Moscow], 3 (1931), reprinted in Marie Seton, *Sergei M. Eisenstein: A Biography* (New York: A.A. Wyn, 1952), p. 496.

"classics" of Marxism, *Potemkin* also forged a link between two different Engeleses, the topographer of *The Condition of the Working Class in England* and the crypto-vitalist briefly visible in *Dialectics of Nature.*

Beyond this, *Potemkin* was also a great leap backward over troubling memories of Kronstadt 1921, an attempt to resurrect the heroic image of the Red Sailor, the exemplary proletarian militant from the "heart of the battle-ship." And, on reflection, nowhere is this resurrection more troubling than in the final shot of the film, when the fraternal shouts and waves of the crews give way to the onrushing juggernaut of the triumphal battleship, bearing bow and keel down upon the suddenly submerged spectator. The horizon is no longer the classical limit of mutinous flight, but rather, in a reprise of the very origins of cinema, a huge machine rushes forward into the beam of light cast by the projector. With this convergence and reversal of all the vectors of the film, this cinematic recapitulation of the ancient maritime punishment of keelhauling, one thinks again of Trotsky's reflections on his own imprisonment in 1905:

> The whole of history is an enormous machine in the service of our ideals. It works with barbarous slowness, with insensitive cruelty, but it works. We are sure of it. But when its omnivorous mechanism swallows up our life's blood for fuel, we feel like calling out with all the strength we still possess: "Faster! Do it faster!"[61]

To this we can contrast a text written by Rosa Luxemburg, who had, after all, invented the trope of "the battleship of the revolution."[62] The following was written after her own release from a German prison in 1918, two months before her assassination by rightists:

> A world must be turned upside down. But each tear that flows, when it could have been spared, is an accusation, and he commits a crime who with brutal inadvert-ency crushes a poor earthworm.[63]

BOXED IN

But the chief thing about Melville's crew is that they work.

C.L.R. James[64]

Walker Evans' marvelous definition of photography: never under any circum-stances is it done anywhere near a beach.

John Szarkowski[65]

Then came the stirring news. Mutiny in the Kaiser's fleet! Young sons of the bour-geoisie who had been sporting sailor's caps now left them at home.

Jan Valtin[66]

When the threat of mutiny was anatomized, it was resolved into a rogue's gallery of more or less brutish physiognomies. This is a long history. We can think of Isaac Cruikshank's 1797 cartoon depicting the Nore Delegates chosen to represent the mutinous sailors of the British fleet: a committee of

[61] *1905*, p. 351.

[62] Rosa Luxemburg, *The Mass Strike, the Political Party, and the Trade Unions* [1906], trans. Patrick Lavin (New York: Harper, 1971), p. 12. The context was a polemic against the Russian anarchists and the "counterrevolutionary lumpenproletariat," whom she referred to as "sharks swarm[ing] in the wake of the battleship of the revolution."

[63] Rosa Luxemburg, "Against Capital Punishment," trans. William L. McPherson, in *Rosa Luxemburg Speaks*, ed. Mary-Alice Waters, (New York: Pathfinder, 1970), p. 399. Here she was to agree—from her grave—with a moral criticism made by the Kronstadt mutineers. In a key statement, the rebels spoke bitterly of the restoration of capital punishment— "that desecration of human dignity"—in the Soviet Union. "Socialism in Quotation Marks" [1921] in *Kronstadt 1921*, p. 245. Is there any historical irony left in the fact that Russian president Boris Yeltsin, now reponsible for more than 24,000 civilian deaths in what he has termed the "armed mutiny" in the rebel republic of Chechnya, has "rehabilitated" the Kronstadt mutineers? See Serge Schmemann, "Yeltsin Extols 1921 Rebellion, Denouncing Its Repression by Lenin," *New York Times*, 11 January 1994, p. A4. See also Steve Erlanger, "Yeltsin Blames Army as He Defends War in Chechnya," *New York Times*, 17 February 1995, p. A1.

[64] C.L.R. James, *Mariners, Renegades and Castaways: The Story of Herman Melville and the World We Live In* (New York: C.L.R. James, 1953), p. 23.

[65] Interview by Jerome Liebling, excerpted in Maren Stange, "Photography and the Institution: Szarkowski at the Modern," *Massachusetts Review*, vol. 19 no. 4 (Winter 1978), p. 698.

[66] Jan Valtin [Ernst Krebs], *Out of the Night* (New York: Alliance Books, 1940), p. 10.

grog-besotted, pistol-packing ruffians, prompted by Jacobins hiding beneath the tablecloth. Or we can think of Francis Galton's appreciation of the pioneering work of the British Admirality in devising a model of individual tracking and surveillance worthy of being elevated into a eugenic program for an entire society:

> I have seen with admiration, and have had an opportunity of availing myself of, the newly-established library of well-ordered portfolios at the Admiralty, each containing a brief summary of references to the life of a particular seaman. There are already 80,000 pages, and owing to the excellence of the office it is a matter of perfect ease to follow out any one of these references, and to learn every detail of the service of any seaman. A brief register of measurements and events in the histories of a large number of persons, previous to their entering any institution and during their residence in it, need not therefore be a difficult matter to those who may take it in hand seriously and methodically.[67]

The exhaustive scrutiny of the lower decks promised an even more exhaustive bell curve. Galton's enthusiasm for eugenic typing was later reciprocated in British naval circles. *Jane's Fighting Ships* offered small capsule summaries of the human capabilities of foreign fleets, arguing, for example, that Russian sailors "were less intelligent than in many navies."[68]

The left was not immune to physiognomic characterization, although its version tended to reject explanations of human ability based on innate qualities, favoring instead more environmental and social explanations for backwardness. Trotsky spoke disparagingly of the Kronstadt rebels as peasant dandies, "on a level considerably lower, in general, than the Red Army, and includ[ing] a great percentage of completely demoralized elements, wearing showy bell-bottom pants and sporty haircuts."[69]

Sailors were thought to be physiognomically distinct from citizens in their primitive, rootless, naive, profligate, and pugnacious ways. For conservative regimes, mutiny was an intrusion into the public sphere by those unqualified to speak, much as slave revolts had violated the fixed subject-object relations of chattel servitude, or suffragism had violated those of domestic servitude. Sailors continued to be regarded as overgrown children well into the twentieth century. For example, merchant sailors were not granted the basic rights of free labor in the United States until the passage in 1915 of the La Follette Seamen's Act, which banned imprisonment for desertion, protecting both American and foreign crews in U.S. ports.[70]

However, by the end of the nineteenth century, the distinctive physiognomic characteristics of seafaring life were thought to be disappearing, as evidenced in the opening paragraphs of Melville's *Billy Budd*, which constitute an elegy for the heroic republicanism and physical prowess of the age of sail. As it had killed the panorama and replaced it with the detail, so also steam killed Melville's Handsome Sailor and replaced him with a caricatured proletarian brute, the Hairy Ape.[71]

The industrialization of the sea provoked in D.H. Lawrence an intense and complex nostalgia for flogging. This was really a complaint against the universalizing American "idealism" behind the rootless egalitarian ethos of

[67] Francis Galton, *Inquiries into Human Faculty* (London: Macmillan, 1883), p. 43. See also Allan Sekula, "The Body and the Archive."

[68] *Fighting Ships*, (1905-06), p. 228.

[69] "Hue and Cry over Kronstadt," p. 104

[70] See Paul S. Taylor, *The Sailor's Union of the Pacific* (New York: Ronald Press, 1923). See also *Workers on the Waterfront*, pp. 44-45.

[71] Eugene O'Neill, *The Hairy Ape* (New York: Boni and Liveright, 1922). O'Neill's stage directions for the opening scene in the firemen's forecastle are as blunt as his title: "The men themselves should resemble those pictures in which the appearance of Neanderthal Man is guessed at." (p. 2).

the sea expressed by Melville and his contemporary Richard Henry Dana. Flogging was a way of renewing "the circuit of vitalism which flows between master and man and forms a very precious nourishment to each." Two years before Eisenstein invented his Bolshevized vitalism of revolt, Lawrence prescribed a romanticized Tory vitalism of reaction, part sex and part chiropractic:

> The poles of will are the great ganglia of the voluntary nerve system, located beside the spinal column, in the back. From the poles of will in the backbone of the Captain, to the ganglia of will in the back of the sloucher Sam, runs a frazzled, jagged current, a staggering circuit of vital electricity.[72]

Implicit in the argument is the idea that democracy begets unhealthy bureaucratic and abstract relations between human beings. This longing for charismatic authority is less quaint today than it might seem.[73]

Once ashore, sailors were no longer distinguishable from the army of labor in general. For American politicians anxious about illegal immigration in the wake of the passage of both the liberal La Follette Act and the restrictive Immigration Act of 1924, the immigrant who pretended to be a foreign sailor was a problem. In Senate hearings in 1926, a Pacific Coast shipping executive testified to the new physiognomic difficulties:

> Q: Does your experience teach you to distinguish a genuine seaman from a landsman?

> Mr. PETERSON: Absolutely, when you talk about sailors.

> Q: Is there not something about his hands, about the way he stands and walks and the way he carries his body that would indicate to you whether a man is an experienced seaman?

> Mr. PETERSON: In the old seafaring class, yes; in the modern sailor, no.[74]

It was in the context of this confusion that Popeye the Sailorman was invented, popular culture's answer to the pomposity and condescension of Eugene O'Neill's *Hairy Ape*. With his massive forearms and scrawny biceps, his toothless but wise-cracking mouth, Popeye both embodied and overcame the industrial system's abolition of "the many-sided play of the muscles."[75]

Aggressive and always triumphant in his deformity, Popeye also mocked the compensatory efforts of physical culture, especially its promotion of vegetarianism, with his miraculous diet of canned spinach. In the Max and Dave Fleischer cartoons that animated E.C. Segar's comic strip character—replacing Popeye's rather whimsical side with a madcap pugilist energetics—the forearms became incarnations of labor power in all its mutability, transforming, for example, a charging bull into a fully stocked butcher shop with a single blow. (*I Eats My Spinach*, 1933). Popeye is a

Fig. 17
E.C. Segar, panel from *Popeye, the Sailorman—The Last Word*, 1934.

72. D.H. Lawrence, "Dana's *Two Years before the Mast*," in *Studies in Classic American Literature* [1923] (New York: Penguin, 1977), pp. 124, 126.

73. After the 1931 Invergordon mutiny in the British Navy, the Admirality proposed building "four fully-rigged sailing barques which would be employed for the training of young sailors. It was seriously believed that a reversion to the exercises of Nelson's Navy would breed better morale and a keener spirit." The idea behind this "atavism ... has since enjoyed wide acceptance, so that today picturesque sailing craft cruise around crewed by various kinds of people thought to be in need of moral regeneration." Lawrence James, *Mutiny in the British and Commonwealth Forces* (London: Buchan and Enright, 1987), p. 166.

74. Senate Committee on Immigration. *Deportation of Certain Alien Seamen*. 69th Congress. 1st sess., 1926, S. 3574, p. 53.

75. Karl Marx, *Capital: A Critique of Political Economy*, vol. 1 [1867], trans. Ben Fowkes (New York: Vintage, 1977), p. 548.

76 Segar introduced Popeye in his *Thimble Theatre* comic
 in 1929. The first Fleischer *Popeye* cartoon appeared
 in 1933. On the "restrictive universe" of the machine
 world created by the Fleischers, see Norman M. Klein,
 *Seven Minutes: The Life and Death of the American
 Animated Cartoon* (London: Verso, 1993), pp. 75-80.

77 Lincoln Kirstein, "Walker Evans: Photographs of
 America," in Walker Evans, *American Photographs*
 (New York: Museum of Modern Art, 1938), pp. 192,
 186, 190. On the sequencing of *American Photo-
 graphs*, see Alan Trachtenberg, *Reading American
 Photographs: Images as History, Mathew Brady to
 Walker Evans* (New York: Hill and Wang, 1989),
 pp. 231-285.

Fig. 18
Walker Evans, *South Street, New York, 1932*. Plate 48
in *American Photographs*, Part 1, 1938.

Fig. 19
Walker Evans, *South Street, New York, 1932*. Plate 49 in
American Photographs, Part 1, 1938.

jack-of-all-trades: sailor, pugilist, lumberjack, rodeo rider, a walking cata-
logue of itinerant Wobbly occupations. But despite this apparent freedom, his
protean movements, unlike those of other cartoon characters of the same
period, are limited by an oscillation between one extreme and another:
human-animal, punch-counterpunch. The signature toot of the steam whistle
from his ubiquitous pipe is the giveaway: Popeye is an anthropomorphized
reciprocating engine.[76]

 If cartoons transformed the Handsome Sailor into a hyperkinetic
brawler, modernist photography discovered him as a canceled worker, an
unemployed drifter or bum, literally "on the beach." During the German eco-
nomic crisis of the 1920s and the Depression of the 1930s, the sailor became
the figure of a more generalized unemployment. It goes almost without saying
that still photography lent itself particularly well to the picturing of idleness,
waiting, dispirited and malnourished human inertia.

 The key American example is found in Walker Evans' *American Photo-
graphs*, in two consecutive photographs placed but one from the end of the
sequence of pictures comprising the first half of the book. This sequence was
described thus by Lincoln Kirstein: "The physiognomy of the nation is laid on
your table." Although Kirstein admitted that the "separate prints" of the book
lacked "the surface, obvious continuity of the moving picture," it is with these
two pictures that even a casual viewer would begin to recognize a principle of
quasi-cinematic continuity at work, a principle that is evident elsewhere in
more subtle resonances, leading Kirstein to compare Evans' "lyricism" to that
of Eisenstein.[77] The two photos were made apparently moments apart: the first
a framing from medium distance of a roughly symmetrical series of three door-
ways, each stoop occupied by an idle male figure, the second a closeup of the
sleeping central figure, who has rolled somewhat toward or away from the cam-
era in the interval between the two exposures, depending on which was made
first. The grim joke of the first picture is this: here are three quotidian figures
of the unemployed, in idle and "undignified" postures, arrayed about the
central pair of pilasters as if they were a neoclassical sculptural group. With
the turn to the close-up, the architectural stasis of the first picture is chal-
lenged by a sudden impression of cinematic transience. This second picture
tightly frames the most abject and unaware of the three men, clothed in a white
cloth cap and cheap gabardine suit, disheveled, unshaven, trouser fly un-
buttoned. The sleeping man is a merchant sailor. The white cap—by itself
evidence only that he is either a sailor or a longshoreman—combined with the
cheap suit, and the location on South Street at the heart of the seaport of
Manhattan, all point to this fact. The photographs were made in 1932, after
Evans returned from a winter voyage to Tahiti as a hired photographer on a
sailing yacht.

 This sequence of two photographs took the measure of two overlap-
ping, but different, worlds. The first of these was a world of work, pointedly
indicated through its absence.[78] Daniel Nelson describes lower Manhattan in
this period of "Red Unionism" as a place of catastrophic maritime unemploy-
ment and militant struggle:

> The upsurge began not on the ships but among the unemployed seamen on the
> beach. In 1932, somewhere between a fourth and a third of the seagoing labor
> force was unemployed, perhaps as many as forty or fifty thousand men....
> Nearly half of the unemployed seamen were concentrated in the port of New

York.... Thousands slept in Battery Park or huddled in doorways in the Bowery.[79]

In July, riots broke out at the Seamen's Church Institute, scornfully referred to by mariners as the "Dog House." The riot was helped along by organizers for the Communist-led Marine Workers' Industrial Union, which promoted the Comintern's version of the old Wobbly idea of "one big union" of maritime workers, bitterly attacking the corrupt and conservative craft-unionism that dominated shipboard and stevedoring work.[80]

The second world, rather more hidden by the subcultural conditions of a "knowing" reading, was a space of sexuality. The New York waterfront was a zone of gay and bisexual desire, home to what the historian George Chauncey has described as a "working-class bachelor subculture" comprised of sailors, merchant mariners, itinerant casual laborers, and common laborers on the docks. Chauncey refers to an undercover investigator's report on a visit to Battery Park in 1931, "whose benches were filled with young men waiting to be picked up by sailors."[81] Lincoln Kirstein's memoirs recount his own tentative entry into this world, which as Chauncey argues was not distinctly coded as "homosexual," with Evans as his initial guide:

> Actually, I longed to have the guts to get drunk and pick up a character who resembled James Cagney in *The Public Enemy*.... Walker Evans helped me, too, teaching me to keep my mouth shut in Brooklyn bars. So, I penetrated the safer borders of jungles without much threat or risk. Denizens of such areas spot strangers on sight: I smelled different but was tolerated for my curiosity.[82]

Within a year, Kirstein was taking the visiting Sergei Eisenstein to "see gangsters" in speakeasies near the Brooklyn Bridge.[83] Through Evans, Kirstein met an older merchant sailor named Carl Carlsen, an aspiring writer whose work Kirstein rejected for publication in his quarterly *Hound & Horn*. The one image that haunted him from Carlsen's otherwise "quite unmemorable" writing is that of an engine-room stoker who "substituted his forearm" for a broken piston rod. Although Kirstein makes no mention of this, the image recalls rhythmic shots found in the final segment of *Potemkin*, in which a crewman's arm oscillates in time with the speeding pistons of the battleship. And Kirstein describes Carlsen's guided tour of the engine room of a steamer docked in Hoboken as if it were a seduction-charged encounter with the dormant Eliotic "objective correlative" of this image of a reverse prosthesis. (A more desperate and solitary energetics flickers in Kirstein's recollection of a story spoken, but not written, by Carlsen: imprisoned for desertion from the Navy some years earlier, Carlsen had "induced himself into a stupor by masturbating nonstop."[84])

Kirstein's recollections situate Carlsen within a homoeroticized machine-age aesthetic, but also within an older literary legacy of seafaring:

> In my idiosyncratic mythology, those whose fortunes followed the sea had a solemn significance. The first dress-up clothes I'd been given to wear were those my father bought me (aged four), the midget uniform of a Royal Navy rating (from Rowe of Gosport), complete with a silver bosun's rope and whistle, in which I was duly photographed. At bedtimes, he read to my brother and me Dana's *Two Years Before The Mast*.[85]

[78] A British reviewer remarked that the first of these pictures "can resume in human terms the whole sum of misery which we cover with the words 'slump,' 'unemployment,' 'depression.'" Geoffrey Gorer, "America Discovered," *The Listener*, supplement 15 (December 1938). And it was pictures like these that prompted another reviewer to say in response to the claim for "the physiognomy of the nation" made by Kirstein: "Hardly, it is nearer the mark to say that bumps, warts, blackheads and boils are here. Those are the blemishes of the physiognomy. The photographs are not typical of the common people so loved by God and Mr. Lincoln. Only a submerged fraction." S.T. Williamson, "American Photographs by Walker Evans," *New York Times Book Review*, 27 November 1938. This latter view was an extreme version of a minority opinion of the book. *American Photographs* was widely and for the most part favorably reviewed. Eleanor Roosevelt commended the book to the readers of her syndicated newspaper column.

[79] *Workers on the Waterfront*, p. 94.

[80] Ibid., p. 95. Nelson's history is sympathetic to the so-called "Third Period" activism of rank-and-file Communist militants, which he sees as precursor to the victory of industrial maritime unionism on the Pacific Coast waterfront in 1934. For an inside account of Comintern maritime policy, beginning with the disastrous 1923 Hamburg uprising and more or less going downhill from there, see *Out of the Night* by Ernst Krebs, a German merchant sailor turned Comintern waterfront operative. Eventually fleeing both the Gestapo and the Soviet G.P.U., Krebs became, in the words of Nelson, a "favorite of the Dies Committee," the House Special Committee on Un-American Activities, founded in 1938.

[81] George Chauncey, *Gay New York: Gender, Urban Culture, and the Making of the Gay Male World* (New York: Basic Books, 1994), pp. 77-78, 89-90.

[82] Lincoln Kirstein, *Mosaic: Memoirs* (New York: Farrar, Strauss, 1994), pp. 190-91.

[83] *Sergei M. Eisenstein*, p. 243.

[84] *Mosaic*, pp. 191, 196.

[85] Lincoln Kirstein, "Carlsen, Crane," [1982] in *By with to & from: A Lincoln Kirstein Reader*, ed. Nicholas Jenkins (New York: Farrar, Strauss, 1991), pp. 47-48.

[86] *Mosaic*, p. 195.

[87] "Carlsen, Crane," p. 59.

[88] Carl Carlsen could well have inspired these trends. Kirstein remarks elsewhere that George Platt Lynes "wore American work clothes as a working costume and diplomatic uniform almost earlier than anyone else." Introduction to *Portraits: The Photographs of George Platt Lynes 1927-1955* (Santa Fe, New Mexico: Twin Palms Press, 1994), unp.

[89] *Mosaic*, p. 206.

[90] Hart Crane, *The Bridge*, in *The Complete Poems and Selected Letters and Prose of Hart Crane*, ed. Brom Weber (New York: Anchor, 1966), p. 81. The description of "Cutty Sark" as modeled on a *fugue*, and the reference to "phantom clipper ships" is given in a letter from Hart Crane to Otto H. Kahn, 12 September 1927 (in ibid., p. 250).

[91] "Three dollars a week went for rent on this tiny fourth-floor room at 633 Hudson Street in lower Manhattan. The other tenants were mostly unemployed seacooks and longshoremen. Whores used the downstairs toilet." Scott Donaldson, *John Cheever: A Biography* (New York: Random House, 1988), p. 58. Cheever was to work as Evans' darkroom assistant in 1935. Donaldson claims that Evans' photo depicts Cheever's room, but since Cheever did not move to New York until 1934, this is unlikely unless the picture was greatly misdated.

[92] *American Photographs*, part 1, pls. 43-44.

For his part, Carlsen voiced literary opinions that "flabbergasted" Kirstein: Joseph Conrad was "an officer spying belowdecks."[86]

Carlsen had been close to, and idolized, the poet Hart Crane. Crane committed suicide shortly after Kirstein and Carlsen met, jumping over the side of the steamer *Orizaba* as it sailed from Veracruz to New York in late April 1932. As Kirstein put it: "His short life was drained on two incompatible levels: Chagrin Falls, a well-to-do Cleveland suburb, and Sands Street Brooklyn, a nirvana of sailor bars."[87] Kirstein's memoir is a complex fragment of a *Bildungsroman*, triangulating and measuring himself, as youthful editor, critic and lyric poet, with and against the absent Crane through the figure of Carlsen. In this it is also a belated apology to Crane for having judged the "perversity and violence" of his writing to be beyond the modernist limits of Kirstein's *Hound & Horn*. The nonspace of Carlsen's failed and "primitive" writing becomes the place of critical (and self-critical) but mournful reincarnation of Crane. Kirstein's mediumistic encounter with the Handsome Sailor is embodied in a 1932 photograph of Carlsen by George Platt Lynes reproduced in the memoir: an idealized, muscular, working-class male in t-shirt, dungarees, and white socks—hands on hips, looking off into the distance. (The clothing style is familiar now, having passed from working-class men to middle-class gay and bohemian men, and on into the generalized flow of fashion.[88])

Kirstein recalls Walker Evans' more indifferent view of Carlsen as "just another of Crane's characters, a sphinx without a secret."[89] About Crane, Evans had stronger feelings: he had illustrated Crane's poem *The Bridge* (1930). Here the network of social relations and aesthetic ambition around Kirstein becomes all the more involuted: both Evans and Lynes, who had what was for each of them their first major exhibition together at the Julien Levy Gallery in 1932, had turned to photography in the late 1920s after sojourns in Paris attempting, and failing, to write. Evans' pair of photographs, in its relentless closing in on abject dereliction, refuses (or refutes) the image of the Handsome Sailor produced by Lynes. In doing this, Evans must have called to mind, for those who knew and mourned Crane, the image of another derelict sailor, whose rantings lead to a vision of "phantom clipper ships." The third canto of *The Bridge*, "Cutty Sark," is a *fugue* that begins:

> I met a man in South Street, tall—[90]

It is impossible to know what Carl Carlsen, who kept a portrait of Crane by Evans on his wall, and who regarded South Street as a different point of departure, might have thought of Evans' oblique memorial. By 1938, he had vanished from the scene.

* * *

Evans' photograph of the sleeping sailor on South Street resonates quite specifically with other pictures in *American Photographs*. The closest spatial contiguity is found in *Hudson Street Boarding House Detail, 1931*, the image of the very place this man would sleep were he able to afford a filigreed wrought-iron three-dollar-a-week bed in a low-ceilinged cell of a room.[91] And that photograph is immediately followed by *Arkansas Flood Refugee, 1937*: a haunted, insomniac Black woman trying to sleep in another sagging bed, this one cast-iron and without ornamental pretense.[92] But *American Photographs* suggests no mutinous community of sleepers, linked to the corpses of

martyred revolutionaries, as does the sequence of pictures Evans produced in 1933 for Carleton Beals' *Crime of Cuba* (1934). Misery in the United States is more inert, compartmentalized, boxed-in.

But if, within *American Photographs*, the *referent* is portrayed as imprisoned in the immanence of its immediate circumstances, the pictures themselves enjoy a great deal of freedom. Evans engaged in a cagey modernist intertextuality, making photos that spoke to each other and to the work of other photographers. In 1931, he published an omnibus book review in *Hound & Horn*, ending with praise for August Sander's *Antlitz der Zeit* (Face of the Time):

> This is one of the futures of photography foretold by Atget. It is a photographic editing of society, a clinical process; even enough of a cultural necessity to make one wonder why other so-called advanced countries of the world have not also been examined and recorded.[93]

The photograph of the sleeping sailor was to become the acknowledgment of Evans' photographic and "sociological" debt to Sander, as it became also the acknowledgment of his "lyrical" debt to Crane. *Antlitz der Zeit* ends with two photographs of unemployed men. The first of these men is also a discharged merchant sailor (*abgebauter Seeman*). The second lacks even a specified lack of work: he is simply "unemployed" (*arbeitslos*), the noun collapsing into the adjective.[94] Thus Sander's movement is from the specificity of a trade to the abstractness of generalized unemployment. In both books, the figure of the sailor marks a pivotal break. In *American Photographs* the break announces a sudden clear relation of the still photographic sequence to the conventions of cinematic editing, throwing the viewer back to the beginning of the book for a re-reading. In *Antlitz der Zeit* the break announces the abandonment of a premodern taxonomy of labor. Until this point, work appears as a wholly positive category, guild-like in its divisions and its hierarchy. With the unemployed sailor, *Antlitz der Zeit* looks capitalism in the face for the first time. This also takes the viewer back to the beginning.

Antlitz der Zeit was a physiognomic portrait of a "nonsynchronous" Weimar Germany, a Germany in which, to use Ernst Bloch's phrase, "not all people exist[ed] in the same now." For Bloch, the concept of nonsynchronicity provided a key to the "pent-up anger" of those social classes—notably the petty bourgeoisie and the peasantry—that had been bypassed or rendered unstable by the relentless "synchronicity" of modernity. This anger was the subjective precondition of fascism, paralleling the objective condition of being "declining remnants" within the economic system. And yet Bloch was interested in discovering the utopian and revolutionary dimension to this longing for the past. Bloch found in the "rooted" peasant type distinct physiognomic evidence of nonsynchronous being:

> ...there are faces in the country which are so old, for all their youth, that even the oldest people in the city no longer resemble them.[95]

Sander's ability to portray this world stemmed from the fact that he himself lived nonsynchronously. This was evident in the odd eclecticism of his method, which was suspended between a metaphysical (and deeply conservative if not protofascist) Spenglerian "physiognomic" model of cyclically recurring cultural archetypes, and a more positivist model—influenced by artists

93 Walker Evans, "The Reappearance of Photography," *Hound & Horn*, vol. 5 (November-December 1931), p. 128.

94 August Sander, *Antlitz der Zeit: Sechzig Aufnahmen deutscher Menschen des 20. Jahrhunderts* [1929] (Munich: Schirmer/Mosel, 1976), pls. 59-60.

95 Ernst Bloch, "Nonsynchronism and the Obligation to Its Dialectics" [1932], trans. Mark Ritter, in *New German Critique*, no. 11 (Spring 1977), pp. 22, 31, 24.

Fig. 20
August Sander, *Unemployed Sailor, Hamburg 1928*.
Plate 59 in *Antlitz der Zeit*, 1929.

96 On Sander's familiarity with Oswald Spengler's
 Decline of the West (1917-22), see Ulrich Keller,
 August Sander: Citizens of the Twentieth Century,
 Portrait Photographs 1892-1952, trans. Linda Keller
 (Cambridge: MIT Press, 1986), p. 39. On his associ-
 ation with Gerd Arntz, see Richard Pommer, "August
 Sander and the Cologne Progressives," *Art in America*
 vol. 64, no. 1 (January-February 1976), pp. 38-39.

97 See Robert Kramer, "Historical Commentary," in
 August Sander: Photographs of an Epoch 1904-1959
 (Philadelphia: Philadelphia Museum of Art, 1980),
 p. 19.

98 Keller, *August Sander*, p. 23.

99 Friedrich Engels, *The Peasant War in Germany* [1850],
 trans. Moissaye Olgin, in *The German Revolutions*,
 ed. Leonard Krieger (Chicago: University of Chicago
 Press, 1967), p. 19.

100 H. Remmele, "The Proletarian Struggle for Power in
 Germany," in *The Communist International*
 (Petrograd/London), no. 2, new series (1924), p. 7.

101 *Out of the Night*, p. 7.

Fig. 21
August Sander, *The Peasant Woman Frau Enders,*
Altenkirchen region, 1912. Presented as Plate 7, "The
Revolutionary," in *Stammappe*, 1925.

who associated with Sander in Cologne, such as Gerd Arnzt—that could be traced to the pictographic methods developed by the Vienna Circle sociologist Otto Neurath, who was both a logical positivist and a socialist.[96]

The paradox of Sander's project centered on his attempt to force the fluidity and disruption of Weimar modernity into a formal structure derived from medieval systems of social description. (If we were to substitute Foucault's spatial categories for Bloch's temporal categories, we would say that Sander was trying to map an order of "relations between sites" into one of "emplacement." And are not portraits in their very origins fantasies of emplacement?) One such static model was the sixteenth-century *Ständebuch*, or book of trades.[97] But the basic model was a pre-Enlightenment physiognomics. Sander proposed that the armature, or "system," for his ambitious catalogue of "People of the Twentieth Century" could be found in a preliminary portfolio, or *Stammappe* of archetypal peasant portraits made in his home region of Westerwald. This 1925 portfolio categorized its subjects temperamentally rather than sociologically: beginning with "The Earth-bound Man" and "The Earth-bound Woman," moving to "The Wise Man" and "The Wise Woman" and then on to "The Revolutionary, or Assailant." Following Spengler, Sander seems to have believed that these temperaments would be repeated cyclically in both more "advanced" and more "decadent" social formations.[98]

If we attempt to map Sander's unemployed sailor back into these archetypal categories, the lineage runs back to Thomas Münzer and the peasant revolutionaries of the early sixteenth century, to a time "when the German plebeians and peasants were pregnant with ideas and plans which often made their descendants shudder."[99] This is the case not because of any "truth" attributable to Sander's archetypal system, but because the image of the sailor in Weimar Germany could not be dissociated form the recent memory and imminent threat of mutiny. The sense of revolutionary upheaval from the waterfront was more strongly felt than in the United States, largely because strikes had escalated into all-out civil warfare. As recently as 1923, a strike of sailors and dockers had initiated the violent but aborted Red uprising in Hamburg, which was nonetheless regarded in official Comintern statements as an exemplary instance of synchronous progress:

> The Hamburg fights furnish a superb lesson of the classical revolution, as it will eventually take its course in Germany.[100]

Sander's archetypal system allowed for the imaginary linking of synchronous and nonsynchronous identities. The problem in making this "archetypal" linkage is that its very underpinnings, however "earthbound" and communitarian in the sixteenth century, had become "earthbound" and nationalistic in the twentieth. As a "revolutionary," the sailor exceeds these latter limits. Consider Ernst Krebs' account of growing up as a battleship torpedo-man's son in working-class Bremen during the First World War:

> ... my personal heroes were neither Bismarck nor Ludendorff, but Magellan, Captain Cook, and J.F. Cooper's "Red Rover"—foreigners all, as, indeed, I was myself.[101]

More than any other of Sander's subjects in *Antlitz der Zeit*, the sailor departed—physically and temperamentally—from the originary site of *Heimat*, or home-place, that provided the material and metaphysical ground for

Sander's taxonomic system. This is evident in the sailor's stance, which departs from the solemnity and rootedness of all the rest. He is the one figure in the book given to comic self-portrayal, the very boatman of the Ship of Fools, a German Popeye.

In a short text from *One-Way Street* (1925-26), called "Stand-Up Beer Hall," Walter Benjamin said something very beautiful but also somewhat wrongheaded about the phenomenology of the sailor's life. Sailors

> know nothing of the hazy distances in which, for the bourgeois, foreign lands are enshrouded. Imbued to the marrow with the international norm of industry, they are not the dupes of palms and icebergs. The seaman is sated with close-ups, and only the most exact nuances speak to him. He can distinguish countries better by the preparation of their fish than by their building-styles or landscapes. . . .
>
> For officers their native town still holds pride of place. But for the ordinary sailor, or the stoker, the people whose transported labour-power maintains contact with the commodities in the hull of the ship, the interlaced harbours are no longer even a homeland, but a cradle. And listening to them one realizes what mendacity resides in tourism.[102]

What this statement misses is the attraction of the horizon, and the sense of being trapped between impossible extremes, as in a remark by an alienated assistant engineer on a tanker (played by Bruno Ganz) in Alain Tanner's film *In the White City* (1983): "Too small in the cabin. Too big outside."

If the sailor was "sated with close-ups," and thus an ideal worker-spectator for a modernist montage aesthetic, these close-ups did not include the homey comforts of the still life, nor was the sailor's meager collecting considered a compensation for the lack of those comforts: "In the sailors' chests the leather belt from Hong Kong is juxtaposed to a panorama of Palermo and a girl's photo from Stettin."[103] The sailor was homeless, *heimatlos*, and therein lay his revolutionary potential. Benjamin shares an insight voiced earlier by Roman Jakobson, in a 1921 essay on dada:

> In these days of petty affairs and stable values, social thought is subjugated to the laws of bell-ringing patriotism. Just as, for the child, the world does not extend beyond the nursery, so the petty bourgeois evaluates all cities in comparison to his native city. . . . Is this not the reason for the fact that sailors are revolutionary, that they lack that very "stove," that hearth, that little house of their own. . . .[104]

For Jakobson, the revolutionary internationalism of the sailor paralleled dada, "one of the few truly international societies of the bourgeois intelligentsia." Otherwise, the world of elites was increasingly nationalistic, closed-in and parochial despite technical progress: "Europe has been turned into a multiplicity of isolated points by visas, currencies, cordons of all sorts" although "space is being reduced in gigantic strides."[105] Almost from this point in time on, from Kronstadt 1921 or Hamburg 1923, these two radical internationalist paths would diverge, taking either the path of Bolshevism and then Stalinism (as in the case of the sailor Comintern agent Ernst Krebs) or the path of Marcel Duchamp. John Heartfield would straddle both paths, especially with his book-jacket design for Theodor Plivier's *Kaiser's Coolies* in 1930.

102 Walter Benjamin, *One-Way Street and Other Writings*, trans. Edmund Jephcott and Kingsley Shorter (London: New Left Books, 1979), p. 102.

103 Ibid.

104 Roman Jakobson, "Dada," trans. Stephen Rudy, in *Language in Literature*, ed. Krystyna Pomorska and Stephen Rudy (Cambridge: Harvard University Press, 1987), p. 34. The article was first published in Russian.

105 Ibid., pp. 40, 34.

Nonetheless, the proletarian world of the sea was not so completely channeled, if for no other reason than that the more powerful and ultimately triumphant forces were those of reaction. Another narrative from the same period offers an even more claustrophobic, stateless, and anarchistic view of the bilge spaces of the maritime world, closer in its absolute homelessness to the youthful anarchism of Victor Serge, and the anarcho-syndicaism of American Wobbly seafarers and dock workers of 1919-23. The book is B. Traven's novel *The Death Ship*, first published in German as *Das Totenschiff* in 1926, the story of a sailor rendered anonymous and stateless by the loss of his passport. The protagonist is hurled from country to country by surly border guards, only to seek refuge working on a doomed vessel, laboring in its heterotopic hell of an engine room. Or as Traven put it in a more utopian moment of filial devotion to the imagined maternal body of the ship: "Home is always a ship."[106]

[106] B. Traven, *The Death Ship: The Story of an American Sailor* (New York: Alfred A. Knopf, 1934), p. 110.

With Traven, the physiognomy of the sailor is erased, in a dark comedy of the loss of "documents." Traven himself, in his Mexican exile, enacted a fierce proletarian anonymity, more radical in his resistance to authorship and citizenship (but not to categories of gender) than most of those who have followed the lead of Duchamp.[107] *The Death Ship* followed both the sailor's path and the path of dada, which led to surrealism:

[107] The most convincing argument is that Traven was Ret Marut, a German anarchist newspaper editor who had gone underground after the suppression of the Munich Soviet in 1919. Marut fled to Mexico in 1922, eventually "creating a long and ingenious array of impediments and false leads for biographers." Heidi Zogbaum, *B. Traven: A Vision of Mexico* (Wilmington, Delaware: Scholarly Resources, 1992), p. XVII.

[108] *The Death Ship*, p. 371.

> He jumped. He did it. There was no riverbank. There was no port. There was no ship. No shore. Only the sea. Only the waves rolling from horizon to horizon, kissing the heavens, glittering like the mirrors of sunken suns.[108]

The drowned and canceled sailor was resurrected in the landlocked figures of the Mayan peasant revolutionaries of the Lacandón rain forest of Chiapas in southern Mexico, the subjects of Traven's novel *The Rebellion of the Hanged*, first published in Spanish in 1952.

But is the phenomenology of the sailor so thoroughly reducible to Jakobson's model of a nomadic, proletarian subspecies of dada, to Benjamin's proletarian epistemology of the close-up? Are there, even today, forms of human agency in maritime environments that seek to build a logical sequence of details, a *synoptic* interpretation of observed events? Is it possible to construct such knowledge from below, or is this only the purview of elites? Can these questions even be approached in the present tense, in the face of an automated, accelerated, computer-driven, and increasingly monolithic maritime world?

* * *

My story, this "dismal science" of the *image* of the ship and the sea and the sailor, has taken us only to the end of the 1930s, when the sea was still within the realm of physiognomic contact, of overlapping cosmopolitanisms, both bourgeois and proletarian.[109] This period saw the triumph of fascism and Stalinism, and the dawn of the Depression-born military-Keynesian "American Century," anticipated symbolically by the glamorization of capitalist industry in *Fortune* magazine. With the end of this decade, "mutiny" disappeared from the popular imagination, only to be replaced by the heroic image of the "convoy."

[109] And here I must confess the source of my title, Thomas Carlyle's satirical term for political economy, coined when his writing had turned increasingly bitter and reactionary, after having been a great source of inspiration to the young Friedrich Engels. Thomas Carlyle, "The Nigger Question" [1849], in *Critical and Miscellaneous Essays*, vol. 4 (New York: Scribners, 1900), p. 354. The "dismal science" of wealth and scarcity was implicitly to be contrasted with the "gay science" of poetry. On Engels' debt to Carlyle, see Steven Marcus, *Engels, Manchester, and the Working Class* (New York: Random House, 1974), pp. 102-112.

After the war, in 1953, the Trinidadian socialist C.L.R. James wrote a book on Melville while incarcerated as an unwanted foreign radical on Ellis

Island, that great heterotopic space of immigration and expulsion in New York harbor, that great valve of regulated difference. James' book, *Mariners, Renegades and Castaways*, was a complex appeal for citizenship as well a meditation on the whale ship as the very model of capitalist domination over labor power and nature. (Written by a prisoner of McCarthyism, to be read by his warders and comrades and the general public, the book has at times the eerie ambiguity of Melville's mutinous-slaveship masquerade *Benito Cereno*.) In the course of his argument, which rejected more allegorical and psychoanalytic readings of *Moby-Dick*, James claimed that the multi-racial crew of the *Pequod* were

> candidates for the Universal Republic...bound together by the fact that they work together on a whaling ship. They are a world-federation of modern industrial workers. They owe allegiance to no nationality.[110]

James' idea, that it is the everyday culture of the workplace that provides the basis for solidarity and revolt, was to become a crucial heuristic insight for independent socialists during the long night of the 1950s.[111]

At about the same time that James was writing his book on Ellis Island, management experts in the shipping industry were beginning to dream of a fluid world of wealth without workers. In a period of declining profitability, postwar strikes, and increased labor costs, the petroleum tankship stood as the model for smooth automated operations for the entire shipping industry:

> ... tankers carry a very limited range of uniform types of cargo, which can be handled at very low terminal costs. Handling costs are low because the cargoes can be transferred by mechanical methods requiring very little labor. If similar improvements, now available, could be introduced in the technology of dry-cargo transfers, the prospects ... could become brighter.[112]

By 1956, experiments with containerized cargo movement had begun in earnest. By the 1970s, the very contours of seaports had changed. The intricate pattern of finger piers, resembling intestinal villi, had given way to the smoothed-out rectangularity of container storage yards. In their insatiable demands for flat open spaces, seaports became remote from urban centers, distanced from the neatly encapsulated possibilities of the Mediterranean seaport tableau found in Joseph Vernet's views of Naples.

In this sense, the port of Los Angeles, twenty miles from the city's downtown, was paradigmatic, both in its remoteness and in the artificiality of its construction. Unlike New York, Los Angeles never had to turn its back on the industrial waterfront. Here was a city with a mythical concept of the sea entirely coded in relation to the imaginary category of "the beach," even to the point, in the 1930s, of promulgating booster photographs showing rows of secretaries typing while sitting on the sand in bathing costumes.[113] Developed from an inauspicious tidal estuary offering no natural shelter at the beginning of America's imperialist initiative in the Pacific, this great "man-made harbor" was a port designed for "relations between sites." Here was a port that would be perpetually suspended between its hatred and fear of, and need for, the Asian continent on the other side of the Pacific.

The joke and fantasy of a Pacific Coast childhood is that one can stand on the cliffs at Point Fermin on a clear day, and see beyond Catalina Island to

[110] *Mariners, Renegades and Castaways*, pp. 19-20. See also Paul Buhle, *C.L.R. James: The Artist as Revolutionary* (London: Verso, 1988.) Buhle argues that this is "the least representative of his major works" (p. 106).

[111] See Stan Weir, "The Informal Work Group," in Alice Lynd and Staughton Lynd, eds. *Rank and File: Personal Histories of Working-Class Organizers* (New York: Monthly Review, 1988), pp. 169-193. See also the novel by Harvey Swados, *On the Line* (New York: Little, Brown, 1957).

[112] Wytze Gorter and George H. Hildebrand, *The Pacific Coast Maritime Industry, 1930-1948. Volume II: An Analysis of Performance* (Berkeley: University of California Press, 1954), p. 314.

[113] "Los Angeles remained inland by ambience. The City of Angels was too far away to hear the call of steamers entering the harbor or to smell the salt on the air." Kevin Starr, *Material Dreams: Southern California through the 1920s* (New York: Oxford University Press, 1990), p. 90.

114 Edward S. Miller, *War Plan Orange: The U.S. Strategy to Defeat Japan 1897-1945* (Annapolis, Maryland: Naval Institute Press, 1991), p. 21.

115 Edwin Stanley Paniagua, in conversation, 15 April 1992.

Japan. The dark side of this fantasy is revealed in the fact that War Plan Orange, the U.S. Navy's patient and successful plan for making war with the island nation on the other side of the Pacific, was initiated in the wake of anti-Japanese-immigrant riots in San Francisco, during the mass-psychosis that followed the 1907 earthquake.[114]

Today, containers are the ubiquitous material link with Asia. Even for those who shun the freeways that lead through South-Central Los Angeles to the harbor, they are hard to avoid on the highway. They bear the logos of companies that are nominally American, Danish, German, Israeli, Japanese, South Korean, Taiwanese. These are now joined by boxes labeled COSCO for China Ocean Shipping, carrying the manufactured goods flowing from the low-wage factories of southern China a little more blatantly, perhaps, than the others. The truck drivers who shuttle the containers from the docks to the inland rail-transfer yards are mostly immigrants from Mexico and El Salvador, driving battered Kenworth tractors that have seen a few previous owners, desperately shuttling back and forth in the hopes of clearing, after expenes, seventy dollars in a twelve-hour day. On Sundays, the tractors can be found wedged into crowded street-side parking in the immigrant apartment districts of central Los Angeles. In a curious reversal of the middle-class American dream, these *troqueros* would prefer to be recognized as workers, rather than independent entrepreneurs, since the latter legal status makes them vulnerable to insurance fraud, excessive taxation, and the trucking companies' indifference to health and safety: "They call you owner-operator, but you work like a slave."[115] Their recent slogan, a funny reference to the distinct tax forms issued to employees and "independent contractors": "W-2, *Si*! 1099, *No!*"

Beyond that, the waterfront truckers have demonstrated in support of fired longshore workers, and against NAFTA. More recently, they have joined demonstrations by Latino high-school students against an anti-immigrant initiative on the California ballot. Their children bring home video cameras, and pay close attention to the behavior of the police. On occasion, when they want to win a dispute with one of the trucking companies, the drivers manage to "lose" large numbers of containers full of valuable goods for a few days.

Other continents were not always so close, their products not so reducible to the illusory uniformity imposed by packaging, a uniformity that hides the chaotic restlessness and indifference of the profit motive. This new proximity and smoothness had to be won:

> In the summer of 1965, Saigon was the only major port in South Vietnam. Saigon is a river port. It lies 60 miles up the treacherous, winding Saigon River. The slow trip up the narrow river from Vung Tau is a nightmare for the ship's crew, and for the pilot, since the jungle on either side of the river is Viet Cong territory and ships make inviting targets for enemy marksmen....

> From the port area, cargo had to be moved through narrow, crowded streets teeming with civilian traffic.... A mishap on a bridge could tie up traffic completely and block the port for hours. To eliminate the bottleneck in Saigon, new ports, depots, and air bases have been carved out of the jungle and sand dunes.

The writer, the United States general in charge of the Army Materiél Command, continues:

One of our most notable logistic tools has been the CONEX container. This is roughly a 7-foot metal cube that is almost worth its weight in gold. Each CONEX carries five tons of cargo....

The CONEX container was designed to speed movement of cargo and protect goods from loss, damage and pilferage. It has found countless additional uses in the war theatre. The metal cubes are converted into dispensaries, offices, supply rooms and command posts....[116]

Perhaps the innovation was yet to come, or perhaps the general saw fit not to sully his suburban metaphor, but the containers were also used to imprison mutinous and delinquent American troops at the Long Binh Stockade, or jail, nicknamed LBJ by its inmates.[117]

The general's enthusiastic remarks predict a protean future for the cargo container. Within the shipping industry, the container comes to be seen as *the* crucial element in the functional ensemble, submitting all the older heroic machines to its rule:

> It is obvious that the ocean transportation industry must rid itself of the *box* syndrome and begin to accept the fact that the container must be viewed as a *vehicle of transportation* and the ship itself only as an underlying carrier, or perhaps, more vividly, as merely a form of locomotion for the container.[118]

This is the manifesto of those who would forever sink the notion of the heterotopic vessel.

Given the increasing ubiquity of the shipping container during the 1960s, one cannot help but wonder why this new form passed unnoticed by the artists most likely to have been interested: artists associated with pop art, minimalism, and conceptual art. One reason, of course, is that containers did not move through either the Manhattan waterfront or the city streets. The container port was developed in Elizabeth, New Jersey.

With his silkscreened boxes, Andy Warhol moved behind the stage of advertising and immediate retail consumption, reaching the warehouse, but no further. Dan Graham, who recognized the serial geometric uniformity of suburban housing in *Homes for America* (1966), also regarded the highway largely as a space of domestic family travel, rather than commercial transport. The one artist who demonstrated a sustained interest in industrial landscapes was Robert Smithson. But Smithson was enamored of a science-fiction scenarios of entropic heat-death and sought only evidence of stasis and decay. Furthermore, his hostility to action painting and kinetic sculpture led him to dismiss anything that moved.

Smithson's *Monuments of Passaic* (1967), with its robotic camera-eye journey to the spaces of his childhood, continually returns to the figure of the box: "I was completely controlled by the Instamatic (or what the rationalists call a camera)." Then later: "I looked at the orange-yellow box of Kodak Verichrome Pan...." Ultimately, the automatic recording device and the dead landscape mirror one another:

> Time turns metaphors into *things*, and stacks them up in cold rooms, or places them in the celestial playgrounds of the suburbs.[119]

Fig. 22
Andy Warhol, *Brillo Box (Soap Pads)*, silkscreen on wood, 1964.

Fig. 23
International Organization for Standardization, illustration from "International Container Standards," [1970], in *Jane's Freight Containers*, 1971-72.

116 General Frank S. Besson, Jr., "From Factory to Foxhole—A 10,000-Mile Pipeline to War," *U.S. News and World Report*, 19 June 1967, pp. 98-99. The description of the port of Saigon echoes the sociologist (and former labor editor of *Fortune* magazine) Daniel Bell's description of the port of New York in the 1950s: "The pier facilities are still inadequate to speed the flow of cargo; the narrow fringe-like piers still have little radial space to permit trucks to maneuver and unload. Forced into the narrow grid-iron-patterned streets built to accomodate the horse and wagon, the trucks force all traffic to back up behind them. And astride the ports stand the mobs; at this vantage point between trucker and steamship company, like medieval rober barons, they erected their sluice gates and exacted their tolls." Daniel Bell, "The Racket-Ridden Longshoremen: The Web of Economics and Politics," in *The End of Ideology: On the Exhaustion of Political Ideas in the Fifties* (Glencoe, Illinois: The Free Press, 1960), pp. 189-190. Furthermore, an early high-speed digital-computer study of the feasibility of containerization was commissioned by the Office of Naval Research, and widely distributed throughout U.S. military circles and the international shipping industry. See Joseph D. Carrabino, *An Engineering Analysis of Cargo Handling-VI: Containerization* (Los Angeles: University of California, Los Angeles, Department of Engineering, 1957). While Bell was concerned with inefficiencies caused by organized crime in New York, the larger fear in this period was of sabotage by the allegedly communist-led West Coast longshore union. See House Committee on Un-American Activities, *Communist Activities among Seamen and on Waterfront Facilities*, Part 1. 86th Congress. 2nd sess., 1960. In the end, neither containerization nor the flow of supplies to the war in Vietnam was resisted by the union leadership.

117 Conversation with William Short, 29 June 1994. Short was an infantry platoon sergeant charged with leading a conspiracy to mutiny in Vietnam in 1969, subsequently sentenced to LBJ for refusing to fight. See the book of photographs and interviews by William Short and Willa Seidenberg, *A Matter of Consience: GI Resistance during the Vietnam War* (Andover, Massachusetts: Addison Gallery of American Art, 1991).

118 R.P. Holubowicz, "Preface," to Patrick Finley, ed., *Jane's Freight Containers* (London: Jane's Yearbooks, 1971-72), p. 60. Emphasis in original.

119 Robert Smithson, "A Tour of the Monuments of Passaic, New Jersey," in *The Writings of Robert Smithson: Essays with Illustrations*, ed. Nancy Holt (New York: New York University Press, 1979), pp. 53, 55, 56. Originally published as "The Monuments of Passaic," *Artforum* (December 1967).

120 Ibid., p. 54.

121 Ibid., p. 53.

122 Ibid., p. 53, 56.

This is a variety of deadpan anti-vitalism. Movement—the image of life—is the source of metaphor, and thus either subject to hilarious disavowal, or simply unknowable. Smithson remarks on his discovery of a "fountain" consisting of pipes discharging effluent into the Passaic River:

> It was as though the pipe was secretly sodomizing some hidden technological orifice, and causing a monstrous sexual organ (the fountain) to have an orgasm. A psychoanalyst might say the landscape displayed "homosexual tendencies," but I will not draw such a crass anthropomorphic conclusion. I will merely say, "It was there."[120]

And earlier in his walk along the river:

> From the banks of the Passaic I watched the bridge rotate on a central axis in order to allow an inert rectangular shape to pass with its unknown cargo.[121]

In Smithson's entropic parable, then, the box becomes the very image of death: the "last monument," a children's sandbox, "somehow doubled as an open grave." What would Smithson have seen if he had chosen not to return to the spaces of his childhood, but to Port Elizabeth instead? What if it had not been Saturday, when "many machines were not working"?[122]

Cosmic entropy fails to explain the moving box, carrying "unknown cargo." Nor does it explain the vampiric vitality of capitalism, although it certainly offers a tempting "explanation" of economic stagnation, which may give Smithson something of the aura of a prophet since he was writing during the Vietnam War economic boom, before the recession of the early 1970s.

I propose a more provisional funeral. If anything, the appropriate metaphor is found in Marx's notion of the "dead labor" embedded in commodities. If there is a single object that can be said to embody the disavowal implicit in the transnational bourgeoisie's fantasy of a world of wealth without workers, a world of uninhibited flows, it is this: the container, the very coffin of remote labor-power. And like the table in Marx's explanation of commodity fetishism, the coffin has learned to dance.

MESSAGE IN A BOTTLE

For Jules Verne, there is no place that cannot be illuminated. Moonlight cuts through the waves and gives the ocean floor the pale luminosity of a romantic ruin. When moonlight fails, electricity cuts in. But the sunken galleons on the floor of Vigo Bay, the secret source of Captain Nemo's mysterious insurrectionary wealth, are never described within Verne's text, although they are pictured in two of the illustrations to the first French edition of *Twenty Thousand Leagues under the Sea*. Within the written narrative, which is elsewhere replete with such scenes, there is no underwater tableau, no landscape, no town on the shore.

Nemo's sunken treasury remains both invisible and frozen in its connection to historic plunder, to the process of what Marx called "primitive accumulation." For Verne, this lost fraction of the wealth that came to fuel the emergence of modern Europe is confiscated by a magical fable of inheritance: "It was for him and him alone America had given up her precious metals. He was heir direct, without anyone to share, in those treasures torn from the Incas and from the conquered of Ferdinand Cortez."[1]

Nemo's wealth, despite his patronage of revolutionary movements, remains liable to the charge of barrenness. His project is blocked on the one side by aristocratic nostalgia and on the other by an abstract and futuristic motto of perpetual flux within flux: *mobilis in mobili*. The Galician writer Ferrín has grasped the irony of Nemo's scavenging in the waters off Vigo. Wealth always leaves Vigo, whether in the form of fish, granite, or sheer emigrant labor power. Nemo, no exception to this rule, is for Ferrín quite simply a "nihilist," another external, destructive demiurge.[2]

For all his genius as a naval engineer, Nemo is also a philosophical idealist. Matter is always subordinated to will and to thought. Nemo embodies the secret idealism of all science fiction. He can flaunt the laws of economics because his relation to wealth is consistently magical. Verne's narrator observes that Nemo's voluminous library aboard the *Nautilus* contained "not one single work on political economy; that subject appeared to be strictly proscribed."[3] Nemo's answer to the misery of the land lies in the imaginary preindustrial plentitude of the sea.

If Nemo has no respect for terrestrial economies, the booksellers and readers of Vigo have either too little or too much respect for Nemo. In the outdoor stalls that are set up from time to time on the Praza de Compostela one can buy inexpensive paperback editions in Spanish, but not in Galician, of most of Verne's novels. Among them, *Twenty Thousand Leagues under the Sea* is nowhere to be found. I am tempted to think that here, under the canvas tarp and the swinging electric light two blocks from the waterfront, amongst the used volumes devoted to Velázquez and the several translations of the American inspirational writer Dale Carnegie, the indifference of Verne and his hero Nemo is reciprocated. And this reciprocated indifference is a function of an economic attitude: the distrust borne toward submarines by those who work the surface of the sea.

[1] Jules Verne, *Twenty Thousand Leagues under the Sea*, trans. H. Frith (London: Everyman's Library, 1908, reprint 1992), pp. 189-90.

[2] Xosé Luis Méndez Ferrín, "Dialogue between Lampetusa and Sponsor: on the face and reverse side of the town of Vigo," trans. Ian Emmett, in Julio Gil, *Vigo: Fronteira do alen* (Vigo, Ir Indo Ediciónes, n.d.), p. 17.

[3] *Twenty Thousand Leagues*, p. 52.

64

65

66

67

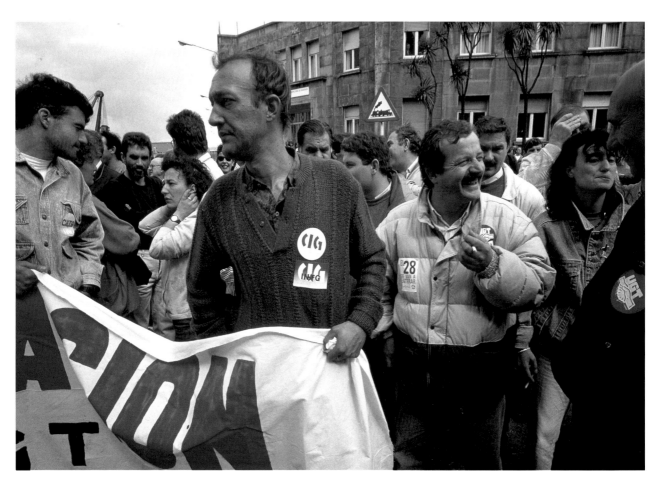

68

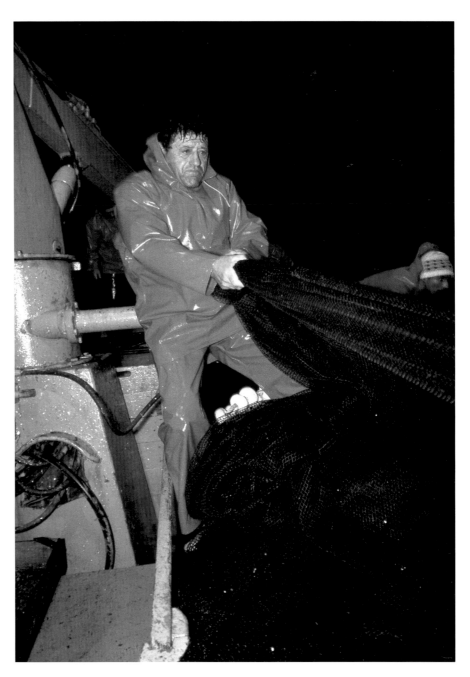

69

Vigo, Galicia, Spain. May 1992.

TRUE CROSS

Seeking to build a fortified port and town at Veracruz, Hernán Cortés complained, "there is no timber or stone, nor any other building material." The Captain discovered "nothing save hills of shifting sand."[1] And so San Juan de Ulúa, the first and last Spanish fortress in Mexico, was built of *piedra muca*, white coral hacked out of the reef. The former living home of fish became a chamber for the inventory of primitive accumulation, temporary warehouse for the flow of Aztec gold to Spain. Cortés closed his first letter to Charles V with a detailed list of golden artifacts: both cargo manifest and promissory note. The promise: carnage and plunder, followed by the bureaucratism of an empire mired in the documentation of its wealth. But in the beginning, as the Nahua scribes put it, "They picked up the gold and fingered it like monkeys; they seemed to be transported by joy, as if their hearts were illumined and made new."[2]

Coral is porous, and salt from the sea leaches through the dead walls. Gold neither oxidizes nor reacts with salts easily: it is one metal that is impervious to the sea. If ships were made of gold, rather than steel, they would not need to be continually re-encrusted with paint. If ships had been made of gold, rather than wood, Cortés could have stayed home.

Later, torture and execution chambers were added to the fortress. The place was governed by an eschatology of prolonged death: three rooms, *gloria*, *infierno*, *purgatorio*, designed to suffocate packed prisoners over intervals calibrated to be shorter or longer according to the gravity of the offense against the crown. (No one knows how many thousands died here.) Today, Mexican schoolchildren, gasping and then whispering, are trooped by their teachers through these dank and salty colonial dungeons. Other children, not in school, cast nets for small fish swimming in the moat.

The coral walls of the fort are crumbling into the sea. The foundation weakens with the dredging of the harbor bottom at the adjacent dock, originally built for the handling of cement, now the largest container terminal in Mexico. Two new cranes have been added to two already in place, in anticipation of an increased flow of goods resulting from the North American Free Trade Agreement. Throughout the fortress, one hears the intermittent crash of descending metal boxes. As a recent history of Veracruz argues, the fortress is "immersed in the modern cargo port, and its architecture has lost its monumentality."[3] Nonetheless, the conservators of San Juan de Ulúa are attempting to grow new synthetic coral by running high-voltage current into the seawater, hoping to precipitate out carbonate of lime: the science-fiction experiment of a team of Frankenstein periodontists. The gum disease of the future eats away at the teeth of the past.

[1] Hernán Cortés, *Letters from Mexico*, trans. and ed. Anthony Pagden (New Haven: Yale University Press, 1986), pp. 325–26.

[2] Miguel León-Portilla, ed., *The Broken Spears: The Aztec Account of the Conquest of Mexico*, trans. from Nahuatl to Spanish by Angel Maria Garibay K., English trans. Lysander Kemp (Boston: Beacon Press, 1992), p. 51.

[3] Hipólito Rodríguez and Jorge Alberto Manrique, *Veracruz: la ciudad hecha de mar, 1519-1821* (Veracruz: Instituto Veracruzano de Cultura, 1991), p. 23.

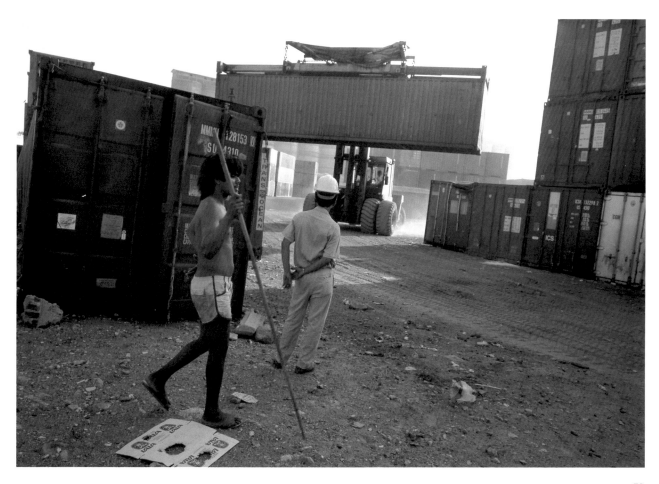

70

71–72

73–74

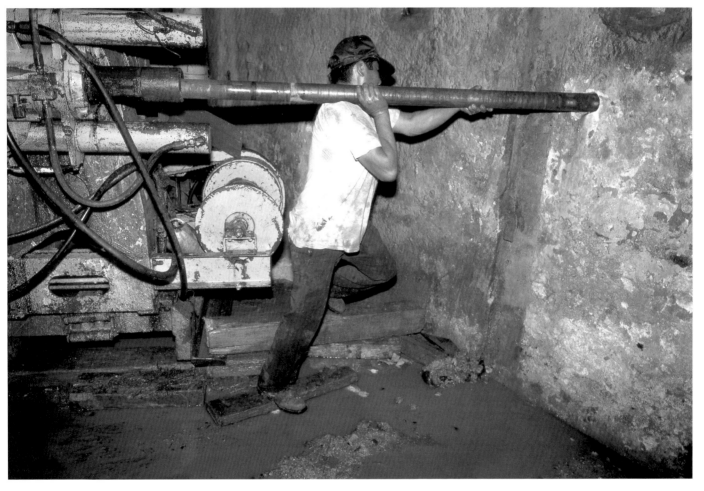

75–76

77–78

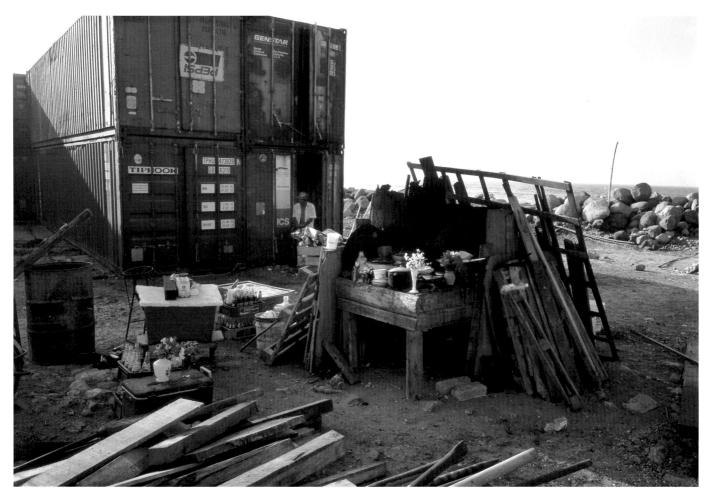

79–80

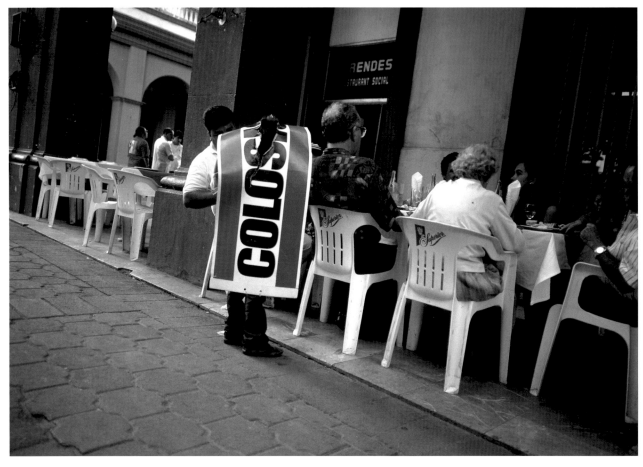

81

82

Veracruz. March 1994.

Chiapas loses blood through many veins: through oil and gas ducts, electric lines, train cars, bank accounts, trucks and vans, boats and planes, through clandestine paths, gaps, and forest trails.... a result of a thousand-some teeth sunk into the throat of southeastern Mexico.

Marcos and the Zapatistas, *Mexico: A Storm and a Prophecy*, trans. and ed. Barbara Pillsbury, Open Magazine Pamphlet Series no. 31 (Westfield, New Jersey: Open Magazine, 1994), pp. 2-3.

For the Zapatistas, the useful metaphors are more vampiric than electric. Electricity would be nice to have, but hydropower leaves Chiapas, like everything else of value. In its absence, blood becomes the universal equivalent, the substance by which an insurgent peasant ethic measures all outgoing commodities.

Chiapas also "bleeds coffee."[4] The cans of "Mayan Blend" that appeared, after the Chiapas uprising, on the shelves of a California chain of discount gourmet markets might well be a cynical recognition of that fact. Mexican coffee regularly arrives in Los Angeles on Japanese NYK Line freighters running coastwise from Salina Cruz, the principal port serving the interior of Chiapas. Salina Cruz is one of several Mexican west-coast ports modernized with the help of Japanese development funds, in an effort to increase and simplify the flow of oil, iron ore, grains, and manufactured goods to Asian markets.

Borrowing the mock-touristic rhetorical style of the Zapatistas, suppose we stop at Salina Cruz, a place named to evoke salt and crucifixion, at the watery edge of the country. President Carlos Salinas de Gortari, the cardiologist responsible since 1988 for improving Mexico's circulatory health, has demonstrated a maritime enthusiasm uncharacteristic of Mexico's elites. His strategy combines port development with privatization of port facilities. The project pivots on the effort to dislodge Mexico's long-established port unions. The neoliberalism of Salinas and the PRI, Mexico's governing party, is very similar to that of Bill Clinton's Democrats in the United States. In the interests of "free trade," the governing party abandons a historic political base in the organized working class. Salinas can play the reformer, crusading against corruption and inefficiency, while acting to reduce the chances for democratic trade unions independent of the state.

The hammer fell first in Veracruz, on the Gulf coast, at the end of May 1991. Aboard the presidential helicopter named (with no irony whatsoever) the *Emiliano Zapata I*, Salinas confided to a reporter for a New York shipping-industry newspaper that he planned a "profound change at the port of Veracruz. I hope it will be through dialogue."[5] Three days later, federal police descended on the port, subjecting it to a *requisa*, or government confiscation. The Mexico City newspaper *La Jornada* noted dryly that Salinas had forewarned his foreign constituents. Roughly 1,600 dockers lost their jobs, to be replaced by inexperienced workers earning in a day what they had earned in an hour. A fired docker bitterly described to me the televised lottery used to hire replacements, conducted under the surveillance of army helicopters: "One glass bowl, three glasses, two beautiful ladies, in front of *Televisa*." Another proposed that the displaced port workers write the indigenous rebels of Chiapas, asking them to "undertake fiscal audits" of the port.[6]

[4] *Mexico: A Storm and a Prophecy*, p. 3.

[5] John Maggs, "Mexico Aims to Break Unions' Hold on Port," *Journal of Commerce*, 28 May 1991, p. 1A.

[6] A. Riz A. [pseud.], "Panorama Portuario," *Sur* [Veracruz], 26 February 1994, p. 5.

For we are not safe, either, from the inner struggles tearing other peoples.

Anita Brenner, *The Wind that Swept Mexico: The History of the Mexican Revolution 1910–1942* [1943] (Austin: University of Texas Press, 1971), p. 6.

The March 1994 assassination of Luis Donaldo Colosio, the candidate handpicked by Carlos Salinas to be the next president of Mexico, was explained into oblivion as the solitary act of a young worker whose ambitions overstretched his limited capacity. The alleged assassin, Mario Aburto Martinez, was described as if he were a belated follower of the anarchist Flores Magon brothers of 1910, fomenting revolution from exile in the United States. Or perhaps like the hapless Peruvian militant in Mario Vargas Llosa's novel *The Real Life of Alejandro Mayta*: a figure of poverty, pseudo-rationality, naiveté and inchoate longing. Reporters from the *Los Angeles Times* interviewed one of Aburto's former classmates from a welding course in Tijuana: "He read so much his head swelled with thoughts." They elaborate helpfully: "Chafing at the grind of Tijuana's assembly plants, he boasted about mysterious meetings with wise elders."[7]

[7] Patrick J. McDonnell and Sebastian Rotella, "Aburto: Man of Humble Origins, Grand Dreams," *Los Angeles Times*, 8 April 1994, p. A1.

Described thus, Aburto is made to serve as a useful antidote, not only to theories of a larger government conspiracy, but also to the disguised and dangerously clever figure of the southern guerrilla *subcommandante* Marcos. This is the ritual unmasking of the southern peasant rebels through the person of a defective northern surrogate. Behind the image of indigenous solidarity, behind the cleverness, the ski masks and bandanas, and the subtle wordplay that seeks to cross all the lines of language in Mexico, insurrection amounts to *only this*: the violent gesture of a lonely and inarticulate madman.

Before he sank into the abyss of interrogation, a closed trial, and prison, Aburto spent his working life shuttling between the factories of Tijuana and those of the Los Angeles harbor district. His father also has spent his life moving from job to job, first fleeing north in 1971 to work in the Terminal Island canneries that processed tuna caught by American boats off the Mexican and Peruvian coasts. (This was before the canneries closed, following the tuna and cheaper labor to the western Pacific, to American Samoa and Thailand.) I imagine Ruben Aburto Cortez standing hopefully among a crowd of other Mexicans at six in the morning outside the main entrance to the Starkist plant on Barracuda Street, wearing the white paper cap that marked those who had worked before and knew how to gut a fish or maneuver the giant wheeled racks of oily flesh.

Sometimes the shuttle for survival is compressed into smaller distances. Just outside the Veracruz container terminal, vendors sell sodas and beer to truck drivers. These entrepreneurs live, as one of them put it, "without permission," inside the empty forty-foot steel boxes, taking shelter from the rain and the unpredictable wind that blows down from the gulf. But the containers rest in one place for only a short time and the vendors constantly move their belongings from one box to the next, dodging the giant tractors, bantering with the dockers. On the checkerboard of international trade, these local nomads are displaced only a few meters at a time.

The dice of drowned men's bones he saw bequeath an embassy.

Hart Crane, "At Melville's Tomb" [1926] in *The Complete Poems and Selected Letters and Prose of Hart Crane*, ed. Brom Weber (New York: Anchor Books, 1966), p. 34.

In Veracruz, on the harbor-front promenade, the Malecón, the tourist discovers an unusual public monument, approaching the spirit of the Gulf-port anarchism of the 1910s and '20s. Unlike the plaque celebrating the Porfirian port modernization of 1902, or the bronze figures of the heroic defenders of Veracruz against the U.S. Marines in 1914, or the monumental statue of the bearded giant Venustiano Carranza, this simple obelisk serves no nationalist purpose whatsoever, but speaks instead "*a los marinos del mundo que ofrendaron su vida al mar.*"

And the ship knows perfectly well that she couldn't move an inch without the crew. A ship can run without a skipper and officers. I have seen ships do it. But I have not yet heard of a ship that went along with only a skipper on board.

B. Traven, *The Death Ship: The Story of an American Sailor* [1926] (New York: Alfred A. Knopf, 1934), p. 110.

When rebellion occurs, it does not take the form of a revolt of sailors or fishermen, as it does in Sergei Eisenstein's *Potemkin* or in Paul Strand's *The Wave*. Mutiny, once thought to be the desperate act of floating nomads, of ragged seafaring vagabonds and cosmopolitans, is now taken up by those with an even stronger moral claim to the earth than can be made by any nation. Thus the Mayan peasants of the south become the mutinous imaginary auditors of Mexico. Flows are tracked, not from the nation's ports, but from their sources in the ground. B. Traven, the mysterious German anarchist who fled to Mexico in the 1920s, moving from the port of Tampico to the mahogany camps of Chiapas, came to know this, writing first about the stateless proletarian anonymity of the sea, then about the "rebellion of the hanged" woodcutters of the Lacandón jungle. The death ship is secretly anchored to the rain forest.

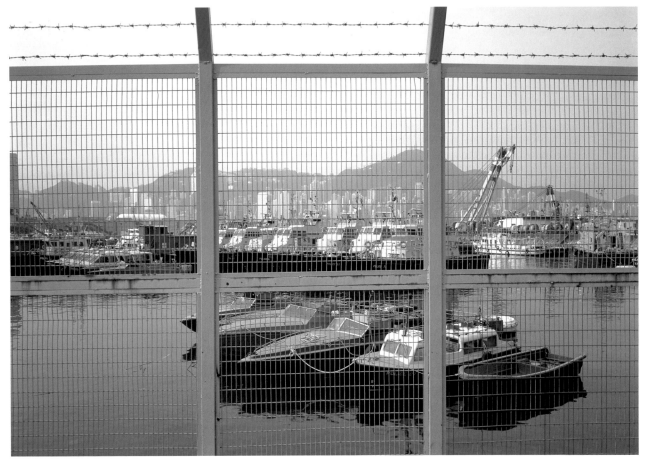

83

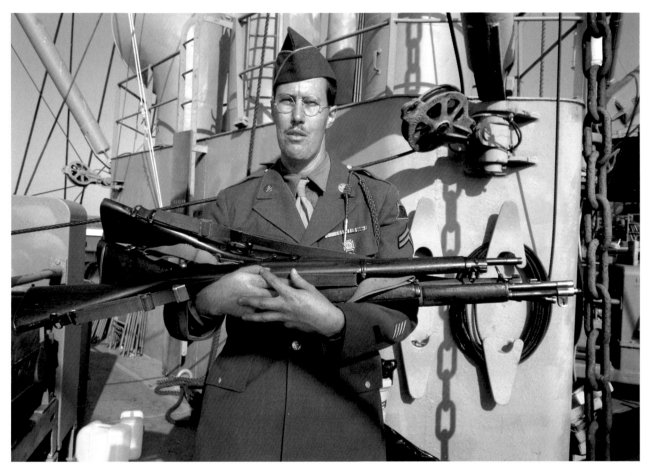

84

85–86

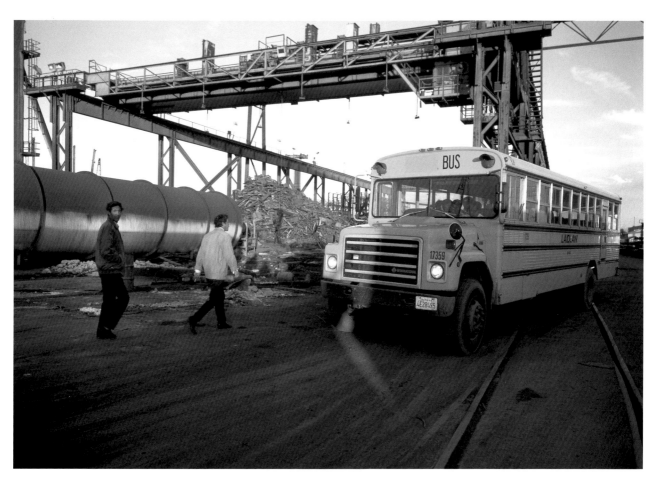

87

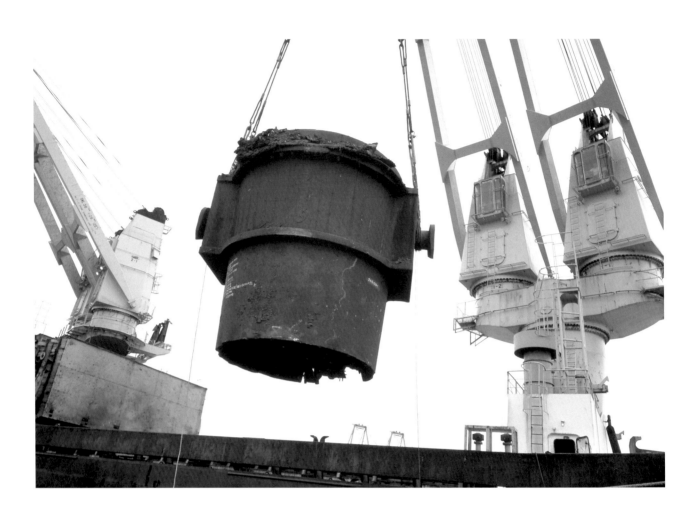

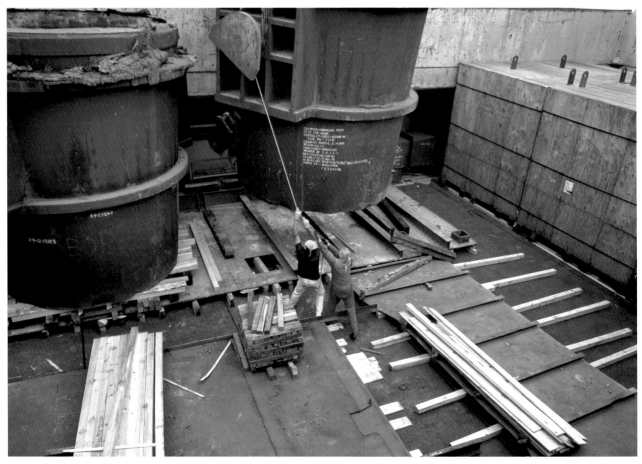

90

91

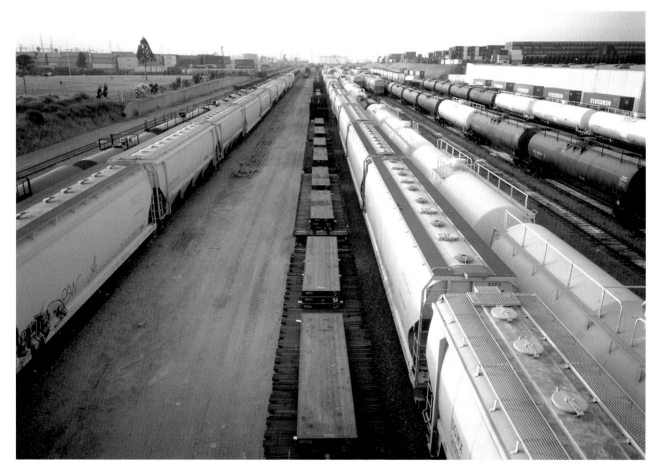

92

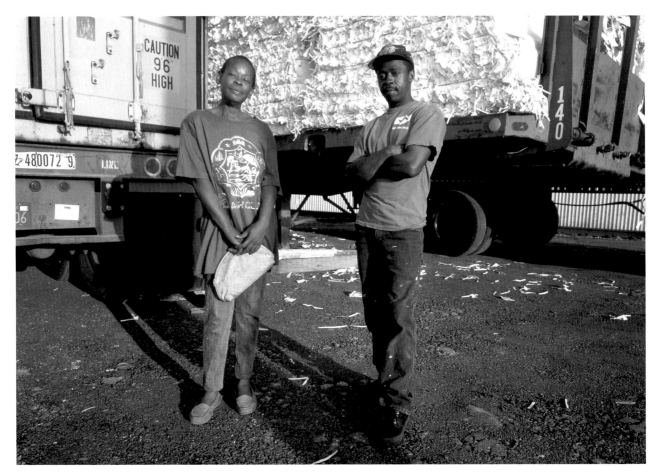

93

94

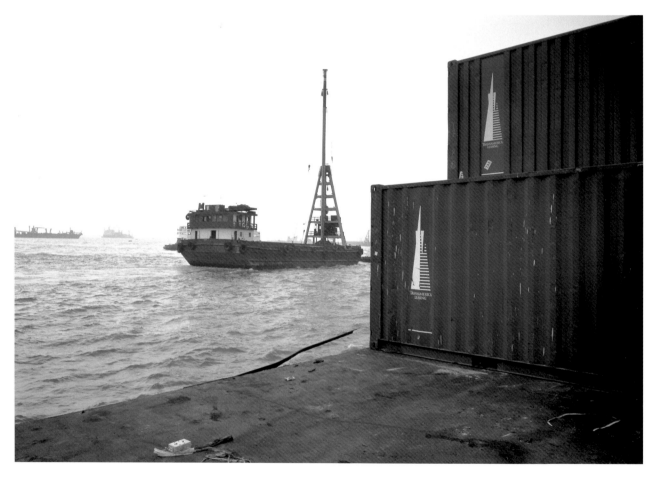

95

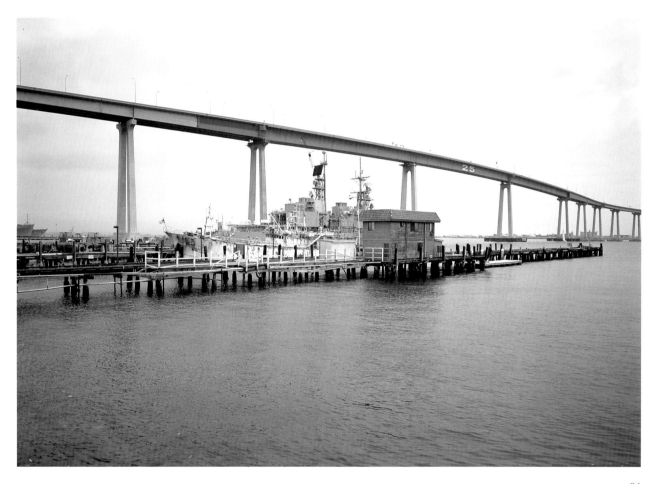

96

Impounded speedboats previously used to transport stolen luxury
cars from Hong Kong to the People's Republic of China.
Government dockyard. Yau Ma Tei, Kowloon, Hong Kong.
September 1993.

Man dressed as an American soldier of 1943 aboard the restored
cargo ship *Lane Victory*. Los Angeles harbor. San Pedro, California.
June 1993.

86 Kaiser steel mill being dismantled after sale to Shougang Steel,
People's Republic of China. Fontana, California. May and
December 1993.

Chinese dismantling crew being bussed to their motel at the end of
the day shift. Kaiser steel mill. Fontana, California. December 1993.

89 Loading caldrons from Kaiser steel mill aboard the bulkcargo ship
Atlantic Queen for shipment to China. Los Angeles harbor.
Wilmington, California. July 1994.

Longshore workers' charcoal grill and the *Atlantic Queen*. Los
Angeles harbor. Wilmington, California. July 1994.

Man sleeping under a eucalyptus tree. Embarcadero Park. San
Diego harbor. July 1994.

Brazilian steel slab headed inland through South-Central Los
Angeles to remaining rolling mill in Fontana. Los Angeles harbor.
Wilmington, California. July 1994.

Mike and Mary, an unemployed couple who survive by scavenging
and who, from time to time, seek shelter in empty containers.
South-Central Los Angeles. August 1994.

Chair designed for since-demolished Channel Heights shipyard-
workers housing in San Pedro, 1943. Architect: Richard Neutra.
Decorative arts collection, Los Angeles County Museum of Art.

Ocean Terminal. Victoria Harbor. Hong Kong. September 1993.

The guided-missile destroyer *Chandler* and an impounded ship used
in unsuccessful attempt to smuggle undocumented immigrants from
southern provinces of China to the United States. San Diego harbor.
July 1994.

LIVE CINDERS

Reasonable discontent ... had been ignited into irrational combustion as by live cinders blown across the Channel from France in flames.

Herman Melville, *Billy Budd, Foretopman* [1891], in *The Shorter Novels of Herman Melville* (New York: Liveright, 1928), p. 242.

If men in black suits come to the door, you don't know nothing.

A Croatian immigrant longshoreman, living in San Pedro, speaking to his son in the late 1950s.

Most sea stories are allegories of authority. In this sense alone politics is never far away. The ship is one of the last unequivocal bastions of absolutism, regardless of the political system behind the flag that flies from the stern, or behind the flag or corporate logo behind the flag that flies from the stern. This makes ships all the more curious and anachronistic in an age proclaimed to be one of worldwide democratization. Ships function both as prisons and as engines of flight and escape. Mutiny, however antiquated as a form of rebellion, somehow retains its threat and promise, its claim to turn the prison itself into a vehicle of flight. Even the elderly and well-to-do passengers on cruise ships are sometimes imagined to be capable of mutiny, and doubtless a television drama has been, or will be, made on this theme.

Seventy-five years ago this fantasy circulated in cheaply printed pamphlets: a worker's republic of the seven seas, a vast informal syndicalist conspiracy of toilers on ships, docks, and fishing boats, linking port to port with a fluid and itinerant contempt for flags and borders. This was a proletarian version of Captain Nemo and his submarine crew of outcast revolutionaries.

On the Pacific coast of the United States, where this idea achieved its strongest expression, this proletarian chain of solidarity was anchored to the redwood forests and lumber camps of Oregon and Washington. Steam schooners carried lumber south to Los Angeles to build a city of soft rot-resistant wood on the arid coastal plain. The Japanese-influenced mansions of the Greene brothers and the more modest Craftsman bungalows of old Pasadena and central Los Angeles were built with wood cut and transported by anarchists.

As this older generation of housing was demolished in the 1980s to make way for massive stucco-clad apartment blocks, the wall studs and ceiling joists were salvaged by Mexican wrecking crews, who resumed the interrupted southward flow of the wood, now drier, but being redwood, still free of termites. The wood followed the earlier travels of restless California anarchists who joined the revolutionary Flores Magon brothers in Tijuana in 1911 in building a short-lived workers' republic. Now Tijuana takes what Los Angeles discards: a booming city of used cardboard, sheet metal, and old tires housing hopeful emigrants and those who find work in the North American, Japanese, and South Korean factories strung along the border fence.

For a long time, ships have been the biggest machines imaginable. A more accurate way of phrasing this would be to say that ships have been the biggest machines imaginable *at a glance*. When machines get any bigger than, say, *The Great Eastern* or the *USS Enterprise* they cease to be unitary objects, and become integrated ensembles of lesser machines, which of course is what they always are from the inside. The limit-form of such machine ensembles may be the factory, or beyond even that, the city or the network of cities. Aircraft carriers, with their crews of 5,000, are often described as "floating cities." According to this logic, the other ships in a battle fleet should be described as "floating suburbs," and submarines would be "floating subways." Hidden in this metaphor is the threat now continually signalled by the floating metropolis of war to the more impoverished and bursting cities of the land.

A steel mill is a machine of sorts, but hardly recognizable as such in its immensity. But in the end a steel mill is no more or less complex than a ship. Of course it might even be said that behind every ship is a steel mill, or even several, depending upon the close attention by the shipyard purchasing agent to the constantly fluctuating world market in steel plate. But at the same time, many ships are required to feed a steel mill and transport its products, and the most competitive large steel mills are now built near the sea. If steel mills depend on ships, they also make ships seem small. It may take seven ships to carry a steel mill, sliced laboriously into its component parts, across the Pacific Ocean from California to China.

The small irony lies in the fact that it takes several weeks to safely stow one-seventh of a steel mill aboard a ship, recalling for older longshoremen a bygone way of doing things, when deck gangs and hold crews would get to know a ship, calibrating the distribution of weights, imagining with each step the ways in which cargo might break loose under heavy seas. In these exceptional cases, the threatening physics of the sea is reasserted against the false complacency promised by boxed cargo. Material objects are reawakened in their heterogeneity, their different weights and densities.

If factories can move across the planet in the same way that raw materials and finished goods and humans move, then perhaps conversely ships become mired in a more static system of physical relations and become less autonomous as machines. The ship is now more likely to be a unit in a functional ensemble encompassing the container crane, the oil pipeline, the port itself, the railroad. This functional embeddedness reduces the charm of ships, blunts the mutinous longing that draws the eye to their form. Thus the exaggerated jet-age streamlining of the cruise ship is a compensatory attempt to sustain that longing. The image of acceleration here lends itself to idleness, to aimless floating pleasure, masking the monotony of the sea, the claustrophobia of the ship, and the driven life of short vacations.

I've got a photo of myself, 19 years old, grinning, my arms spread wide, holding a head in each hand.... I cut off heads for the U.S. government. It's all about murder. This is a government of murderers. Put that in your book.

A man in his mid-thirties in a bar frequented by submarine crews from the Mare Island Naval Station, Vallejo, California. February 1994.

If ships have become too functional and too big, boating and model-building restore the ship to its ancient proportional relation to the rest of the world. Ronald Reagan described his transformation in 1945 from a "near hopeless hemophilic liberal" to a conservative anti-communist. Resting in the "calm, vacant center of the hurricane" of Hollywood labor struggles, he took a vacation at Lake Arrowhead, high in the mountains above Los Angeles. He rented a speedboat for "twenty-four hours a day ... the rental cost more than the total cost of the boat." I like to think of Reagan roaring around the lake in circles, rather like the figure of the spoiled playboy acted by Rock Hudson in Douglas Sirk's *Magnificent Obsession*. But if Hudson had to be hurled from his speeding craft to be transformed by chance and desire into a better man, for Reagan the boat itself was the metaphoric engine of his political remaking. With false modesty, he referred to his emerging evangelical conservatism: "I just want to take a drive on the water. I can't walk on it anymore." So Reagan entered the boat as a Truman Democrat and left it as a Republican, spun rightward by his careening turns through the cold mountain water.

But Reagan's appreciation of the therapeutic and transformative power of vessels does not end there. Earning $3,500 a week from Warner Brothers but without a movie part, mulling over his new politics, he turned to building model ships: "The *U.S.S. America* and a freighter... life wasn't complete until you built a model boat."[1] Both models, roughly crafted, can be seen at the Reagan Presidential Library in Simi Valley, California, overlooking the smog-bound inland suburbs of Los Angeles.

[1] Ronald Reagan with Richard G. Hubler, *Where's the Rest of Me? The Ronald Reagan Story* (New York: Duell, Sloan and Pearce, 1965), pp. 138, 139, 140.

But this time they didn't disappear. They kept floating out there, suspended, as if the horizon had finally become what it always seemed to be from shore: the sea's limit, beyond which no man could sail. They floated awhile, then they began to grow, tiny gulls becoming boats again, the white armada cruising toward us. "They're coming back," my mother said.

Jeanne Wakatsuki Houston and James D. Houston, *Farewell to Manzanar* (Boston: Houghton Mifflin, 1973), p. 5.

Imprisoned during the Second World War in the Manzanar concentration camp, Takao Shintani built from memory a replica of the tuna boat *Nancy Hanks*, named for Abraham Lincoln's mother. On this boat Shintani had sailed as a radio operator with other Japanese-American fisherman from Terminal Island. Late in the morning of December 7, 1941, as the women on shore watched, the Coast Guard confiscated the boat at machine-gun point as it entered the passage through the harbor breakwater, arresting half the crew. The FBI suspected these fishermen to be scouts for the Imperial Navy, but this was only the latest round in the periodic ethnic cleansing of the California coastal fisheries.

It is one thing to live ambitiously upon the land and imagine the panorama of the sea by building a small replica of a boat. It is quite another to remember the sea from the land by the same procedure, after the panorama has closed in, like a net.

Map from story in *The Independent* (London) of 11 September 1991 on rioting by unemployed youth from the Meadow Well Estates, North Shields, Tyneside. These housing estates were originally built in the 1930s for shipyard workers.

They are building churches so that people can pray for homes.

Joke circulating in Poland, 1990

ALLAN SEKULA: PHOTOGRAPHY BETWEEN DISCOURSE AND DOCUMENT

Benjamin H.D. Buchloh

Landscapes, heads and naked women are called artistic photography, while photographs of current events are called press photography.

Alexander Rodchenko, "The Paths of Modern Photography"

How does photography serve to legitimate and normalize existing power relationships?…How is historical and social memory preserved, transformed, restricted and obliterated by photographs?

Allan Sekula, "Photography between Labour and Capital"

The relationships between the discursive field of photography and the discursive field of artistic production are reconfigured within each artistic generation according to the needs and laws governing social specularity. Each procedure of production offers and sollicits different aesthetic and ideological investments at each particular moment: ranging from claims of empirical truth and activist critical negativity to the substitutes of representational plenitude and the functions of aesthetical and historical memory. To study the *intersection* of these opposite cultural practices, the menaces (and promises) made by the one against or on behalf of the other (e.g., the worn-out promise of photography to supercede painting), might tell us more about a particular historical status of a society's visual culture than to consider its manifestly declared avant-garde intentions in clearly delineated homogeneous fields.

This principle is especially applicable when a singular discursive field such as photography internalizes the hierarchical order of the traditional artistic genres which have positioned painting at the apex and photography at the base of the technologies of representation, a condition that—as the epigraph indicates—Rodchenko had understood eighty years ago. In the present moment, however, the hierarchy of (photographic) genres appears to operate in a slightly more peculiar configuration, placing the photographic derivations of artistic practices such as photomontage and the photographic aggrandizements of genre painting at the apex of the hierarchy (presumably as a result of their productive symbiosis with advertising) while keeping traditions that reflect the legacy of the documentary photograph at the base (unless they succeed in spectacularizing the victims of their operations).

The reception history of Allan Sekula's photographic work provides an exemplary case of the official avant-garde and museum culture's marginalization (and, with a vengeance, that of the more recent museum culture of photography) of those practices whose proximity to the "base" of the (photographic) genres is perceived either as threatening to the high-art status of the newly accredited photographic objects or as having by-passed/ignored the current codifications of "proper" avant-garde ruptures.

What is considered "base" in Sekula's production as an artist (as opposed to his activities as a critic and historian of photography) is the fact that his work programmatically redeploys precisely those subjects and semiotic and textual conventions that have been disqualified within modernism by longstanding interdictions: documentary photography, historical narrative and, most of all, a model of signification that recognizes the complex condition of the sign as functioning simultaneously as a semi-autonomous discursive structure *and* as a material construct overdetermined by historical and ideological factors. Sekula establishes this point in the introduction to his first book in 1984:

1 Allan Sekula, *Photography against the Grain: Essays and Photoworks 1973-1983*, ed. Benjamin Buchloh (Halifax, Nova Scotia: The Press of the Nova Scotia College of Art and Design, 1984), p. IX. The preface to this volume traces Sekula's intellectual and artistic development and concisely outlines his "theory of a photographic practice."

2 Underlying all of these parameters is of course the dialectic of fragmentation and totality which had been at the core of modernist thought since its emergence in the 1830s, unfolding into the fundamental oppositions of modernism: an aristocratic orientation towards the opacity and autonomy of the signifying devices, opposing the bourgeois order of absolute instrumentality (embodied in the lineage from Théophile Gautier to Stéphane Mallarmé), and a collectivist, not to say socialist, dimension embodied within the realism of Courbet and its emphasis on the viability of a link between referent, representation and class, and between artistic production and artisanal and industrial labor.

When Gautier stated in 1834 that
 ... only those things that are altogether useless can be truly beautiful; anything that is useful is ugly, for it is the expression of some need, and the needs of man are base and disgusting, as his nature is weak and poor.

he laid the groundwork for aesthetic arguments that reverberate up to the present day, notably the aforementioned prohibition on the representation of the conditions of production and labor, the acknowledgement of bodily and economic needs, and the disqualification of an aesthetic of utilitarian functions.

It is the subsequent abolition of this modernist dialectic (of which realism after all had been an original and integral element) in favor of an exclusive and dominant aesthetic of the fragment (e.g., the focus on the signifying devices, the structural autonomy of the sign) which has disqualified almost all subsequent attempts at (re)constructing a complex aesthetic of realist and referential representation.

3 Allan Sekula, op. cit., note 1, p. X.

Thirteen years ago, when I first began making photographs with any seriousness, the medium's paramount attraction was, for me, its unavoidable social referentiality, its way of describing—albeit in enigmatic, misleading, reductive and often superficial terms—a world of social institutions, gestures, manners, relationships. ... At that time photography seemed to me to afford an alternative to the overly specialized, esoteric, and self-referential discourse of late modernism, which had, to offer only one crude example, nothing much to say about the Vietnam War.[1]

This apparent "illegibility" of Sekula's work within current artistic practices (which in fact is more the result of cultural elisions) points to several parameters of exclusion. They concern first of all the question regarding the contemporary (im)possibility of an iconography of labor in a self-declared post-industrial and post-working class society, where large segments of labor and production are in fact concealed from common view since they are exported to the geo-political "margins." Accordingly, the experience of *production* and the conditions of industrial labor have been banned by a massive representational prohibition from modernist visual culture.[2]

This is especially true in the present where visual culture functions increasingly not only as a social system of narcissistic distinction and the enforcement of class differences in cultural reception at large but—if at all involved with experiences of the "real"—as an ironic palliative of the universal condition of *consumption* and commodification.

The second aspect of Sekula's work to explain the difficulties in how it is received would be his insistence on a model of "critical realism" and its inherent structural and semiotic challenges to a current definition of photographic signification that privileges, as Victor Burgin once proposed, the "politics" of the signifier over the signification of politics. By contrast, Sekula states that he

...wanted to construct works from *within* concrete life situations, situations within which there was either an overt or active clash of interests and representations. Any interest that I had in artifice and constructed dialogue was part of a search for a certain "realism," a realism not of appearances or social facts but of everyday experience in and against the grip of advanced capitalism. This realism sought to brush traditional realism against the grain. Against the photo-essayistic promise of "life" caught by the camera, I sought to work from within a world already replete with signs.[3]

It is not surprising therefore that Sekula's critique of the exclusive validity of models of structural signification and his scepticism regarding "semiotic *détournement*" have proven to be a particularly difficult reading lesson for "art world" audiences specialized in the conventions of contemporary "high-art" production. One could argue that Sekula's project of a "critical realism" opposes the ideology of the simulacrum no less than the privileging of psychoanalytic theories of subjectivity; it is a realism that challenges the exclusivity of post-structuralist semiotics no less than it criticizes the traditionalist models of realism propounded within the aesthetic discourses of the Left.

Yet even within theories of the New Left, the historical disqualification of an aesthetic of representation has lately been taken as an irrefutable fact. Most Western Neo-Marxist aesthetic thought since the sixties has been particularly eager to disassociate itself from the traditions of a realist

aesthetic, since it has been thoroughly tainted by its association with the socialist and Stalinist versions of 1930s realism. For example, Theodor W. Adorno's modernist prohibitions of the representation of history resonate here, as much as his more notorious prohibition of lyrical poetry after Auschwitz, with both the authority of a biblical ban on representation and with the authority of historical trauma when he states, "The name history may not be spoken since what would be true history, the other, has not yet begun."[4]

[4] T.W.Adorno, "Notes on Kafka," in: *Prisms*, trans. Samuel and Shierry Weber (Cambridge: MIT Press, 1990), p.257.

More recently even Fredric Jameson, one of the last theoreticians of Marxist aesthetics to seriously engage with the legacy of Georg Lukacs, has dogmatically pronounced his prohibition on representation, narrative and realism. For Jameson—arguing with the hindsight of a sceptic who has studied the failed claims of the Left to renew realism—who has followed the arguments between Adorno and Lukacs, between Adorno and Sartre, and between Brecht and Benjamin, the contemporary impossibility of realism can be historically deduced: it is no longer an aesthetic law established by the discourse of modernism, rather it is by now perceived as an ontological condition. Artistic practices such as Allan Sekula's which attempt to reconstitute aspects of the "realist" dimension of modernism are now—according to Jameson—more than ever discredited (and we do hear an echo of Lukacs's melancholic phantasies about a realism still accessible in the recent past but irretrievably lost in the present):

> That the possibility of plot may serve as something like a proof of the vitality of the social organism we may deduce, negatively from our own time, where that possibility is no longer present, where the inner and the outer, the subjective and the objective, the individual and the social have fallen apart so effectively that they stand as two incommensurable realities, two wholly different languages or codes, two separate equation systems for which no transformational mechanism has been found: on the one hand the existential truth of individual life, which at its limit is incommunicable, and at its most universal turns out to be nothing more than the case history; and, on the other, the interpretive stereotype, most generally in a sociological overview of collective institutions that deals in types of character when it is not frankly expressed in statistic or probabilities. But at the time of the classical novel, this is not yet so, and faced with such tangible demonstration of the way in which intellectual destinies interweave and are slowly, through the process of their interaction, transformed into the collective substance itself before our very eyes, we are not unwilling, to limit ourselves for a time to the "realistic" mode of thinking about life.[5]

[5] Fredric Jameson, "Metacommentary" (1971), in: *The Ideologies of Theory: Essays 1971-1986*, vol. 1 (Minneapolis: The University of Minnesota Press, 1988), p.25.

Thus it is in fact difficult to clarify which of the two prohibitions against representation (for they are certainly not originating in the same concerns) is the primary subject of Sekula's critical probing: that of the modernist repression of narrative and representation or that of the Marxist self-critique of its past failures at resuscitating the functions of representation and historical narrativity.[6]

That Sekula's project is engaged in the reconstruction of critical realism after and against the abrogation of photography by modernist aesthetics is first of all evident through his continuous involvement with those photographic practices that were already identified by Rodchenko as "unartistic": photojournalism and the traditions of (American) street photography and documentary photography. While it was possible for pop art of the sixties and seventies to integrate quotations from these photographic practices as "indexes" of common conditions of everyday life or as "traces" of the "real" (e.g., the banality of the found photographs of photojournalism in the paintings

[6] One exemplary argument between the realist position of the orthodox Left and the opposite position of the modernists is clearly evident in the discussions of photomontage. For the orthodox Left (such as Lukacs), the radical aesthetic of (photo) montage was ultimately just one more index of the Imperialist decline and a bourgeois ruse to aesthetically cement the existential experience of fragmentation as a universal condition of experience: it celebrated the annihilation of signification altogether in favor of a generally accepted condition of passive domination and anomie. Adorno—not exactly known to be a champion of dadaism or Heartfield—would later

criticize this simplistic rejection of dadaist montage aesthetics as voiced by traditionalist Leftists, arguing almost from a proto-structuralist definition of textuality:

> It is all too facile to dismiss neo-dadaism, for instance on the grounds that it is apolitical and lacks meaning and indeed purpose. It should not be forgotten that its products ruthlessly display what became of meaning.

T.W. Adorno, *Aesthetic Theory*, trans. C. Lenhardt (London: Routledge, 1984), p. 220.

[7] Allan Sekula, "Photography between Labour and Capital," in: Benjamin Buchloh and Robert Wilkie, eds., *Mining Photographs and Other Pictures: A Selection from the Negative Archives of Leslie Shedden* (Halifax, Nova Scotia: The Press of the Nova Scotia College of Art and Design, 1983), p. 200.

of Robert Rauschenberg, amateur photography in the paintings of Gerhard Richter, the censored cruelty of the press photographs of Andy Warhol's car-crash paintings), the inclusion of the photographic quotation was permitted only on the condition that it was extracted from its narrative, that it remained suspended in the play between referentiality and the subversion of formal convention, and that it ultimately—as a result of this suspension—appeared transformed into a purely aesthetic object according to the specific parameters of modernism (parameters as durable as they were hidden): those of non-intervention, those of a disinterested specularity, those of an exclusive deflection onto the signifier.

While it was possible for pop art to embrace the common sources of image production (advertising, photojournalism and amateur photography) as seeming challenges of its high art aspirations (and de facto allies of its emerging status to become integrated within the culture industry at large) in a gesture of camp appeal, in a manoeuver of cohabitation, in a posture of critical self-negation, it would remain for the most part culturally "illegible" when barely ten years later artists like Sekula started to *investigate* the popular discourses of photojournalism and street photography in an attempt to analyze their actual position and ideological functions within that industry of technologically produced representations. Sekula's critical commentaries on pop art clarify these contradictions while emphasizing simultaneously his deliberate distance from the field of contemporary artistic production in general:

> The strategy here is akin to that initiated and established by pop art in the early nineteen sixties. The aesthetically informed viewer examines the artifacts of mass or "popular" culture with a detached, ironic, and even contemptuous air. For pop art and its derivatives, the look of the sophisticated viewer is always constructed in relations to the inferior look which preceded it. What disturbs me about his mode of reception is its covert elitism, its implicit claim to the status of "superior" spectatorship. A patronizing, touristic, and mock-critical attitude toward "kitsch" serves to authenticate a high culture that is increasingly indistinguishable from mass culture in many of its aspects, especially in its dependence on marketing and publicity and its fascination with stardom.[7]

The second level in Sekula's work to indicate a "realist" approach to photography is one of structural transformation, namely, his decision to organize his photographs according to a narrative sequence. Following neither the seemingly random arrangement of found photographs in an open form of drifting anomic units nor the serial accumulation of images predetermined by a narrowly circumscribed subject, Sekula distances his work from the two organizational principles that have governed most photographic activities in contemporary artistic practices since the sixties. By contrast, Sekula has been reconsidering the profoundly discredited principles of the textual narrative and the photographic sequence. These strategies have inevitably removed Sekula's work even further from the attention paid to artistic (photographic) practices since the early sixties that fit within the historical spectrum between pop and conceptual art: from the legacies of the photomontage aesthetic (as it has been prominently exercised since Rauschenberg's reintroduction of a fully dilute version into the New York School context) to the legacies of the *Neue Sachlichkeit* photography (as it has been reincorporated into artistic production in the work of the German photographers Bernd and Hilla Becher).

While it was possible (i.e., culturally legible) to produce and serially organize an entire oeuvre around the visual archaeology of the industrial archi-

tecture of the late nineteenth and early twentieth century (as in the work of the Bechers), it was apparently inadmissible in the cultural reception of the mid-1970s (nor since then, really) to analyze and provide a narrative photo-textual account of actually existing working conditions (e.g., in a contemporary San Diego Pizza Parlor, as in Sekula's *This Ain't China: A Photonovel*, 1974). Nor, for that matter, did an even earlier work by Sekula that almost programmatically positioned itself in an explicit dialogue with the Bechers—and already posited the question of the (im)possibility of representing labor—succeed in communicating with the audiences of that period. This work, an untitled slide projection from 1972 depicting workers leaving the Convair/General Dynamics military aerospace factory in San Diego, challenges the conviction (and the discursive limitations) with which the Bechers' monumental account of the principal work sites of industrial capitalism of the twentieth century apparently had to exclude the active participants from these locations and from the possibility of representation in order to gain its aesthetic accreditation within the larger account of modernist visuality. Sekula's approach seems to insist on a condition of photographic representation that Walter Benjamin, in his essay "A Short History of Photography," had already identified in 1931. When Benjamin spoke of photography as the new, politically educated way of seeing that overcomes the cult of the interiority of the centered bourgeois subject, a vision that dissolves private intimacy in favor of the public illumination of details, he emphasized simultaneously that "to do without people is for photography the most impossible of renunciations."[8]

Thus Sekula's attempt to develop a critical realism aims also to systematically overcome this aspect of "renunciation," to overcome the ban on the representation of labor imposed by an aesthetic of modernist restrictions. At the same time, his work addresses yet another symptomatic limitation operative in the Bechers' project: that their melancholic archaeology of industry not only excludes the depiction of a human presence in those sites, but their iconography also prohibits the depiction of *contemporary* places and structures of actual industrial production in the present.

Finally, Sekula's slide series of factory workers—as a dynamic, temporally and sequentially structured projection cycle—also opposes the discursive exclusivity of the most venerable of all photographic objects: the seemingly self-contained, single frame, black-and-white still image. The slide series opposes it with a presentational format that emphasizes its necessarily ambiguous position with regard to both "classical" still photography and "contemporary" technologies of filmic or electronic imagery. In a continuous cancellation of either convention, it is neither the sensationalist account of filmic or video imagery that establishes a voyeuristic proximity to the worker as an authentic, spectacularized victim, actually visible in the process of the production of surplus value, nor is it the still photograph that monumentalizes the worker by isolation and extracts the working subject from its actual context.

The third major aspect of Sekula's work, in which his departure from the governing usages of photographic imagery in artistic practice of the sixties and seventies becomes evident, could be called a semiological difference. Rather than deploying a singular photographic model continuously—a strategy which seems to have become the precondition for artistic practice to function as enterprise—Sekula has always attempted to juxtapose the most complex and contradictory range of photographic conventions. Rather than reducing the photograph to a mere indexical record operating in manifest analogy to the ready-made, or to a purely denotative device of simplified structures and actions, as in the photographic records of conceptual artists, Sekula con-

8 See Walter Benjamin, "A Small History of Photography," in: *One Way Street and Other Writings*, trans. Edmund Jephcott and Kingsley Shorter (London: Verso, 1979), p. 251. The title of this essay is variously translated as "A Short History" (Patton) or as "A Small History" (Jephcott). Although the latter corresponds more literally to the original adjective *kleine*, it is for once Phil Patton's otherwise totally flawed translation that is closer to the original.

structs what one could call a rhetoric of the photographic: his accounts of the instability of photographic meaning continuously oscillate between a conception of photography as contextual (i.e., as a discursively and institutionally determined fiction) and a conception of photography as referential (i.e., as an actual record of complex material conditions).

This model is inevitably less attractive to photography critics and art historians who have become habituated to the pleasures of the photographic text provided by artists who willingly deprive their viewers of the arduous tasks of reflecting on the labor of representation and the representation of labor by providing the received radicality of a photomontage aesthetic that has turned into a mere design strategy, or by pretending to the possibility of reconciling advertisement culture and history painting.

While it had been possible in conceptual art of the sixties and seventies, for example, to construct an aesthetically tantalizing series of amateurish photographs of California gas stations or parking lots along the paradigm of the ready-made, it turned out to be culturally illegible when Sekula carefully investigated the relationships between the economic macrostructure of the California aerospace industry and the microstructure of the family dynamics of an unemployed aerospace engineer (as in his *Aerospace Folktales*, 1973).[9] Or, to give another example of the peculiar restrictions imposed on the usages of photography by modernist discursivity, one could consider the photographic production of Dan Graham which began after Edward Ruscha's work in the second half of the sixties. Here Graham articulates the "social dimension" of everyday life in manifest opposition to the reductivist approach to the "real" that pop art had propounded. Yet at the same time, Graham's photographs have to continuously efface any attempt at a systematic investigation or a cohesive analysis of the social by depicting it as a fundamentally inaccessible, ultimately unrepresentable, world of random discontinuities and anomic conditions. The "social" in Graham's photographs—as in the Duchampian paradigm of the ready-made in general—is always already closed to the investigative enlightenment project (for example, that of documentary photography), let alone to a concept of intervention and change. Thus the indeterminacy of random choices of social subjects finds its corresponding strategy in Graham's emphatic denial of photographic skills through his demonstrative deployment of the cheap technology of the photographic tools of consumer culture. Graham's "deskilling" of photography denies the validity of the claims made by photographic documentary: to provide—if not guarantee—a more precise, reliable and accurate inspection of social experience.

It is in comparison with some of the dominant models of artistic deployment of photographic strategies in the conceptual work of the seventies that one can recognize in Sekula's work the points of critical departure from these models. Neither entrapped in the subversion of photographic skills like Ruscha or Graham nor in the emphatic resuscitation of photography as *the* chosen discipline for rendering the "real" as in the work of the Bechers, and neither denying access to the representation of the social in a gesture of camp futility nor claiming the control and commensurability with which documentary photography approaches social reality, Sekula has developed a dialectical method that permeates even his definition of photographic skills: they are performed with the exactitude and the comprehensiveness of photography's traditional capacities to record facts and details on a scale from the microscopic imagery of scientific photography to the large-scale dimension of the panorama. Their technical execution emphasizes photography's unique disposition towards the real and recognizes those photographers of the past (e.g.,

9 It would be appropriate to mention here that Fred Lonidier, a friend and a "political mentor" of Allan Sekula's in San Diego in the seventies, actually produced a work in direct response to Ruscha's accumulations of random (photographic) objects: Lonidier's work, entitled *Thirty Nine Arrests*, documented the police activities during a political demonstration in San Diego, where opponents of the Vietnam War protested against the departure of military vessels shipping more soldiers and weapons from San Diego harbor.

Walker Evans) whose artisanal skills corresponded visibly to their trust in both medium and method: skills with which they approached their task at providing access to a documentation of the real and their confidence in the possibility of developing an understanding of social reality.[10]

At the same time, Sekula's iconography continuously negates those principles that—if unchecked—inevitably lead to an internal hierarchy analogous to those operating within modernist photography: his continuous juxtaposition of photographic conventions makes his work appear at times as though its primary concern is an analysis of the rhetoric of photography. The sudden focus on a seemingly irrelevant and banal detail interrupts the overall narrative in the manner of a Brechtian intervention that reminds the viewers/readers of the constructed nature of the representation with which they are confronted. Ultimately, what distinguishes Sekula's work from traditionalist realism, however, is the fact that the subjects addressed by his photographic narrative sequences are both the social subjects and spaces and their conditions of experience *as well as* the linguistic and institutional conventions. Rather than changing the signifier itself, Sekula—in a manner comparable to the shift from Roland Barthes to Michel Foucault in poststructuralist criticism—addresses the institutions and discourses of (photographic) signification; it is within this field that Sekula's work performs its "realistic" interventions.

Analogous to his reconfiguration of photographic functions, Sekula has also reintroduced a wide range of textual functions into his work since the early seventies, criticizing the paradigmatic limitations of conceptual art. Even though the foregrounding of language in conceptual art had allowed for a broad spectrum of linguistic positions, ranging from those of analytical philosophy, and those of structural linguistics to those of a model of pure performativity, Sekula's redeployment of the linguistic functions of factual and descriptive reports, his constructions of a relatively cohesive and circumscribed plot (however self-conscious in its constructedness as partial fiction), have instantly disabled the reading public of conceptual and postconceptual art from positioning his work in a "legible" tradition of advanced avant-garde practices.

Finally, one could argue that Sekula's model of an oppositional critical "realism" is of course also based on a radically different conception of spectatorship, namely, one that presumes that the potential of communicative action between readers/spectators on the one hand and the artistic proposition on the other is not always already foreclosed, necessitating or justifying therefore hermeticism of structure and opacity of the sign.[11]

The model of communicative action operative in Sekula's work presumes, by contrast, the possibility of an intervention of the artistic proposition within the common reality shared by spectator and producer, thereby challenging the already foregone conclusion that works of art operate inevitably in a space of passive discursive contemplation, rather than in the still accessible conventions and social institutions of communicative exchange and self-determination. It is a model that retrieves the "commonplace" (in his case, the discredited conventions of photographic narratives and documentary and street photography), not in the laconic tradition of pop art where it had ultimately functioned as a cultural legitimation of the experience of reification, but rather in Jean-Paul Sartre's productive definition of the "commonplace":

> This fine word—the commonplace—has several meanings; it refers without doubt to the most hackneyed of thoughts, but the fact is that these thoughts

[10] An excellent example of this dialectic is incorporated in Allan Sekula's design for the poster of the exhibition *Fish Story (work in progress)*, at the University Art Museum at Berkeley (1994), that juxtaposes two images in a tightly designed graphic space: the one recording the close-up image of a ship's inclinometer, the other presenting an almost romantic panoramic view above and beyond the vast expanse of the container ship's cargo, leading into the seeming infinity of ocean and cumulus clouds above.

Sekula has repeatedly mentioned his interest in the pictorial and photographic panorama as the quintessentially anti-modernist conception of a representation whose manifest function is the maximization of visual information, citing, for example, his early fascination with the panoramic paintings of Joseph Vernet and the examples of the survey functions of panoramic photography.

[11] The poles of this debate focus of course on the two oppositional models of meaning production. The traditionalist one, as it had been based on concepts of empirical observation, had been valid throughout most of the nineteenth century and had generated a signfication of referentiality. Its successor would be the models which emerged in the beginning of the twentieth century, emphasizing the priority of structure and difference over the relationships between signifiers and material objects.

But the foregrounding of the semiotic over the referential in artistic structures implied of course an assumption about the reception process as well, namely, that aesthetic experience primarily, if not exclusively, occurred on the level of the linguistic and the unconscious. Even in aesthetic theories such as Adorno's it is ultimately the unconscious that is theorized both as the site of domination and, accordingly, as the site of the liberatory and emancipatory effect of the aesthetic. A more recent reconfiguration of this conception of modernist montage-aesthetics would be Julia Kristeva's concept of the "semiotic" (in her more strict definition of the term) and her ideas about the functions of the aesthetic as the "chora," which she considers a successful fusion of a structural linguistic model of signification and psychoanalytical concepts of aesthetic experience.

12 Jean-Paul Sartre, Preface to Nathalie Sarraute,
 Portrait d'un Inconnu (Paris: Gallimard, 1957).

13 John Heartfield's and George Grosz's critical
 departure from the montage concepts operating in
 dadaism had already voiced an opposition against the
 radical semantic refusal in the opacity of the
 fragmented signifier, emphasizing the necessity of a
 new (realistic) communicative action model of
 montage.

14 Ossip Brik, "From Painting to Photograph," in: *Photo-
 graphy in the Modern Era*, ed. Christopher Phillips
 (New York: The Metropolitan Museum of Art and
 Aperture, 1989), pp. 230-232.

 Further in the same essay Brik explains very specifi-
 cally how the conflict between traditional forms of
 representation and new social and political realities
 has to be addressed with the means that photography
 provides:
 Whenever the people's commissar is isolated from
 his environment, the result is an iconography: he's
 being regarded as a heroic figure, just like
 Napoleon, who might seem to be the central figure
 in the Napoleonic campaigns. . . . To take a
 snapshot, a photographer does not have to differ-
 entiate the individual. Photography can capture him
 together with the total environment and in such a
 manner that his dependence on the environment is
 clear and obvious. The photographer, then, can
 resolve this problem—something that the painter
 cannot do.
 Alexander Rodchenko argues in almost identical
 terms for the formal transformation of perceptual
 experience in accordance with political changes:
 There's no revolution if, instead of making a
 general's portrait, photographers have started to
 photograph proletarian leaders—but are still using
 the same photographic approach that was em-
 ployed under the old regime or under the influence
 of Western art.
 Alexander Rodchenko, "A Caution," in: *Photo-
 graphy in the Modern Era*, p. 265.

have become a meeting place for the community. Everyone recognizes both themselves and others in them. The commonplace is everyone's and mine; it is the presence of everyone in me. It is, in essence, the generality; to appropriate it for myself, I must perform an act, an act by which I divest myself of my particular-ity in order to attach myself to what is general, to become the generality. Not sim-ply to resemble everyone, but to be precisely the incarnation of everyone. By this eminently social act of association, I identify myself with all other beings in the indistinctness of the universal.[12]

It is precisely this model of an aesthetic of communicative action that has been discredited by the contemporary restrictions of aesthetic experience to a semiotics of the Unconscious. This aesthetic is enacted particularly in the contemporary *avant-gardiste* interpretations of modernist montage. Sekula's critique of this aestheticization of the montage models of the historical avant-gardes and his simultaneous advocacy of a contemporary paradox of a "mon-tage of realism" retrieves some of the earlier disputes concerning the func-tions of radical montage practices.[13]

Analogous questions concerning the dialectic between single photo-graphic imagery and the photomontage/photosequence, between the techni-cally crafted still image and the snapshot, between a photographic aesthetic of monumentality and one of contingency had of course been voiced in the famous photography debate conducted in the pages of *Novyi lef* between the Soviet practitioners and critics of photography. Rodchenko and Ossip Brik on the one hand and Boris Kushner and Sergei Tretjakov on the other had, how-ever, been concerned with the representational functions of photography in modern industrial (socialist) societies (from its new distribution forms to its new definitions of authors) *and* the structural and perceptual strategies of its reception.

The photographic image was now defined as dynamic, contextual, and contingent. The serial structuring of visual information emphasized open form and a potential infinity, not only of eligible photographic subjects in a new social collective, but equally of contingent, photographically recordable details and facets that would constitute each individual subject within perpet-ually altered activities, social relations and object relationships. Ossip Brik argued, for example, that

> Differentiating individual objects so as to make a pictorial record of them is not only a technical, but also an ideological phenomenon. In the pre-Revolutionary (feudal and bourgeois) period, both painting and literature set themselves the aim of differentiating individual people and events from their general context and concentrating attention on them. . . . To the contemporary consciousness, an individual person can be understood and assessed only in connection with all the other people—with those who used to be regarded by the pre-Revolutionary consciousness as background.[14]

The argument implies a radical redefinition of the photographic object itself. It is no longer conceived as a single-image print, carefully crafted by the artist-photographer in the studio and framed and presented as a pictorial sub-stitute. Rather, in Brik's (as well as Rodchenko's definition, see note 14), it is precisely the cheaply and rapidly produced snapshot that will displace the tra-ditional synthetic portrait. The organizational and distributional form will become the photo-file—a loosely organized archive, a more or less coherent accumulation of snapshots relating and documenting one particular subject. Yet at the same time, the photo-file does not follow the rigid structure of an

archival order, an externally imposed principle that has become one of photography's foundational discursive forms. And lastly, the photo-file, in spite of its emphasis on contingency of subjects as well as formats, will never be governed by a mere principle of randomness and chance encounter, the structural equivalent of *anomie* that has determined photographic accumulations since the sixties.

It would be tempting to establish the Soviet model of the photo-file as the predecessor of Sekula's realist montage-aesthetic as it comes to its most complex articulation in his work *Fish Story*. In fact, this model prefigures in many ways the characteristics of Sekula's work that we have tried to identify in our discussion above: the dialectic of contingency and contextuality, and the opposition between narrative sequence and random encounter, as well as the technical tension between the "deskilling" aesthetic of the snapshot and the commitment to an approximative ideal of photographic truth value in the professional artisanal photograph. Sekula has emphasized that one of his most formative experiences of the early seventies was in fact his encounter with the photographic and filmic aesthetic of the Soviet artists.[15] However the stylization of that legacy, its transformation into a stylistic affectation, which emerged in the work of some of his generational peers in the late seventies and early eighties as a result of that encounter, linked as it was to a general dehistoricization of the epistemes and strategies of the Soviet avant-garde in favor of the aestheticization of its products, was utterly unacceptable to Sekula.

Photography in the hands of the masses and the universal transformation from cultural consumers into authors—the utopian dream of the worker photographers of the Soviet Union and of Weimar Germany in the late twenties and early thirties—can clearly no longer be the question or the reality of a post-World War II photographic aesthetic. Rather, its point of departure would have to be its utter opposite: the dystopian universe of amateur photography as one of the largest industries to emerge since the post-war period, as analyzed, for example, by Pierre Bourdieu's *Un art moyen*. Neither could Sekula's work be guided by the revolutionary ideal of a factographic aesthetic that the Soviets had developed, since already in the late twenties it became evident that photo-journalism and the rise of the American type picture press would guarantee the disappearance of factual historical experience altogether, as Siegfried Kracauer was the first to observe in his extraordinary essay in 1927:

> Never before has an age been so informed about itself, if being informed means having an image of objects that resembles them in a photographic sense. Most of the images in the illustrated magazines are topical photographs that, as such, refer to existing objects.... In reality, however, the weekly photographic ration does not intend at all to refer to these objects or ur-images. If it were offering itself as an aid to memory, then memory would have to determine the selection. But the flood of photos sweeps away the dams of memory.... In the illustrated magazines people see the very world that the illustrated magazines prevent them from perceiving.... Never before has a period known so little about itself.... What the photographs by their sheer accumulation attempt to banish is the recollection of death, which is part and parcel of every memory image.[16]

Sekula's project of a critical realism, as it has evolved over the past twenty years, culminates for the time being in his extensive photographic installation of *Fish Story*. The massive effort of the project's research and travel, of its scientific and theoretical accounts of the transformation of the sphere of seafaring and the world of harbors, serves first of all as a metonymic-

15 Rather than the photography debate which was only partially accessible in translation at that time, it was in particular Sekula's encounter with Dziga Vertov's *The Man with a Movie Camera* that generated his extensive interest in the photographic and filmic legacies of that avant-garde moment.

16 Siegfried Kracauer, "Photography" (Die Photographie), in *Das Ornament der Masse* (Frankfurt: Suhrkamp, 1963), pp. 21-39. Translated by Thomas Y. Levin in *Critical Inquiry*, vol. 19, no. 3 (Spring 1993), pp. 421-436.

ally detailed account of the general political and economic transformations brought about by the globalization of late capitalist rule. At the same time, the paradoxical conflict of the work is that between the scope of a narrative of epic dimensions and an accumulation of often small photographic facts, presented in an understated travesty of both narrative and documentary traditions, the term "Fish Story"—while self-deprecatory and referring to a dubious hyperbolic tale—still recalls its great opposite, the heroic and tragic account of the seafaring entrepreneur Captain Ahab in Herman Melville's *Moby-Dick*.

It is in this first layer of paradox that the endeavor of *Fish Story* becomes evident as one whose monumentality is linked first of all to the disappearance of historical and material facts from photographic—rather electronic—representation (and with them, as Kracauer argued, the disappearance of experience and memory altogether). The work's efforts and scope provide insight into the textual and photographic labor that is necessary at this moment in history to retrieve any aspects of the "factual," the "social" and the "political" and to redeem memory with the means of photography within a culture of television. These efforts also indicate that Brecht's optimistic prognosis that the provision of a textual caption under the photograph would suffice to reconstitute legibility and historical information to the photograph (what Kracauer called the "contextual framework available to consciousness") is no longer valid; that rather a whole system of captions is necessary, intricately tracing the network of hidden relationships occluded from view by the total contiguity of "visual information." Thus, as much as *Fish Story* is a rhetoric of photographic discourses and conventions, it is also an allegorical (re)construction of the possibility of understanding history in the age of electronic media: the seemingly outmoded practices of still photography correspond to the outmoded and disappearing sites of the mythical world of harbors and the romanticized notions of a seafaring proletariat.

The second level of paradox in *Fish Story* which allows us to recognize the historical distance that separates its realistic strategies from those of the factographic avant-gardes of the twenties, is the very conception of "factuality." In the Soviet model of factographic writing or photography, "fact" could still be conceived as an episteme of emancipatory forms of knowledge: "fact" implied distance from, if not altogether absence of, myth and domination as much as it implied participation within the material construction of historical factuality. "Facts" in Sekula's *Fish Story* are always parts of the fallen facticity of the world, that is, they are sites of cover-ups and myths, of clandestine and concealed "public" operations. These are the operations of capital; the continuous process of shifting, changing, and social and political reorganization determines the pace and intervals of these facts. Sekula's paradox of a "realistic montage" therefore engenders less of a semiotic montage, rather it records these intervals, the spatial discontinuities and temporal gaps occurring in the production of these "facts." If they enter (re)presentation at all, they appear as isolated and unrelated in order to prevent them from becoming coherent and transparent. "Facts" in *Fish Story* are therefore both sites of exploitation and domination as much as structures of discursive control that require in the first place an author/reader intervention to break down the concealment and the isolation to become legible at all. But Sekula's realistic montage retains at the same time that strategy's original emphasis on shock and chance occurrence, sustaining the incommensurability of the accidental dimensions of these factual intervals against the overcoded regularity of photojournalism and traditional documentary that always presume a perfect fit between the photographic genre and the motif.

The last level of our consideration would again consider the semiotic functions within *Fish Story*. Sekula emphasizes that it is a work of both writing *and* of photography.[17] Writing functions in *Fish Story* on the one hand as the main impediment against the discursive hierarchy of photographic genres, on the other it constructs a "polyphonic, time-oriented photographic work"[18] that is neither instantly contained in the archival structure of accumulated photographs nor allows for the rigorous reduction of the multiple semiotic functions to a single modus (to be a modernist means to remove the overlay of the iconic and the symbolic). The syntagmatic dimension which Sekula aims to generate in the multiplicity of voices and photographic conventions that operate simultaneously in *Fish Story* is one that operates primarily within its own structure rather than as another incident of intertextuality within the complex history of modernism. In other words, an intertextuality that—rather than addressing its discursivity—addresses the construction of experience and memory in the dialogue with the reader/viewer.

[17] Sekula explicitly would like the work to be associated with a model for this practice that he equally encountered in the mid-seventies: John Heartfield's and Kurt Tucholsky's book *Deutschland, Deutschland Über Alles* (Berlin: Neuer Deutscher Verlag, 1929).

[18] Allan Sekula, in a conversation with the author, June 1994.

A NOTE ON THE WORK
ACKNOWLEDGMENTS
CREDITS AND SOURCES

A NOTE ON THE WORK

Fish Story is the third in a cycle of works on the imaginary and material geographies of the advanced capitalist world. *Sketch for a Geography Lesson* (1983) charted a relation between the pictorial space of German romanticism and the trip-wire border terrain of the Cold War. *Canadian Notes* (1986) examined connections between the landscape of extractive industries, the architecture of banks, and the iconography of printed money, moving between a bank that masqueraded as landscape and an industrial landscape that masqueraded as a bank.

With the shift from the groundedness of landscape to the fluidity of seascape, and with the destabilization of the world geopolitical balance beginning in 1989, the drift and uncertainty of an extended work in progress seemed appropriate. Sites were chosen for reasons that were whimsical as well as thematic. In general the choices were predicated on a search for past and present centers of maritime power, as well as more peripheral zones, often those that have been subjugated to a single power, as has been the case with Mexico, or those that have endured a history of being caught between greater powers, as is the case with Korea and Poland.

From the beginning, the project was conceived as becoming both an exhibition and a book, with "chapters" being presented as they envolved. The final sequence of chapters, and of pictures and texts within chapters, is virtually identical in both exhibition and book. In the exhibition, 105 color photographs are organized in sequence over a series of walls and rooms with 26 text panels interspersed at varying distances from the pictures. On a graphic level, these text panels are the black-and-white photographic companions to the color pictures. The spatial relationship of image to image, image to text, and text to text necessarily takes a different form within the pages of a book. Furthermore, the book allows for the inclusion of another, parallel text, and becomes an altogether different object.

As published, *Fish Story* is a work in seven chapters, with an accompanying essay in two parts. The introductory sequence, "Fish Story," (1990-93) is here in its fourth and final version. The first version was exhibited at the California Museum of Photography in Riverside, California and at Galerie Perspektief in Rotterdam in 1990. The second version was also exhibited in 1990, at the Fotobienal of Vigo, Spain. The third version was shown at the Museum of Contemporary Art, Los Angeles, in 1991. The introductory text, virtually unaltered from the first to the fourth version, was first published in *Polemical Landscapes* (California Museum of Photography, 1990) and in *Perspektief* 39 (1990).

The first version of "Loaves and Fishes" (1992) was shown in the traveling exhibition *Real Stories* originating at the Museet for Fotokunst in Odense, Denmark in 1992. The work was published in its entirety in the catalogue to that exhibition. The second and current version of "Loaves and Fishes," together with the fourth version of "Fish Story," were exhibited at the 1993 Whitney Biennial in New York, traveling to the National Museum of Contemporary Art in Seoul, and then in 1994 at the University Art Museum in Berkeley, Califonia.

The first version of "Message in a Bottle" (1992/94) was shown at the 1992 Vigo Fotobienal, and published with the text in Galician translation in the exhibition catalogue. It was also exhibited in 1993 at the New Museum of Contemporary Art, New York.

The exhibition *Fish Story* also includes two slide projections. These are not included in the book, although the prologues to both have been joined to form the epilogue here. The projections were designed to introduce a markedly different temporal and pictorial experience from that elicited by the images and texts on the walls. Each slide projection consists of 80 transparencies shown continuously at fifteen-second intervals in a separate projection room, with captions and accompanying text available in a booklet positioned outside the room. The first of these projections, "Dismal Science" (1989/92) follows several days of movement along the Rivers Tyne and Clyde, the great spaces of British and Scottish shipbuilding during the first and second industrial revolution. The second, "Walking on Water" (1990/95) follows a similar movement between Warsaw and Gdańsk, the "Glasgow" of the former socialist bloc. "Dismal Science" was first exhibited at the Photo Biennial of Rotterdam in 1992. An excerpt from the work was published in the Belgian magazine *Forum International* (November-December 1992).

"Middle Passage," "Seventy in Seven," "True Cross," and "Dictatorship of the Seven Seas" were all completed in 1994 and are published here for the first time.

The essay with the shared title "Dismal Science" developed from a paper first presented at the Center for Twentieth Century Studies at the University of Wisconsin, Milwaukee in 1992. Versions of the original paper were subsequently presented over the next two years at Erasmus University in Rotterdam, at the Moderna Museet in Stockholm, the Center for Creative Photography in Tuscon, Arizona, the Kulturwissenschaftliches Institut in Essen, Germany, the University Art Museum, Berkeley and the Getty Center for the History of Art and Humanities, Santa Monica, California. "Dismal Science" was completed in 1995.

Allan Sekula

ACKNOWLEDGMENTS

Six years of gratitude is owed to many.

In Los Angeles: Michael Asher, Thom Andersen, Kaucyila Brooke, for critical advice and support. John Bache and Ellen Birrell for taking over the photography program at CalArts. Mike Davis for suggestions and for his work. Stephen Callis and William Short for help with some of the photographs and Alex Slade for help with studio preparation. Kelly Dennis and Anetta Kapon for research assistance and Cristina Cuevas-Wolf for translations from the Mexican press. Michael Dawson and Carolyn Kozo Cole for access to historical documents and photographs from the Port of Los Angeles. Jorge Klor de Alva, Deborah Cohen and Peter Bloom for suggestions. Ann Goldstein for her interest in the work from its early stages, and Andrea Liss and Brigitte Werneburg for writing about the work when it was still developing. Tom Reese and the Getty Center for the History of Art and the Humanities for an invitation to spend a semester as a visiting scholar in 1993. Gordon Baldwin for help with photographic reproductions from the Getty Museum. Dr. Raymond Purcell, orthopedic surgeon, and Ned Andrews, physical therapist, for getting me back on my feet after a 1994 earthquake/work injury. Frank W. Green for his skill as a printer. Sherri Schottlaender for proofreading.

In the Port of Los Angeles: Eugene Pekich, for keeping me in touch with San Pedro, Mark Fuette and the crew of the tugboat Point Vincente, and Tony Salcido, crane driver and informal historian of ILWU Local 13, for lessons learned. In San Diego: Fred Lonidier and Peter Zschiesche for access to the shipyards and an overview of the union situation. In Berkeley: Larry Rinder for supporting the project with an exhibition at a crucial stage. Cinthea Fiss for help with research, and Saundra Sturdevant and Iain Boal for suggestions. Thanks also to Hal Foster for engaging in a public conversation in Berkeley about the work.

In Spain: Antonio Espejo and Juan Madrid of La Coordinadora in Barcelona for introducing me to their democratic union and the port, Manuel Sendon in Vigo for the opportunity to work, and the crew of the fishing boat Mi Nombre Quatro Cesantes for taking me along.

In Mexico: Olivier Debroise and James Oles in Mexico City and Ida Rodriguez Prampolini, Ferruccio Asta, and Daniel Göritz in Veracruz for historical lessons. Several former Veracruz dockworkers came forward with stories but for political reasons cannot be thanked by name.

In South Korea: Kim Hyung-Su for interpretation and generous overall guidance, Cheong Tae-Im and professor Kim Yong-Gi for economic and political insights, Oh Hyong-Keun for a reading of Itaewan, the officials of Hyundai for access to the Ulsan shipyard, Kim Kyung-Seok for a sense of the beleagured fishing economy. Park Chan-Kyong helped with Korean translations.

In Hong Kong: given the uncertain prospects for democracy after 1997, it is unwise to thank by name several public officials who helped.

In Poland: Tony Dyrek for initial advice, Malgorszata Paradzinska and Krystyna Wróblewska for interpretation, Piotr Bikont for his videos on the struggle in Gdańsk, Jane Dobyia and Stefan Bratkowski for accounts of the Polish economy in transition, Professor Jerzy Doerffer for insights into the history and prospects of Polish shipbuilding, and Józef Góral for insights into life spent working in the shipyard, and Solidarity for access to the Gdańsk Shipyard.

In Newcastle: Chris Killip for giving me the beginnings of a cognitive and affective map of the Tyneside.

In Stockholm: Jan-Erik Lundström for supporting the project at an early stage.

In the North Atlantic: the officers and crew of the Sea-Land Quality, especially Bruce Myrdek, Keith Brack, and David Brown, for their hospitality.

In Rotterdam: Hripsimé Visser and Bas Vroege for initial interest and support. The crews of the Havendienst boats and the employees of ECT for access to the working port. Frans van Hamburg for access to the collection of the Maritiem Museum. Gé Beckman for trips to the Maasvlakte. Tonia van den Berg and Jürgen Preuss for arranging passage across the Atlantic.

This project would not have been realized without the energy and tenacious support of Chris Dercon. My gratitude goes also to the staff at Witte de With, especially to Paul van Gennip and to Barbera van Kooij for their precise and committed work on the exhibition and book, and to Robin Resch for proofreading the texts. In Los Angeles, again, Catherine Lorenz is to be thanked for her inventive work on the design of the book. In Düsseldorf, Klaus Richter's skill as a printer and publisher, and his sympathy for the project, have been crucial.

Thanks also to Benjamin Buchloh for his essay in this book, for a reading that reaches back to engage critically with work that he helped to bring into public view more than a decade ago.

Some debts exceed location. My father, Ignace Sekula, has helped with translations from Polish. My mother, Evelyn Sekula, and my sister, Victoria Sekula, helped with clippings

from the northern California press. My brother, Stefan Sekula, took time out to build a workable studio space at a crucial point in the project. But their help was more than practical. Ann Stein is also to be thanked for her support. Stan Weir, with his close attention to the sociology of work, his knowledge of maritime worlds, and his dissident path, has been a source of inspiration and guidance. I am grateful to him and to Mary Weir for their encouragement.

Geographically dispersed work of any kind tests commitments to a shared life lived in one place. I am more than grateful to Sally Stein for her support, for the sustained dialogue with her own work on photography and the world of images, and for her wise interventions in the process of assembling meaningful sequences of pictures.

Allan Sekula

Frank W. Green of The Lab, Burbank, California, made the Cibachrome exhibition prints from the original 35mm and 120mm color transparencies. The exhibition text panels were designed by Allan Sekula and Catherine Lorenz and printed by Olson Color Expansions, Los Angeles. Framing was done by Ron de Hoog, Een visie in lijsten, Maassluis. The slide duplicates for the two projections were made by Allan Sekula and by Assemblyline Film Services, Hollywood, California. The slides were mounted by Martha Godfrey. The duplicate transparencies for reproduction in the book were made by A&I Color Laboratory, Hollywood.

The text illustrations are taken from the following sources:

Frontispiece: *Fishing, fabrication of nets*, plate 24 from Denis Diderot and Jean Le Rond d'Alembert, eds, *Encyclopédie, ou dictionnaire raisonné des sciences, des arts et des métiers, plates*, vol. 7 (1771). Getty Center, Resource Collections, Santa Monica, California.

Fig. 1: Tate Gallery, London. Fig. 3: Museum Boymans-van Beuningen, Rotterdam. Fig. 4: Coll. Westfries Museum, Hoorn. Fig. 5: © Cousteau Society, Chesapeake, Virginia. Fig. 12: Philadelphia Museum of Art, Philadelphia: Given by Mr. Peter Benoliel (Funds Contributed). Figs. 13-14, 18-19: Collection of the J. Paul Getty Museum, Malibu, California. Fig. 17. © King Features Syndicate, New York. Reprinted with special permission. Fig. 20-21: Museum Folkwang, Essen. Fig. 22: © A. Warhol, 1995 c/o Beeldrecht Amsterdam. Fig. 23: International Organization for Standardization, Geneva. Epilogue: map © *The Independent*, London.